艺术设计
双语教程

应宜文 主 编

徐育忠
陈 炜 副主编

Bilingual
Lectures
of
Art and Design

中国建筑工业出版社

图书在版编目（CIP）数据

艺术设计双语教程 / 应宜文主编. —北京：中国建筑
工业出版社，2015.6
ISBN 978-7-112-18229-9

Ⅰ.①艺…　Ⅱ.①应…　Ⅲ.①艺术–设计–双语教学–
高等学校–教材–英、汉　Ⅳ.①J06

中国版本图书馆 CIP 数据核字（2015）第 141557 号

对于设计学的本科生及研究生，在提高专业文献阅读能力的同时，还特别需要有效地运用英语了解设计学领域的最新发展动态，而本书正是一本融实用性和前瞻性于一体的教学用书。

本教材共分 8 章，内容包括艺术设计构思与构成专题、艺术设计与多元文化专题、欧美设计经典文献专题、艺术设计评论专题、创新设计与获奖作品专题、欧美设计大师专题、艺术设计与环保材料专题、艺术设计流程与管理专题等。

本书的写作目的是使学生对设计学英语理论体系有一个总体的认识，旨在培养和提高读者的设计英语运用能力。本书可作为高等院校设计学、艺术学等专业的双语教学用书，也可供其他艺术设计相关专业参考使用。

责任编辑：李东禧　吴　绫
责任校对：李美娜　刘梦然

艺术设计双语教程
应宜文　主　编
徐育忠　陈　炜　副主编

*
中国建筑工业出版社出版、发行(北京西郊百万庄)
各地新华书店、建筑书店经销
北京嘉泰利德公司制版
北京云浩印刷有限责任公司印刷
*
开本：787×1092毫米　1/16　印张：12　字数：270千字
2015年6月第一版　2015年6月第一次印刷
定价：39.00元
ISBN 978-7-112-18229-9
　　　（27487）

本书为"浙江工业大学 2014 年校级重点建设教材项目"

（项目批准号 JC1419）教研成果

前 言
Preface

当代艺术设计专业在传承我国历史文脉与发扬民族文化特色的同时，国际化交流日益频繁，国际化进度也日益拓展。随着艺术设计学科国际同步化教学的实施，各大高校对双语教学以及适用的双语教材需求日益增加。作者编写《艺术设计双语教程》的目的在于为艺术与设计学专业的本科生及研究生提供一本既能使读者掌握设计专业英语术语，又能培养和提高读者专业文献阅读能力，并了解设计学领域最新发展动态，融实用性和前瞻性于一体的教学用书。通过使用本教材不仅可以提高读者理解专业文献、解读国外设计原作的综合能力，还可以从我国传统文化的视角启迪设计思维及开拓专业视野，为日后从事相关的设计创新工作和理论研究打下坚实的基础。

目前，不少学生在学了十多年英语以后，仍不能有效地运用英语获取专业知识和前沿的学科信息，有时甚至不能准确解读西方新兴设计的设计说明与作品内涵。根据这种情况，当务之急需要加强艺术与设计学的双语教育和提高专业英语的运用能力，其关键在于如何运用独特的视角和崭新的知识结构去进行双语教育。21 世纪优秀的设计人才必定是具备"跨学科、多领域"知识的综合型创新人才，而不是单一局限的设计模式。我们在《艺术设计双语教程》的编写过程中力求改革创新，遵循艺术设计学科的知识规律，由艺术设计基本要素的双语解析，拓展到专业设计评论、设计经典文献、获奖设计解析、设计流程与管理等的双语比较，开拓设计创新思维，弘扬我国传统文化，提高综合创新能力等。本教材集思广益，从设计学科各专业知识体系中凝练而成 8 个专题，涵盖了艺术设计学科多层面、多环节的基本知识及要点，它犹如为读者铺路的基石，循序渐进地帮助读者步入更广阔的国际设计领域，了解国际设计趋向，有效地参与国际设计合作。

本教材共分 8 章，内容包括艺术设计构思与构成专题、艺术设计与多元文化专题、欧美设计经典文献专题、艺术设计评论专题、创新设计与获奖作品专题、欧美设计大师专题、艺术设计与环保材料专题、艺术设计流程与管理专题等。本教材的特色在于以专题教学的编撰方式，使主题明确、知识点集中，有益于启发读者的设计创新思维；教材范文主要选自近几年国外出版的教材和经典著作，精选

欧美艺术教育协会推荐的文献以及 2014 年度欧美艺术设计学科前沿的论文，以获取最新的专业知识与信息；收录了大量国内、外经典的创意设计作品，既有写实、富有艺术感染力的设计范例，又有生动、准确的中英双语解析与导读，加强艺术设计专业用语的理解与运用，图文并茂，参比性较强，内容新颖，知识覆盖面广，能够使读者对设计学理论体系有一个系统全面的认识，是对专业学科知识的最好补充。

全书语言规范、结构清晰、难度适中，能够更好地提高学生理解专业英文资料和解读设计作品的能力。本教材适合于艺术与设计学二年级以上的学生，建议采用 32 课时或 48 课时教学。采用 32 课时的教学时，每周讲解一个专题，以第 1 章、第 2 章、第 4 章和第 8 章内容为重点；采用 48 课时的教学时，在掌握教材内容的基础上，教师可以结合教材第 5 章的范文，指导学生进行设计说明文写作练习。

本教材的编写过程中，我们征求了设计学知名教授和设计研究所的设计师等的建议，使教材更具有专业性、实用性、时代性、新颖性。GEORGIAN COURT UNIVERSITY 美国乔治亚大学 Lili Bruess 教授、中国艺术研究院任平教授等在教材编写过程中提供了宝贵的支持与帮助。中国建筑工业出版社的编辑在全书出版过程中提出了许多中肯的建议。在此，编者向他们表示由衷的感谢！

由于编者水平所限，教材中若有误漏欠妥之处，恳请读者指正。

本教材的编写得到了"浙江工业大学 2014 年校级重点建设教材项目"（项目批准号 JC1419）的资助，特此致谢！

目　录

Contents

图版目录
List of Figures

第 1 章图 :

第 2 章图：

第 3 章图：

第 4 章图：

第 5 章图：

第 6 章图 :

第 7 章图：

第 8 章图：

1

第 1 章　艺术设计构思与构成专题

CHAPTER 1　Topic on Art and Design Composition and Concepts

[本专题导读]

1.1 艺术设计平面构成要素
Elements of Plane Composition in Art and Design

教学范文中英文对照

　　设计，是运用美学原理，按照产品的功能要求而策划、制定的方案、图样。它是一门将物质文明与精神文明、科学技术与文化艺术高度结合的应用学科。

　　人类区别于其他动物的本质特征之一是语言，它是人们最重要的交际工具。语言是一种特殊的社会现象，它随着人类社会的产生而产生，发展而发展。我们认为，设计语言，是具有直观特征的表现语言，作为一种视觉艺术的传递形式，是设计方案的表达方式和手段，亦即设计的形式法则、结构系统和构成基础。设计语言能全面、具体地反映设计内容和设计思想，丰富的视觉符号是设计语言的"词汇"，多变的框架结构是设计语言的"语法"，将符号分框架构图加以组合排列，便能形成充分表达设计方案的实施蓝图。

Design means to plan and work out schemes and patterns according to functional requirements of products and it is an applied subject for combination of material civilization with spiritual civilization, science and technology with culture and art.

Language distinguishes humans for other animals essentially and it is the most important communication tool of people. Language, as a special social phenomenon, is produced and developed with the production and development of human society. We believe that design language means presentation language of visual features, a transfer form of visual art, expression ways and methods of design scheme, or it is design's form, principle, structure system and composition foundation. Design language can comprehensively and specifically reflect design contents and concepts and rich visual signs are "vocabulary" of design language, and variable framework structure is "grammar". When combining symbols and frame composition, a blueprint for the full expression of design plan can be formed.

设计语言分为形状和构架两大部分。形状是设计语言的"视觉元素"之一。视觉元素包括形状、色彩、肌理、质感、结构等。任何可视之物必有形状。

点

点，是只有位置，没有方向、长度或宽度，只有微小面积的形状。点是线的始或终，也可存在于两线交叉处，是最短的线条。点又是最活泼跳跃的形状，以圆、方、三角、椭圆、多边等形态呈现出来。

线

线，是由点的连续或点的运动轨迹形成的。线有长度而无宽度，有位置及方向。我们也可以把"线"理解为面的边缘。线的形态有直、曲、波纹形、螺旋形、抛物线形等，可有实线、虚线、点划线排列组合之分，还有刚柔、长短、粗细之分。线是多变的具有运动感的形状。

面

面和点、线同是几何基本形。线的重复平行排列、线的运动轨迹形成面。面有长度、宽度而无厚度（高、深度），面有位置和方向。它的形状丰富多变，有方形、圆形、三角形、多边形、多角形和不规则形（由自由弧线、直线随意构成的面形）。面形

Design language is divided into two parts: shape and framework. Shape is one of the "visual elements" of design language. Visual elements include shape, color, mechanism, texture and structure. Any visible thing must have its own shape.

Point

Point is a shape with a small area and location, yet without direction, length or width. Point is the beginning or end of a line and it may locate at the cross of two lines, as the shortest line. Point is a lively and leaping shape, as it is presented in such forms as circle, square, triangle, oval and multiple lines.

Line

Line is shaped by continuous points or movement trace of point. Line has length, location and direction, yet without width. We can understand "line" as the edge of surface as well. Line has such forms as straight, curved, rippled, spiral and parabola and it is divided into solid line, dotted line and chain line. Moreover, it is also distinguished by rigid, soft, long, short, thick or thin. Line is a variable shape with the sense of movement.

Surface

Surface, point and line are all basic geometric forms; and surface is formed by repeated parallel arrangement of lines or movement trace of line. Surface has length, width, location and direction, yet without thickness (height and depth). Its forms are rich and variable, like square, circle, triangle, polygon and irregular surface (surface composed of free arc and straight line at will). Surface shape is commonly

是我们设计作图时最常用的形状。

used in our design.

体

多个面的组合成为体。体是具有长、宽、厚三度空间的形状。它具有位置、方向，占有立体空间。体的形状变化无穷。基本形体有球体、立方体、菱体、椎体、圆柱体等。如将多种基本形体再加组合，则形成复杂的组合体。以上所指的是实体。运用设计语言也可以在图面上对"体"形作多种反映和描述，以平面图、立面图、剖面图、透视图等形式把设计意图加以体现。

我们进一步了解形状与形状的构成关系（图 1-1），诸如：

Hedra

Hedra is composed of several surfaces. It is a shape with length, width and thickness as well as location and direction. Moreover, it also occupies cubical three dimensional spaces. Its basic forms: ball, cube, rhombohedreon, centrum and cylinder etc. If several basic forms are combined together, complicated complex will be formed. The ones stated previously are entities. Apply design language to reflect and depict forms of "hedra" in patterns and present the intention of design in plane graph, vertical drawing, profile map and perspective drawing etc.

We know more about shapes and constitution relations of shapes (Figure 1-1). For instance:

分离

接触

1. 分离。面与面之间互不接触，始终保持若干距离。

1. Separation. Surfaces do not contact with each other. A certain distance is always kept between them.

2. 接触。面与面的边缘，在互相靠近的情况下，可以发生接触，但不交叠。

2. Contact. When adjacent, edges of surfaces may get in contact but they do not overlay.

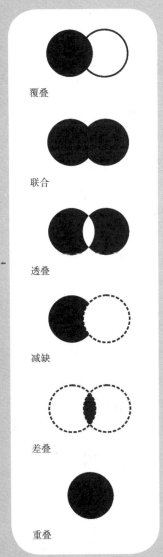

图 1-1　平面构成的形状与形状的构成关系

3. 覆叠。面与面互相靠近时，由接触更近一步，就成为覆叠。覆叠在设计中就有了前后之分。

3. Overlaying. When adjacent, surfaces go further than contact and overlaying occur. In design, the question as to which surface is in the front needs to be taken into account.

4. 联合。面与面互相交叠而无前后之分，可以联合成为一个多元化的形象。

4. Combination. Surfaces overlap but no distinction as to which surface is in the front is required. A diversified image is thus produced through combination.

5. 透叠。面与面交叠时，交叠部分产生透明感觉，形象前后之分并不明显，就是透叠。

5. Transparency in overlapping. The overlapped part seems transparent when two surfaces overlap. The distinction as to which surface is in the front is not distinct.

6. 减缺。面与面覆叠时，在前面的形象并不画出来，只出现后面的减缺形象。

6. Omission. When surfaces overlay, the image in the front is not depicted and remains only the omission image.

7. 差叠。面与面交叠时，交叠部分产生出一个新的形象，其他不交叠的部分则消失不见，就是差叠。

7. New image in the overlapped part. When surfaces overlap, a new image in the overlapped part is produced while other parts that do not overlap disappear.

8. 重叠。面与面完全重叠，成为一个独立的形象。

8. Total overlapping. Surfaces totally overlap and become an independent image.

关于构架，又称骨骼。它是形状在画面上有秩序的编排规律。人有骨骼，树木有枝干，建筑物、交通工具有一定的框架结构。根据力学和数学、几何学的黄金分割比率，设计要有章法地进行，就必须理解架构的组织与变化。一些形状和色彩在画面上无论怎样安排都要受到架构的约束。它犹如一根无形的线，把零散的珠子（视觉符号——形状、色彩、肌理等）串联起来。架构是设计语言的章法、语法。遵循它的规律，把语言符号巧妙地组合编排、变化。

架构最基本的线是水平线、垂直线与斜线。诸如贯穿画面的"一"字把图画分成两个部分；"人"字把画面分成三份；"十"字把画面分成四等分等（图1-2），这是最基本的画面分割形式。我们进一步了解架构的重复与变化，诸如：

（1）宽窄变化（图1-3）。这是将架构骨骼线的粗线，以及线与线之间的距离加以变化，仅用架构本身就能够产生无穷的图案纹样，例如：瓷砖、墙纸的纹样以及服装面料格子纹等。

（2）方向变化。这是将水平线或垂直线变化而成为不同斜度的斜线，让原先平静、稳重的画面产生运动感，使之比较活泼（图1-4）。

Framework is also named the skeleton. It is the regular arrangement pattern of shapes in the screens. Human beings have skeletons, trees have trunks, and buildings and vehicles have their own structures. According to the golden section ratio in mechanics, mathematics and geometry, understandings of organizations and changes of structures are necessary if the design obeys its own rules. However settled, shapes and colors in the screens should be under the restraint of framework. It is like an invisible string that links together the scattered beads (i.e. the visual signs—shapes, colors, textures, etc.). Framework is the art of composition, the grammar of design. Its laws should be followed to skillfully combine, arrange and change the linguistic symbols.

The basic lines of framework are horizontal lines, vertical lines and oblique lines. For example, the picture could be divided into two parts by using the framework of the Chinese character "YI 一". It could be divided into three parts by using the framework of the Chinese character "REN 人". It could also be divided into four parts by using the framework of the Chinese character "SHI 十", etc (Figure 1-2). This is the most fundamental method of splitting screens. We know more about the repetitions and changes of framework. For instance:

(1) Changes of the width (Figure 1-3). This means changing the lines of the framework and changing the distances between lines. Innumerable patterns appear when only the framework itself is involved in the adjustment. For example: the patterns of tiles and wallpapers, the gird patterns of cloth for the garment.

(2) Changes of the direction. This means changing the horizontal lines or the vertical lines into oblique lines of different angles. Thus the once peaceful and steady images have the impression of movement and become vivid (Figure 1-4).

图 1-2　平面构成的十字形构架

图 1-3　平面构成的线与面的宽窄变化

图 1-4　平面构成的多维视觉效果

图 1-5　平面构成产生的立体效果

（3）架构质变。除直线外，用弧线、曲线、虚线、波纹线、点划线等作为架构线来运用（图1-5）。

（4）迁移变化（图1-6）。这是将垂直或水平的线做间断处理、迁移变动，增加画面的节奏变化，令画面生动、活跃。

在艺术设计时，架构与形状两者密不可分，它们之间正如"骨"与"肉"的关系，缺一不可。架构通常会决定形状的位置（图1-7）。比较简单的架构可以安排复杂一些的基本形状，比较复杂的架构则适合于编排外形整体一些的形状，这样才能取得良好的效果。

(3) Changes of the framework. Apart from straight lines, arcs, curves, dotted lines, ripple lines and dot-and-dash lines can be adopted as the framework line (Figure 1-5).

(4) Changes of the place (Figure 1-6). This means to cut the vertical or horizontal lines and move the parts, which increases the rhythm changes of the images and make them vivid and active.

In artistic design, the framework and the shapes are inseparable. Their relation is like the "bones" and the "flesh" and neither can be absent. In general, the framework determines the position of shapes (Figure 1-7). Simple frameworks can be combined with some basic shapes; and intricate frameworks are more suitable with shapes that have integral outlines. This considered, a more satisfactory design result will be achieved.

图1-6 平面构成的迁移变化

图1-7 平面构成的近似设计效果

思考题：

1. 请用英文专业用语说出平面设计的四种基本视觉形态是什么。

2. 形状与形状之间具有八种构成关系，请采用双语对照的方式表述。

3. 请用英文简述"设计"的概念。

1.2 艺术设计色彩构成要素
Elements of Color Composition in Art and Design

教学范文中英文对照

色彩是什么？它们是怎样产生的？又是怎样被人们所感知的？伟大的色彩教育家约翰内斯·伊顿说过："色彩向我们展示了世界的精神和灵魂。"光使人们能感知缤纷的世界。光是一种电磁波辐射能。人们只能感知电磁波中的很少部分，这便是可见光。由于波长不同，其性质也不一样。太阳光是宇宙间最大的光源体。它包含波长400~700毫微米的光。1666年，英国的物理学家牛顿发现了光谱色。太阳光是红、橙、黄、绿、青、蓝、紫色光的混合。各种色因波长的折射率不同而产生变化。其中红色的折射率最小，紫色最大。在太阳光里，包含同样比例的各波长的光，所以呈白色。如果光源中包含的波长有不同的比例，这便是光的演色性。

由于光源色遇到物体时，变成反射光或透视光后，再进入眼睛，对眼

What is color? How do they produce? And how it is perceived? Jogannes Itten, the great color educator said: "Color shows us the world of spirit and soul." It is the light that people could perceive the colorful world. The light is a kind of electromagnetic wave radiation energy. People only can perceive small part of the electromagnetic wave, which is just the visible light. Different wave length leads to different feature. The sunlight is the biggest light source in the universe. It contains the light with the wave length from $400m\mu$ to $700m\mu$. In 1666, Newton, a famous physicist, discovered the spectrum color. The sunlight is the integration of red, orange, yellow, green, cyan, blue and purple light. It contains lights with the same proportion of different wave lengths, so that it presents white. If the wave length contained in the light source has different proportion, it is the color rendering of the light.

The light source color encounters the article, and then turns into reflected light or perspective light, enters into eyes,

图 1-8　色彩构成的欢乐色调感知

图 1-9　色彩构成的静谧色调感知

球内的网膜产生刺激，又通过视神经传达到支配大脑视觉的视觉或中枢，从而产生了色的感觉。因此，色是光刺激眼睛所产生的视感觉。其中光、眼、神经即物理、生理和心理三个因素缺一不可。这就是人们感知色彩的必要条件。

人们感知不同色彩时，和周围环境，物体的形态、肌理，人的视距、焦点以及人们的修养、喜恶、情绪等有着密切的关系。艺术设计师们往往利用人们这一心理特殊规律，增加艺术感染力（图1-8、图1-9）。

一、色彩的三属性

在色彩世界里大致可以分为两大类：单纯以色彩的亮度来区别明暗（其中白色是最亮的色，黑色是最暗的色），由它们相混而产生的灰色我

generates stimulation on the omentum inside the eyeballs, and then conveys to the visual sense of pivot dominating the brain through the optic nerve, and thus it generates color perception. Therefore, the color is the visual sense generated by the eye stimulation. As for light, eye, and nerve (i.e. physics, physiology, and mentality), any of these three factors cannot be omitted.

Colors have close relationships with surrounding environment, shapes and textures of objects, horizon and focus of people, and people's culture, likes and dislikes, emotions and so on when perceiving different colors. Art designers tend to take advantage of these psychological special laws to increase artistic appeal (Figure 1-8, Figure 1-9).

Ⅰ. Three Attributes of the Color

The color world can be approximately divided into two categories: distinguish the value and darkness only through the value of the color (the white is the brightest and the black is the darkest), and the grey from their mixing is called

们称为无彩色。若把白、黑作为两端，在中间根据明度的顺序等间隔排列灰色，便成了明度的序列。明度序列可以分为 8 个以上阶段。

除了黑、白以及由它们混合而成的灰色之外，其他都属于有彩色。有彩色中存在不同的明度。例如，黄色系列明度较高，紫色系列明度较低等。如果将它们中的任何色和白色相混，便会使它们的明度提高。反之，如果将它们中的任何色和黑色相混，便会使其明度降低。在有彩色中，每种色彩都有明显的区别。有红色系列、米色系列等。这种带有不同色味的色彩系列统称为色相。这是由于颜色处于光谱上主要波长的位置不同而造成的。

如果将黄、橙、红、紫、蓝、绿色等间隔的色相差的代表色相，环状地排列起来，便成了色相环。有 10 色、20 色、24 色，甚至 100 个色相组成的色相环（图 1-10~ 图 1-12）。

neutral color. If the black and white are regarded as the two ends, the sequence of the value comes into being according to the gray arranged in the value sequence in the middle. The value sequence can be divided into more than 8 stages.

Apart from the black, white and grey from their mixing, others belong to chromatic color. There is different value in the chromatic color. For instance, the yellow series has relatively high brightness, and the purple series has relatively low brightness, etc. If mixing any color among them with the white, their value will be increased. On the contrary, if mixing any color among them with the black, the value will be decreased. In the chromatic color, each color has obvious difference, such as red series, beige series, etc. Such color series with different color taste is named as hue, which is caused by the different position of the color in the major wave length of the spectrum.

If the hued difference spaced by the yellow, orange, red, purple, blue, green and other colors is sorted, it will become color cycle. The color cycle may be composed of 10 colors, 20 colors, 24 colors and even 100 colors (Figure 1-10-Figure 1-12).

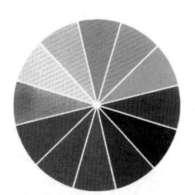

图 1-10　高明度色相环

图 1-11　高纯度色相环

图 1-12　低彩度色相环

图 1-13　色彩构成的多元组调 1

图 1-14　色彩构成的多元组调 2

有彩色中，有的颜色鲜艳，有的颜色暗淡。这种区别，称为彩度，也称色彩的饱和度。鲜度即色彩的纯度。无彩色，没有色相感，彩度为零。明度、色相、纯度都有独立的性质，成为色彩的三属性（图 1-13、图 1-14）。全部色彩都可以用三属性来界定。因为它们具有三次元的要素，可以制成立体模式即色立体。

In the chromatic colors, some are bright, and some are dim. Such difference is named as chroma or colorific saturation. The freshness is the purity of the color. The neutral color does not have hue sense. The chroma is zero. The brightness, hue and purity have their own independent nature, which becomes three attributes of the color. All colors can be defined by three attributes (Figure 1-13, Figure 1-14). As they have three-D elements, it can be made into a stereoscopic mode, i.e. color solid.

二、色彩的表示方法
—— 色立体

随着科学技术的不断发展，人们认识到色彩的内部构造和外部形态与物质世界一样，是立体三次元的。美国的数学家梦亚于 1745 年构想了颜色图谱，做出了最早的色地球。1839 年，德国浪漫派画家龙格第一次把色彩的两大体系相结合，构成为地球形状的立体色谱模式。此后，又相继产生了各种色立体图谱。

Ⅱ. Color Representation
— Color System

With the constant development of the science and technology, people have realized that the internal structure and external form of the color is the same as that of the material world, and it is stereoscopic three dimensions. An American mathematician conceived the color atlas in 1745, and made the earliest color earth. In 1839, Rung, a German romanticism painter, integrated the two major system of the color for the first time, and constituted stereoscopic chromatography mode in the shape of the earth. Afterwards, various color solid atlas came into being in succession.

1. 孟赛尔色系表（图 1-15、图 1-16）
1. Munsell Color System (Figure 1-15, Figure 1-16)

图 1-15 孟塞尔色系表

图 1-16 孟塞尔色系模型树

这个色体系,是由色相H、明度V、纯度C三属性构成。明度是从黑到白中间排列九个明度渐变的灰色。黑色在下为零级,白色在上为11级的纵轴。纯度以无彩色为零,用渐增的等间隔色感来区分,从无彩色开始依次排列。距离无彩色轴越远的色彩,纯度越高。

环绕在明度轴周围的色彩以黄(Y)、红(R)、绿(G)、蓝(B)、紫(P)这五色为基础色相,再把每一个色相展开10个渐次变化的色相,共有100个不同色相,环成一个球状体,而每个色相的第5号即5R⋯⋯代表色相。孟赛尔色系表的表示记号为HV/C,即色相、明度、纯度。

This color system is composed of the hue (H), value (V), and chroma (C). V is to arrange grey with nine values gradually varied in the middle from black to the white. The black is regarded as zero level in the lower part, and the white is regarded as the vertical axis of Level 11 in the above part. The neutral color is taken as zero. Distinguish them through the gradually increased uniformly-spaced color sense, and put in proper order from the neural color. The color keeping farther away from the neural color has the higher purity.

The color surrounding the value takes the yellow (Y), red (R), green (G), blue (B), and purple (P) as the basic hue. Then, unfold each hue into 10 hues with gradual change, and there are 100 different hues in total, which makes into a spheroid. No. 5 of each hue is 5R… which represents the hue. The mark of Munsell color system is HV/C, i.e. hue, value, and chroma.

2. 奥斯特瓦德色系表(图1-17、图1-18)
2. Ostwald Color System (Figure 1-17, Figure 1-18)

图1-17 奥斯特瓦德色系表　　　　　图1-18 奥斯特瓦德色系模型图

由诺贝尔奖奖金获得者，德国化学家奥斯特瓦德创造。全部色都是由纯色与适量的白、黑混合而成，具有白色量 + 黑色量 =100 的关系。

色相。以黄、橙、红、紫、蓝、蓝绿、绿、黄绿 8 个为主色相，每个色相展开为 3 个色相，形成 24 色相环。从 1 号柠檬黄到 24 号黄绿，环绕在无彩色明度轴周围。相对应 180° 的两个色相为互补色。

无彩色明度轴仍是纵轴。白在上，黑在下，共分 8 个明度阶段，用 a、c、e、g、i、l、n、p 为记号。a 代表最亮的白，奥氏认为没有 100% 的白。表示方法为：第一个字母表示色相；第二个字母表示含白量；第三个字母表示含黑量。从 100—含白量—含黑量，就是该色的纯色量。因此，他的最白的 a 内包含有 11% 的黑，而最黑的 p 内包含有 3.5% 的白。其间有 6 个阶段的灰色。以此轴为边，成正三角形的色相面，在顶点放置各色的纯色色标。成为等色相的三角形，环绕在无彩轴而成为复圆锥体——奥斯特瓦德色立体。

三、色彩源于大自然

凡是在艺术设计中运用的色调组织，其源泉都来自生活和大自然（图 1-19~ 图 1-22）。我们将五彩缤纷的色彩，组合和应用在设计中，这便是

It is created by a famous German chemist named Ostwald. He is a Nobelist. All color is mixed by the pure color and proper white and black. The white amount + black amount =100.

With regard to the hue, take yellow, orange, red, purple, blue, blue green, green, and yellowish green as the main hue. Each hue is unfolded into 3 kinds of hues, and forms 24 color cycles. From No. 1 lemon yellow to No. 24 yellowish green, they encircle around the value of the neutral color. The corresponding 180° two hues are regarded as complementary colors.

The value axis of the neutral color is still the vertical axis. The white is above and the black is beneath. There are totally 8 value stages, which are marked by a, c, e, g, i, l, n and p. a represents the brightest white. Ostwald holds it is not 100% white. The presentation method is as follows: the first character represents the hue; the second one represents the white content; the third one represents the black content. 100 − White content − black content is the purity amount of this color. Therefore, the whitest part contains 11% black, while the blackest p contains 3.5% white. There are 6 stages of grey. Take this axis as the edge, and form a triangular hue surface, and place the pure color code of each color on the top. Then, the formed triangle with equal hue surrounding the neutral color axis and becomes round cone—Ostwald color solid.

Ⅲ. Colors Come from Nature

In art and design colors, the sources usually come from life and nature (Figure 1-19-Figure 1-22). We use multiple colors into design by composition and application, which are the important method to draw from nature. Colors could

向自然汲取的一种重要方法。色彩也可以分为自然色彩和人工色彩两大类。当我们直接面对自然界的山水风景、花鸟虫鱼等物象获取的是自然色彩，经过艺术设计者的观察、分析、归纳出基本色彩，只用色块来界定明确的色相、明度和纯度，再现于设计作品中的就是人工色彩。通过专业训练，任何自然色彩都可以转化成为变幻莫测的人工色彩的组合。设计师往往能够很好地把握色调，达到得心应手的程度。

also be divided into two categories such as natural color and artificial color. We could see natural colors when we are face to face with images such as natural landscape, flowers, birds, insects and fishes, etc. Art designers observe, analysis, and sum up these basic colors. They only define clear color hue, value and chroma, and reproduced in their design artwork. This kind of color belongs to artificial colors. Any natural color could be unpredictably converted into to the combination of artificial color through professional training. Designers tend to master the ability to control colors with high proficiency extent.

思考题：

1. 请用英文专业用语说出色彩的三属性是什么。

2. 本文阐述了哪两种色立体名称及特点，请采用双语对照的方式表述。

3. 请用英文描述出您所见到的各种自然色彩。

图 1-19　大自然的色彩肌理

（摄影：Peggy Qian）

图 1-20　大自然的色彩组合
（摄影：Peggy Qian）

图 1-21　大自然的色彩组调
（摄影：陈炜）

图 1-22　大自然的色彩景观
（摄影：陈炜）

1.3 艺术设计立体构成要素
Elements of Three-dimensional Composition in Art and Design

教学范文中英文对照

　　立体构成是在三次元的空间内，占据实际空间的构成，培养我们对形体和空间的审美感应能力，通过智慧和情感的开发来丰富我们对空间的构想。当感应能力和构想连接在一起时，就有了"创造力"。立体构成揭示了立体造型的基本规律，其基本造型要素包括点、线、面、体、空间、色彩和肌理。这些基本造型要素按照美的原则构成新的立体形态，我们称之为立体构成。

　　对于艺术设计专业来说，这是对形、色、质（心里效能）等的探求，对材料强度、加工工艺（物理效能）的探求，也是对立体形象的想象力和直觉判断力的锻炼。它为设计提供广泛的构思方法和方案。设计者可通过逻辑推理计算出由有限构成要素组合而成的形态可能存在的方案数量和组构形式，也可以按照美的原则及工艺

　　Three-dimensional composition takes up the actual space and fosters our appreciation for beauty in the 3-D space and polishes our conception through the development of wisdom and emotion. Thereafter, "creativity" is born when the inductive ability and conception are linked. Three-dimensional composition reveals the basic rules of solid modeling, whose basic components include the point, the line, the plane, the solid, the space, the color and the texture. Solid forms consisting of these components are called three-dimensional composition.

　　In terms of the specialty of art and design, three-dimensional composition is an exploration of the form, the color, the texture (mental efficiency), etc. It is an exploration of the intensity and processing techniques (physical efficiency), as well as a practice of imagination of solid modeling and intuition. It offers a wide range of ideas and plans for designs. Designers can calculate possible numbers of plans and forms of contracture made of limited components through logical thinking. Otherwise, designers can elect

技术、材料等要求，筛选出优秀的组合方式和方案，为设计服务。它可以为设计师积累大量的素材形象。这种形象与通常设计时所考虑的形态思路恰好相反，因而，较易出现让人们出乎意料的新方案。

　　立体构成的形态可分为偶然形态、有机形态和几何形态。偶然形态是指偶发性行动创造的形态，例如用手把纸糅皱而成的形态等，从而创作出难以预料的不规则形态。有机形态则以圆滑的曲线行为特征，暗示有机生命体的紧张度与扩张。几何形态是指依据一定比例和尺度来创作的形态，一般要借助绘图工具来完成，如球、圆柱、圆锥、角柱、椭圆体、多面体等。

一、半立体构成，即"二点五维"构成

　　半立体构成或称二点五维构成（图 1-23、图 1-24），是从平面走向立体的最基本练习。这是在平面材料上对某些部位进行立体化加工，使之在视觉上和触觉上都具有立体感。二点五维构成经常使用的材料有纸张、塑胶板、泡沫板、木板、石膏、水泥、石板、金属板、玻璃等。其中纸材比布料光滑，有适度的韧性、透光性、吸湿性和吸油性、加工方便等特点而最适合作为半立体构成的基础材料。

suitable combinations and plans based on requirements like aesthetical principles, crafts and resources for the purpose of design. This composition may provide designers abundant resources, which have reverse forms with the ordinary ones. Thus, extraordinary new plans may be generated easily.

Three-dimensional composition can be divided into the accidental form, the organic form and geometric form. The accidental form refers to forms created by accidental behaviors, such as a piece of paper which takes shape through rubbing, to create irregular shapes. The organic form features smooth curves, indicating stress and expansion of an organic life. The geometric form refers to forms created according to certain proportion and scale via drawing instruments like the sphere, cylinder, cone, corner column, ellipsoid and polyhedron and so on.

I. The Half Three-dimensional Composition, or 2.5-dimensional Composition

Half three-dimensional composition, or 2.5-dimensional composition (Figure 1-23, Figure 1-24), is the fundamental practice from the plane to the solid. This is the three-dimensional processing of some sections on a plane which allows for more three-dimensional sense visually and sensationally. The common materials of 2.5-dimensional composition are paper, plastic board, foam board, wood board, plaster, concrete, stone board, metal board, glass, etc. Among them the paper is smoother than cloth with suitable flexibility, transparency, absorption of water and oil and convenience of processing, so the paper is the most proper basic material for half three-dimensional composition.

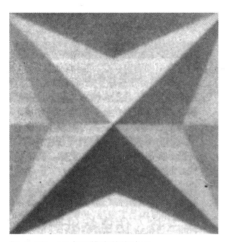
图 1-23　二点五维立体构成 1

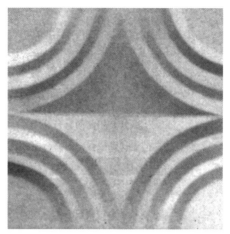
图 1-24　二点五维立体构成 2

1. 折式。仅限用折的方法。以几何形态为主，表现出对比与调和、节奏与韵律、密集与疏松、比例与尺度、对立与统一的美学形式。

1. Folding. Only folding is allowed. The geometric forms reflect aesthetic forms of contrast and adjustment, rhythm and rhyme, concentration and Looseness, proportion and scale, contradiction and unity.

2. 切式。仅限用切的方法。一张白纸就可能成为千变万化的形态，这种切须穿透纸背，切后可挪动纸体，使之出现新的形态与视觉效果。

2. Cutting. Only cutting is allowed. With a piece of white paper, a range of forms can be generated by thorough cutting, after which the section can be moved and be transformed into new shapes and visual effects.

3. 切加折式。将前述的切和折两项设计的综合。具体由于切数和折数的不同有多种构成形式，以"一切多折"的二点五维形式最为多见。

3. The combination of cutting and folding. This is an integration of cutting and folding mentioned above, which vary based on different numbers of cutting and folding. The common type is the 2.5-dimensional composition with one cut and multiple folds.

4. 压花式。用压凹凸的加工方法使纸面产生各种浮雕图形。在古代，这种加工法称为压花术，是用模型从反面将纸压出各种浮雕花纹。由于印刷术的发展，在现代包装、书籍封面、贺年片、圣诞卡等印刷物上往往可以见到这种压凸的印刷形式。

4. Embossing. A number of patterns in relief sculpture are produced via the processing of pressing. In ancient times, this was named embossing, which referred to patterns in relief sculpture pressed by a model from the back side of the paper. With the development of printing, embossed printings can be found in the modern package, book cover, greeting card, Christmas card, etc.

5. 粘贴式。采用粘贴手法，形式丰富，产生凹凸对比作用，兼有触觉上的新奇变化以及视觉上的冲击效果。

5. Sticking. The approach of sticking has a wide range of forms and leaves the concave-convex effect with amazing changes when being touched and striking visual effects.

6. 插联式。将若干小纸片分别进行局部割切加工，再将这些经割切加工的小纸片一个一个连在一起，以形成一个整体的新形态。

6. The combination of cutting and link. Several pieces of paper are cut and processed separately as part of the work, and then they are linked one by one to be components of a whole new form.

二、三维立体构成

三维立体构成的重要特征是可以让人们通过不同距离、角度来观察形态，并将不同角度的观察印象统合成一个完整的立体物概念。三维立体构成的基本单元可以是线，也可以是面，还可以是体（块），分别采用不同的材质与元素来完成。

1. 线立体构成

线立体构成（图1-25），可分为硬线材和软线材构成两大类。硬线材包括木条、金属条、玻璃条、塑料条等；软线材包括棉线、麻线、丝线等。线框、桁架、硬线排出等构成形式是硬线材构成中最多见的形式。通过线群的集聚及线组成的虚体和实体的呼应关系，表现出独有的节奏韵律。软线材构成常常用硬材作为引拉软线的基体，基体的"硬"与软线的"软"形成一种对比，并使软线集聚、交错、弧转、扭曲而具有高度秩序感。

II. Three-dimensional Composition

A key feature of three-dimensional composition is that it enables people to observe forms from different angles in different distances, and merge the impressions on the observations from different angles into a complete solid object concept. The elementary unit of three-dimensional composition may be line, plane and body (block), finished by the use of different materials and elements.

1. Three-dimensional Composition of Line

The three-dimensional composition of line (Figure 1-25) can fall into two categories — the composition of hard line and that of soft line. Hard lines include batten, metal strip, glass strip and plastic strip, etc. Soft lines include cotton thread, twine and silk thread, etc. Such constitution forms as line frames, truss and hard lines discharge are the most common forms in the composition of hard lines. The responding relationship between the virtual body and real body clustered by line group and constituted by line reflects unique rhymes. For the composition of soft line, hard material is often used as a matrix of pull soft line. The "hardness" of matrix and the "softness" of soft line form a contrast. As a result, soft lines are clustered, interleaved, arced and distorted to form a high sense of order.

图 1-25 立体构成之线构成

2. 面立体构成

面立体构成是以板材（纸板、木板、塑料板、玻璃板、有机玻璃板、金属板等）为基本单元的造型。层面排出、面框组构、薄壳、透空柱体等都是面立体构成中常见的艺术表现形式。

3. 块立体构成

块立体构成（图 1-26）是以块材（实心块体和空心块体）为基本单元的造型。实心块体包括雕塑泥、胶泥、金属块、木块、石块等。空心块体包括中央镂空的块体和由面材包被成的空心块体。

块的切割、演绎、增减构形是块的单体研究中最基本的手段，面块的集聚构形则包含若干相同块体的集聚构形和若干异同块体的集聚构形两大类。有许多的块立体构成设计是从柏拉图的五种多面体中展开进行的。

4. 线、面、块混合的立体构成

线、面、块混合的立体构成（图 1-27），包括线面结合构成，线块结合构成，面块结合构成，线面块结合构成。通过理解线、面、块的空间交变关系，提高运用线、面、块创造形态的能力。

2. Three-dimensional Composition of Plane

The three-dimensional composition of plane is a shape with the boards (paperboard, wood board, plastic board, glass board, organic glass board and metal board, etc.) as an elementary unit. Bedding plane discharge, plane frame composition, thin shell and permeable cylinder are common artistic expressions in the three-dimensional composition of plane.

3. Three-dimensional Composition of Block

The three-dimensional composition (Figure 1-26) of block is a shape with the block materials (solid block and hollow block) as an elementary unit. Solid block includes sculpture clay, daub, metal block, wood brick and stone, etc. Hollow block includes hollowed-out block and the hollow block enveloped by plane materials.

Block cutting, deducing and increase or decrease configuration is the most basic means in the research on the monomer of block. The cluster configuration of plane block includes two categories: the cluster configuration of several same blocks and that of several different blocks. The three-dimensional composition of many blocks is designed based on Plato's five polyhedrons.

4. The Mixed three-dimensional Composition of Line, Plane and Block

The mixed three-dimensional composition of line, plane and block (Figure 1-27) includes the mixed composition of line and plane, the mixed composition of line and block, the mixed composition of plane and block and the mixed composition of line, plane and block. An understanding of the spatial alternate relationship among line, plane and block can improve the ability to create forms with the use of line, plane and block.

图 1-26 立体构成之体构成

图 1-27 立体构成之线、面构成

三、仿自然纸雕

仿自然纸雕（图 1-28），可分为动物、人物、植物和第二自然物这四大纸雕类。动物纸雕又可分为走兽类、飞禽类、鱼虫类、理想化动物类（包括龙、凤、吉祥动物等）；人物纸雕又可分为舞蹈人物类、戏装人物类、体育人物类、普通人物类（男、女、老、少）、名人类、理想化人物类；植物纸雕又可分为树类、花类、草类、果类、理想化植物类；第二自然物纸雕又可分为建筑类、机器类、生活用品类等。

立体构成形态的创造，关键在于从几何学角度去观察、改造自然形，学会把自然形象的积、量还原到最单纯的几何形式，抓特征，求整体。有时，一种自然物（或自然物的某一部件）可有数种简单的几何对应物，而

Ⅲ. Nature-imitated Paper Reliefs

Nature-imitated paper reliefs (Figure 1-28) can fall into four kinds, which are animal, human, plant and second natural object. Animal-shaped paper relief is divided into beast, bird, fish and insect, as well as ideal animal (including dragon, phoenix and auspicious animal, etc.). Human-shaped paper relief is divided into dancing human, human in theatrical costume, sports human, ordinary human (male, female, old and young), famous human and ideal human. Plant-shaped paper relief is divided into tree, flower, grass, fruit and ideal plant. Second natural object-shaped paper relief is divided into architecture, machine and articles for daily use, etc.

The key to create three-dimensional composition forms is to observe and transform natural forms from the perspective of geometry, and learn to revert the product and quantity of natural images to the simplest geometric form, to identify the features and clarify the whole. Sometimes, a natural object (or a part of a natural object) may have several simple geometrical

这些对应物都有各自的特点，并且都或多或少地表现了该自然物（或自然物的某一部件）之原本的一般特征。任何自然形式的几何形转换体，都包含有关被转换的自然形的原型知识。总之，这种几何形转换体乃是一种长期对自然形的观察、写实和研究，而不是偶然碰巧的某种情绪和感受的作用体（图 1-29、图 1-30）。

counterparts, and these counterparts have their respective characteristic. Moreover, they more or less show the original general features of this natural object (or a part of the natural object). The geometrical conversion medium in any natural form contains the prototypical knowledge of the relevant conversed natural form. In a word, these several geometrical conversion mediums are a long-term observation, realism and research of natural form, rather than an action object of some occasional emotion and feeling (Figure 1-29, Figure 1-30).

图 1-28　立体构成之仿自然纸雕

图 1-29　立体构成的景观雕塑 1

图 1-30　立体构成的景观雕塑 2

思考题：

　　1. 请用英文专业用语列举几种"二点五维"构成的制作方法。

　　2. 请用英文专业用语说出"三维"立体构成有哪三种形态。

　　3. 自己设计一款仿自然纸雕，并请采用双语对照的方式表述作品的特点。

第 2 章　艺术设计与多元文化专题
CHAPTER 2　Topic on Art and Design and Multi-culture

[本专题导读]

　　艺术设计与文化传承有着紧密的关联，将文化融入设计作品是未来发展的必然趋势。中国传统文化历史悠久、源远流长，中国历代文人对书斋陈设的设计反映出最典型的传统知识分子具有高度修养的生活形态。清代人查继佐撰写的《徐光启传》中云："观时深而验物切……"体现了富有远见的设计思想。我们将设计与文化相融，从而了解和传承民族传统文化，并用中国传统的民族文化衍生出我们物质与精神的产品，就像融化在血液中，展现在母体般的生活方式里。本专题采用双语解读范文，展现不同文化背景下的设计作品特色以及各类设计作品中蕴含的文化理念。通过中西设计风格与多元文化内涵的比较，使我们更系统而有条理地掌握设计发展的文化印记与脉络。

2.1　中国传统文化与设计理论
Chinese Traditional Culture and Design Theory

教学范文中英文对照

一、战国·韩非子《韩非子·十过》

尧禅天下，虞舜受之，作为食器，斩山木而财之，削锯修其迹，流漆墨其上，输之于宫，为食器。诸侯以为益侈，国之不服者十三。舜禅天下，而传于禹，禹作为祭器，墨染其外，而朱画其内。

中文解析：

作为禹时祭祀用品的漆器，在形制与色彩方面必须符合礼的要求，所谓"墨染其外，而朱画其内"便成就了这种漆器的色彩模式，以至今天我们仍津津乐道这黑、红两种色彩配合的艺术效果。我国古代器物设计色彩不限于黑外红内，黑地红纹组合较多，红地黑纹较少。红、黑两种色彩配合，显得明快简洁，在朴素中展现出华美。

英文翻译：

As the lacquer works for sacrifice in Dayu period, this kind of lacquer works should be in accordance with the ritual for the shape and color, which is called "Ink stained the outside of it, cinnabar painted the inside of it". And that is the color pattern of this kind of lacquer works, which makes us take delight in talking about the artistic effect of the match of black color and red color. The color of ancient Chinese implements is not only one type, which has a black surface and a red interior, there are also ones with black surface and red lines, and ones with red surface and black lines. The former is more, the latter is less. The match of black and red is lively and concise. It is a beauty in simplicity.

二、战国·韩非子《韩非子·外储说右上》

堂谿公谓昭侯曰："今有千金之玉卮，通而无当，可以盛水乎？"昭侯曰："不可。""有瓦器而不漏，可以盛酒乎？"昭侯曰："可。"对曰："夫瓦器，至贱也，不漏，可以盛酒。虽有千金之玉卮，至贵而无当，漏，不可盛水，则人孰注浆哉？"

中文解析：

千金玉卮这种贯通而无底的玉制的酒杯虽精贵，但在韩非子看来，不如材质普通但不渗漏的粗陶器（图2-1~图2-4）。恰好体现了我国古代"以实用为美"的造物观念，认为"美"只有附着在实用功能上才有意义。

英文翻译：

Precious Jade Cup, the anastomosing and bottomless cup of jade is very exclusive, however, in Han Feizi's eyes, it is not better than the normal coarse pottery without leakage (Figure 2 1 Figure 2 4). It just reflected in ancient Chinese words and the concept of creation, "beauty should be based on practical things". That is to say that "beauty" is meaningful only when it adheres to the practical functions.

图 2-1　中国古代彩陶瓮
（仰韶文化，体现古人"实用为美"的造物观念）

图 2-2　中国古代舞蹈纹彩陶盆
（马家窑类型，体现古人生活劳动中的乐趣）

图 2-3　中国古代单耳带流陶罐
（马厂型，该形态展现了古人"不拘一格"的造物观念）

图 2-4　中国古代彩陶筒形瓶
（大溪文化，该形态展现了古人造物功能与美观兼备的观念）

三、西汉·刘安《淮南子·汜论训》

夫夏后氏之璜，不能无考，明月之珠不能无颣，然而天下宝之者何也？其小恶不足妨大美也。

中文解析：

夏后的玉璜不能没有瑕疵，明月之珠不能没有疵点，但是，天下人都将它们视为珍品，为什么呢？因为一些小的毛病，并不伤害其大的美质。这就告诉人们要从整体出发来看待事物、判断美丑，注重物品整体的审美感，不要拘泥于个别小的缺点。

英文翻译：

It's impossible that the jade of Xia dynasty queen has no blemish, and the bright pearl like the moon has no flaw spot. However, why do all the people regard them as the treasures? Because some slight blemishes will not destroy their good qualities. It tells us that we should view things and judge beauty from the overall perspective, focus on the integral aestheticism of the objectives and avoid the rigid adherence of the particular small defects or faults.

四、西汉·刘安《淮南子·泰族训》

瑶碧玉珠，翡翠玳瑁，文彩明朗，润泽若濡，摩而不玩，久而不渝，奚仲不能旅，鲁班不能造，此之为大巧。

中文解析：

像那瑶碧玉珠、翡翠玳瑁一类的物品，色彩鲜艳，润泽光滑，抚摸它不会缺损，时间久不会变形，奚仲不能仿制，鲁班不能创造，这种天然的造化，就叫作"大巧"。

自然界的"大巧"，自然之物的巧妙构造启迪了设计师们的创作灵感。诸如奥地利设计理论家维克多·帕帕内克（1925—1998）的新型设计，他就是根据豆荚的造型制造出了一系列独立剂量的药物容器。又如建筑师

英文翻译：

Some objects, such as the green jade, jade bead, emerald and hawksbill, are smooth glossy and have bright colors. The gentle stroking will not damage them and time will not deform them. Xi Zhong can't imitate them and Lu Ban fails to create them. This natural beauty creation is called "grand exquisiteness".

The "grand exquisiteness" of nature and the exquisite constructions of the natural objects enlighten the creating inspiration of designers. For example, Victor Papanek (1925-1998), the Austrian design theorist, creates his new construction. Based on the construction of the pod, he creates

受到"树形仙人掌"的影响并使之成为加固建筑结构的完美典范，设计成为连续网状结构的摩天大楼。可见，大自然中蕴含了几乎所有的视觉形式要素：色彩、光影、对称、比例、对比、均衡、协调、形态、空间、肌理、图案 …… 自然物象建构秩序是设计形式的重要资源，将自然物的功能演绎成为人工的、具有实用价值的设计物品，甚至建筑设计等，以自然元素为基础获得独特的形式美感。

a series of medicament containers with the independent dosages. Another example is that the architect, inspired by the tree-like cactus, designs the skyscrapers with the continuous net-like construction and makes the tree-like cactus the perfect model to reinforce the building construction. As we have seen, the nature contains almost all the visual-form factors: color, light and shadow, symmetry, proportion, comparison, balance, coordination, form and construction, space, texture and pattern and so on. The construction orders of the natural objects are the important sources of the morphology designing. The functions of the natural objects become the man-made designed objects with the practical values and even the building designs. Based on the natural factors, the objects and buildings obtain the aestheticism with the special forms.

五、宋·李公麟《李伯时〈考古图·序言〉》

圣人制器尚象，载道垂戒，寓不传之妙于器用之间，以遗后人，使宏识之士，即器以求象，即象以求意，心悟目击命物之旨，晓礼乐法而不说之秘，朝夕鉴观，罔有逸德，此唐虞画衣冠以为纪，而使民不犯于有司，岂徒眩美资玩，为悦目之具哉！

中文解析：

这段话摘自李公麟的《考古图·序言》，其文阐明了古代礼器制作的目的、手段、原则。"制器尚象"是说明从自然事物取象，取象的目的是为了"载道"。同时代的人以及后人看到器物，就如同展现出一幅历史画卷，看到古人的音容笑貌以及他们的艺术精神、思想情感、审美追求；以求得

英文翻译：

Excerpted from Li Gonglin's *Preface to Archeological Patterns*, this statement explains the objective, method and principle of the production of ancient sacrificial vessels. The ancient quote "Making Artifacts Based on the Images of Objects" refers to seeking images from natural objects to "Convey Thoughts". Contemporary people and future generations see these ancient sacrificial vessels and objects produced in this way enable to imagine the historical pictures,

象，再从象求得意，从而"晓礼乐法"，不言而喻，其传达之意也就在于此。

由此可知，我国古代器物的造型、纹样并非为了单纯的审美意象，也不仅仅是为了赏心悦目或者玩赏观看，这些器物的造型及纹样是奉行"礼乐法"的一种教科书。它们的内涵寓意在于道义的作用。因此，我国古代器物在纹样考释、自然取象、蕴含寓意等方面都为当代艺术设计提供了可借鉴的宝贵资源。

predecessors' appearance and voice, their artistic spirits, thoughts and feelings, sentiments and aesthetic pursuits. Then, viewers can obtain the images, thoughts and "Cultural Rituals", without any need of deliberate explanation. This is the convey meaning behind.

With that in mind, one can see that the shapes and patterns of ancient Chinese artifacts are not based on purely aesthetic images or simply for appreciation and pleasing the eye, but to manifest "Cultural Rituals" containing the same function as textbooks. Their propound connotation and meaning lie in morality. Hence, such artifacts serve as invaluable resource for modern artistic design in respect of verifying patterns research, seeking objects from nature, and revealing the meaning underneath.

六、南宋·郑樵《通志》卷四十七《器服略·尊彝爵觯之制》

器之大者莫如罍，物之大者莫如山，故象山以制罍，或为大器，而刻云雷以象焉。

中文解析：

这段话阐释了我国古代工艺美术品上的各种纹样、装饰、造型的象征作用。古代礼器不仅仅具有祭祀之需，而且蕴含了不同的象征意义。器物的造型及其象征纹样既是源自功能的需求，也是满足欣赏的审美需求，两者的完美结合产生了我国古代工艺美术品的装饰形态及风格（图2-5、图2-6）。

英文翻译：

This statement explains the symbolic functions of various patterns, decorations shapes and modellings of ancient Chinese arts and crafts. In addition to meeting the sacrificial demand, ancient sacrificial vessels contain different symbolic meanings. Shapes and symbolic patterns were created to realize intended functions and meet the aesthetic demands. A perfect combination of function and aesthetics generated the ornamental forms and styles of ancient Chinese arts and crafts (Figure 2-5, Figure 2-6).

图 2-5　中国传统纹样的云纹　　　　　　　　　图 2-6　中国传统纹样的花卉纹

七、明·文震亨《长物志·器具》

　　琴为古乐，虽不能操，亦须壁悬一床，以古琴历年既久，漆光退尽，纹如梅花，黯如乌木，弹之声不沉者为贵。

中文解析：

　　我国古代将"琴"视为高雅品性之物。作者将琴列入室内装饰品，即使不会弹琴，也在墙上挂琴一具，可见情真意切之寓意。为了打造居室的文化品位，作者主张所悬之琴"历年既久"、"漆光退尽"、"黯如乌木"，他认为惟旧为上、越旧越好，力求室内环境优雅、超凡脱俗之氛围。这种物我情融、物饰求精的装饰手法对当今设计必有启迪。

英文翻译：

　　In ancient China, the "Ku chin" was set as an elegant temperament. The author brings the "Ku chin" into the indoor decorations, even if you would not to play it, if put it hanging on the wall, it would be an implication of sincerity. In order to build the culture grade of the bedroom, the author thinks that the suspension of the "Ku chin" should be "Retain for a long time", "the light of oil paint should disappear", "like a dark ebony". The older, the better, it would make an elegant indoor environment and an atmosphere without vulgarity. The decoration method of melting identity of object and self and pursuing for the elegant decoration must be enlightenment for today's design.

八、明·郑元勋《园冶·题词》

此记无否之变化，从心不从法，为不可及，而更能指挥运斤，使顽者巧，滞者通，尤足快也。

中文解析：

这是《园冶》中一段评说计成的造园艺术和理论的题文。郑元勋是计成的一位朋友，他很推崇计成之功力，称其为"为不可及"，意思是计成的创造性设计造诣很深，无人可比，造园工程指挥工巧，事半功倍，形容其为"尤足快也。"郑元勋将计成之功绩归结为两个方面。一方面是"从心不从法"。这里"从心"就是指有自己的想法、自己的设计。"不从法"就是指不能墨守成规，不采用老办法、陈旧规划之法，不生搬硬套别人的一些既定法则，总而言之，造园与建造领域必须勇于创新，创生自己的新设计。另一方面是"能指挥运斤"。计成之成就，不仅仅在于设计，而且熟练掌握造景、构园的方法，在实践施工中，得心应手地指挥工匠们，"通"和"巧"运用自如。

英文翻译：

Excerpted from *The Craft of Gardens*, the ancient book is about the garden-building art and theory of Ji Cheng, a renowned garden builder and architect in Ming Dynasty. This comments comes from Zheng Yuanxun, Ji Cheng's friend. Zheng Yuanxun advocated Ji Cheng's artistry and said "Ji Cheng achieved the unachievable", meaning that Ji Cheng had an incomparable capability in creative design. Ji Cheng was also praised to be "particularly skilful and efficient" in managing garden-building projects. In addition, Zheng Yuanxun summarized Ji Cheng's achievements in two respects. The first, Ji Cheng created his own ideas and designs instead of blindly following established old principles and old rules. In other words, garden builders and architect ought to have the courage to innovate and create their new designs. The second, Ji Cheng was "able to manage easily". Apart from design, his achievements are not only in garden building design, but also have a good grasp of landscape creation and garden structuring. In practical construction, Ji Cheng could instruct the craftsmen by employing his ideas and skills freely.

九、清·李渔《闲情偶寄·词曲部》

人惟求旧，物惟求新。新也者，天下事物之美称也。

中文解析：

这段话提出了我国古代"物惟求新"的造物思想。这里的"物"，作

英文翻译：

This statement presents "Pursuing Novelty in Creating Things", the ancient Chinese thought on creating things.

者是指事物，即分为"事"与"物"两个层面。"事"主要针对文学艺术而言，"物"主要是对器物、造物设计等的创新思想。以作者的观点，"自然之物"是原材料，不能够用新与旧来衡量或者鉴别。然而，一旦将自然的物材加工制作成一件家具时，就成为一件"人造物"，此时就产生了新与旧式样之区别。可见，我国古代关于"造物设计"已有"不喜雷同，力求创新，不断突破"的思想基础，唯有遵循创新——否定——创新的造物规律，才能推进器物设计与造物文化的发展。

Here, "Things" are divided into two aspects, the "Issues" and the "Objects". The former "Issues" mainly focuses on literature and art, whereas the latter "Objects" is mainly for the innovation ideas for objects design and artifacts creation.

According to the author's view, "Natural Objects" are raw materials which cannot be judged as new or old. However, the difference of old and new patterns arises once natural material is made into a piece of furniture and becomes an "Artificial Object". Hence, since ancient times, there has been the theoretical design foundation of "Preferring Innovation and Continuous Breakthroughs to Sameness" in China. Only by following the regularity of "Innovation — Negation — Innovation" can we facilitate the development of object design and the culture of object creation.

思考题：

1. 请用英文解析中国古代造园理论"天人合一"的含义。

2. 结合《园冶》，请用英文描述出"通"与"巧"的意思。

3. 请采用双语的方式，谈谈我国古代设计的创新思想。

2.2 芬兰的文化传承与设计创新
Culture Heritage and Design Innovation in Finland

教学范文中英文对照

我们从芬兰的一家玻璃工厂开始发展，创造出了一代又一代丰富人们生活的基本物件（以下称为"作品"），现在我们为此庆祝。我们深信作品应该是与众不同、可以组合、功能多样的，它们有着不过时的设计，并考虑到个体的使用与表达（图2-7~图2-9）。

我们的设计英雄，也就是许多设计师们的进步哲学激励着我们努力让品牌永不过时。我们不仅仅创造美好的事物，我们还信仰那些从不被抛弃的永恒设计。

20世纪初期，餐具等的装饰风格烦琐。19世纪三四十年代，即现代主义和功能主义发展早期，这一传统风格得到突破。当时，诸如阿尔瓦·阿尔托和卡伊·弗兰克这样的先锋设计师引领了著名品牌的发展。他们相信设计物件时，要始终秉承一种"最基本的，也是重要的"思想。正是他

What started as a glass factory in Finland, now celebrates generations of essential objects that are made to enrich people's everyday lives. We believe objects should be distinctive, combinable and multi-functional, with lasting design that allows for individual use and expression (Figure 2-7-Figure 2-9).

The progress philosophy of our design heroes, many designers still inspires us to keep brands forever relevant. We don't just create beautiful objects. We believe in timeless design that will never be thrown away.

In the beginning of the 20th century dinnerware was decorated with a variety of ornaments. The breakthrough came in the early years of modernism and functionalism during the 1930s and 1940s. At that time it was pioneers like Alvar Aalto and Kaj Franck who led the development of famous brand. Their belief was that objects should always be designed with a thought, essential and above all, available to all. It was their thinking that set the foundation for the design

图 2-7　芬兰 Marimekko 泡泡袜形玻璃杯设计

图 2-9　北欧商业中心产品陈设 2
（摄影：陈炜）

图 2-8　北欧商业中心产品陈设 1
（摄影：陈炜）

们的设计思想奠定了设计哲学的基础——突破边限，给人们以美观与实用之感（图 2-10）。

philosophy—to push the boundaries and to give people beauty and function (Figure 2-10).

流动的形状

被誉为"阿尔托式花瓶"看起来与众不同，它奠定了永恒的设计基石（图 2-11）。与同时期其他的装饰品相比，这个花瓶的形状简洁而自然。1936 年"阿尔托式花瓶"问世时，其形状本身就呈现了一份革命性的声明。阿尔瓦·阿尔托创造出了一个能激发时间、影响时间并且超越时间的系列设计。这款花瓶设计流动的形状虽简单，却是对传统（花瓶形态）的反叛[①]。

The Shape that Moves

Looking like nothing else, the Aalto vase laid the foundation for timeless design (Figure 2-11). Compared to the decorative objects of that time, the simple yet organic shape of this vase was a revolutionary statement when it arrived in 1936. Alvar Aalto had created a collection that would inspire, influence and transcend time. Simple yet rebellious, it's the shape that moves.

图 2-10 美观又实用的芬兰产品设计

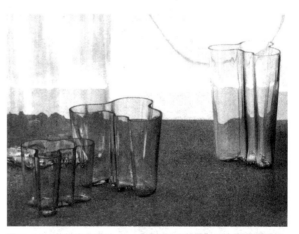

图 2-11 芬兰产品设计——"阿尔托式花瓶"流水型花瓶设计

① 这里 rebellious，直译为"反叛"，寓意是指"阿尔托式花瓶"设计上的标新立异。

结合之美

设计的差别在于创造力背后所隐藏的各种技巧与工艺。芬兰设计与技艺的核心就是设计出那些令人振奋又易于组合的色彩。设计师卡伊·弗兰克在他的设计中摒弃了所有多余的东西，只保留那些必需的要素。玻璃作品的简洁以及餐具物件最基本的形状，把握住了任何一种设计思维。这些设计可以组合、功能多样而永不过时。

打造气氛

用自然而来的光线打造气氛的这种方法，起源于一个冬季时间很长的地方。伴着一点光亮，轻松的气氛便会使每一天、每一处都变得丰富多彩。可以轻松地通过大量不同构思设计的烛台创造出不同的风格和氛围。所有的这些设计显得或简约，或多彩，或独创，或经典。各种各样的颜色、材质、设计使你能根据一年中不同的季节和场合打造出个人独特的氛围。

传承经典、立足现代

在各种材质、色彩与图案的交织中展现你的个人魅力与我们的设计理念。

对"自由灵动"加以重新定义，这些部件千变万化，并且可以随时选用，无论是单独使用还是组合使用都充满着无限的乐趣。每当抚摸这些铭刻着浮雕图案的玻璃材质作品，享受那柔和而淡雅的色调，或许可以创造

The Beauty of Combinability

The difference lies in the skill behind the creation. To design colors that are inspiring yet easy to combine— this is the core of Finnish craftsmanship. Designer Kaj Frank removed everything excessive in his designs, leaving only the essentials. The simplicity of the glass and basic forms of the tableware, captures that every thinking. Combinable and multi-functional, these designs are forever relevant.

Set the Ambiance

To set the mood with light comes naturally, stemming from a place where the winner season is long. But a lit up, relaxing atmosphere enriches the everyday and anywhere. With an abundance of different votive and candle holders, it is simple to create different styles and moods. All design show minimalistic or colorful, unconventional or classic. A wide range of colors, materials and designs lets you create your personal mood for every season and occasion of the year.

Shaped by Tradition, Tailored for Today

Design ideas exhibit to tailor your personal range by mixing and matching textures, colors and patterns.

Redefining the freedom of flexibility, these parts can be used whenever for whatever, playing just as well together as by themselves. Touch the embossed glass, enjoy the soft, muted tones of the color palette or make your own personal composition. Shaped by tradition, tailored for today, Finnish design gives you the natural tools to create, as you like

出你个人风格的作品。传承经典、立足现代，芬兰的设计风格似乎带给你一种"天然工具"，任由你去创造，随心而变（图2-12）。

将用户始终放在心上，芬兰的工具系列设计蕴含着专业厨师的真谛与设计师的灵魂。它的诞生是为了使你的厨艺发挥到极致，而且能够使你在烹饪的时候仍能获得视觉的享受，这些设计意图与理念打破了厨具设计的传统。采用顶级的材料与绝佳的设计比例使之成为厨师的完美工具。

一切有关个性

通过对色彩与个性的关注来专注于葡萄酒的精髓。当代经典设计的革新趋势越来越迎合使用者的实际生活方式，犹如人们对葡萄酒的兴趣变得越来越大众化，我们将经典设计转变为现代风格。通过提升品位与加强口感，芬兰的设计使你拥有完美的享受（图2-13、图2-14）。

(Figure 2-12).

Having the end user in mind, the tools range is formed with the insight of professional chefs and the aesthetic of designer. Created to make the most out of your cooking, yet still be pleasing to the eye when serving, these objects break with convention of how to design kitchenware. First class materials and generous proportions make them the chef of all tools.

It's a Matter of Character

The essence plus range of wines, by shifting focus from color to character. This contemporary twist of a classic design adapts to the users actual lifestyle, where the interest for wine is becoming more and more popular. By enhancing the taste sensation, Finnish design makes your enjoyment complete (Figure 2-13, Figure 2-14).

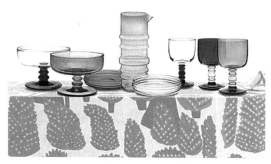

图2-12 芬兰产品设计——玻璃杯系列设计

图2-13 芬兰 Marimekko littala 冰淇淋杯设计 1

图2-14 芬兰 Marimekko littala 冰淇淋杯设计 2

想象力的传承

设计的核心体现了芬兰的传统与传承——注重风格与高端质量，同时也激发起众多设计的灵感。Taika 图案在芬兰语中的意思是"魔力"，使你的思绪沉浸到传说与神话的想象之中。这一系列充满魅力与魔力的设计缓缓地将其作品的细节与丰富的意义展现给使用者。当时间恰到好处，将传统的玻璃制造术与设计师独特的设计理念相结合，这些产品就成了真正的艺术品（图 2-15）。

例如：产品设计 Ultima Thule[①] 的外观同样如此，其最初的灵感源自于芬兰、挪威北部拉普兰德融化的冰川。这件作品的设计独具特色，它的名字取自神话中用来形容"极地之北"的神秘领域。20 世纪 60 年代，设计师 Tapio Wirkkala[②] 在平面模型上雕刻出了它的外观。为了使其尽善尽美，需要高超的玻璃吹制工艺以及大约 1000 小时的制造时间。

A Heritage of Imagination

At the core of design lies the Finnish heritage—a legacy that values style and high quality, but also inspires a lot of the designs. The Taika pattern which means "magic" in Finnish, moves your mind to fairytales and mythology. The fascinating and magical designs gradually reveal their details and layers of meaning to the user. When the timing is just right, combining traditional glassmaking and designers' unique design visions, these products are true pieces of art (Figure 2-15).

For example, so does the surface of the Ultima Thule (the product of Iittala), originally inspired by the melting ice in Lapland. The Characteristic Ultima Thule got its name from a term within mythology that is used to describe a place as the "furthest north". Designer Tapio Wirkkala created the surface in the 1960s after carving into graphic mold. To perfect it, a superior glass blowing technique and a thousand hours were needed.

图 2-15　芬兰 Ultima Thule 经典设计系列

思考题：

1. 请以教学范文为基础，简述芬兰的设计思维。
2. 请结合自身的设计体验，谈谈"Shaped by tradition，tailored for today"的设计理念。
3. 请用英文表述芬兰的产品设计中如何体现其民族文化。

① Ultima Thule 是芬兰 Iittala 伊塔拉品牌系列中的一件经典产品，该产品设计是芬兰的传统文化与现代工艺的结晶。
② Tapio Wirkkala（1915—1985）芬兰著名设计师，曾获得 Triennale in Milan 等三项国际设计大奖，他的设计理念有："简约中求变化，变化中求极简"和"一生，至少要创造一个经典"等。

2.3 民族文化与国际设计师
National Culture and International Designers

教学范文中英文对照

　　"民族是人们在历史上形成的有共同语言、共同地域、共同经济生活以及表现于共同的民族文化特点上的共同心理素质这四个基本特征的稳定的共同体。"①

　　文化是民族特征的基本构成要素，是一个民族屹立于世界的核心竞争力。文化是民族的灵魂，是人类在社会历史发展过程中所创造的物质和精神财富的总和。

　　民族文化体现了民族历史发展的脉络，代表了不可复制的民族精神，是构成民族价值观、审美观的核心内容，同时，它作为一个民族的意识形态也反映了社会中多层面的状况。民族文化由物质文化、精神文化、制度文化以及地域文化组成。其中物质文化包括：建筑、服饰、饮食、交通、

　　"A nation is a stable community forming in human history consisting of people sharing four basic characteristics: common language, common area, common economic life and psychological quality which is reflected by the common cultural characteristics of the nation."

　　Culture is the basic element of national characteristics and also the core competitiveness for a nation to stand firm in the world. Culture is the soul of a nation. It is the sum of material and spiritual wealth created in the social and historical development of mankind.

　　National culture reflects the main line of a nation's historical development and represents the national spiritual which cannot be duplicated. It is the core content constituting the national value and aesthetic standards. Meanwhile as a nation's ideology, it also shows the situation of many levels of the society. National culture consists of material culture, spiritual culture, system culture and regional culture. Material culture includes architecture, dress, diet,

① 中国社会科学院语言研究所词典编辑室编 . 现代汉语词典 . 北京：商务印书馆，1985：791.

图 2-16　中国苗族姑娘的节日盛装

图 2-17　中国水族的农家小院

（图片来源：民族画报社编辑 . 中国民族 . 北京：中国民族摄影艺术出
版社，1989：185.）

生产工具等内容；精神文化包括：文字、语言、科学、文学、艺术、哲学、伦理、宗教、风俗、节日和传统等内容；制度文化包括：社会制度、族群、规范、级别等内容。人类文化很难将物质创造与精神创造截然分离。所有以物质形态存在的创造物，都凝聚着创造者的智慧、观念、意志，这些都源自精神层面的因素（图 2-16、图 2-17）。

艺术设计充分展现了民族文化的差异性。自 20 世纪 30 年代以来，西方设计界越来越显现出现代设计的两个趋向，即现代大众文化的设计取向，以及以"精英、奢华、高雅"为主导的文化设计取向。尤其是后者，由于受到特定消费者群体对传统文化的回归与继承性，促使新设计的观点更多地与"高雅品位"概念联系起来，更

transportation, production tools etc. Spiritual culture includes words, language, science, literature, arts, philosophy, ethics, religion, custom, festival and tradition, etc. System culture includes social system, ethnic group, norm, level, etc. It is difficult for human culture to separate material creation from spiritual creation completely. All the creations existing in the form of substances embody the wisdom, ideas and will of the creator, and all of them result from the elements on spiritual level (Figure 2-16, Figure 2-17).

Art and design fully demonstrates the differences between national cultures. Since 1930s, two trends of modern design have been more and more apparent in western design circle: the design orientation driven by modern popular culture and the design orientation led by "elite", "luxury" and "elegance". Especially the latter, due to the fact that the specific groups of consumers return to traditional culture and inherit it, motivates the idea of new design connected more with the concept "elegant taste", which further

加凸显了民族文化的印记。对设计日用品、服饰等蕴含高雅文化的要求出自中产阶层突出自我的愿望，他们希望在消费行为中表现高雅品位及文化素养，这部分具有品位意识的消费群体通过爱慕"民族化的新型设计产品"试图建立一个有别于他人，凸显个性的知识体系、审美品位与身份象征。

在意大利，很多产品和家具品牌是用设计师群体或者个人的名字来命名设计作品，并宣传设计师不断创造着优良的从传统到现代设计的艺术品。一些中小型意大利家具公司的发展之路在于为国际化、有品位意识的精英市场生产高质量、以传统文化为主导的现代家具。一方面确保了家具设计的创新性和现代性，另一方面使家具产品以"文化"的名义销售（图2-18~图2-20）。

在美国，著名的赫尔曼·弥勒家具公司曾经推出一种自行研发设计的"赫尔曼·弥勒椅子"，获得了巨大的成功。回顾这款产品进入市场的过程，首先，以传统装饰艺术为导向；其次，采用了高雅文化的设计路线。具体而言，这款"赫尔曼·弥勒椅子"的发明者是建筑师查尔斯·埃姆斯，他与妻子为自己建立了一种十分令人向往的现代生活方式，甚至制作了一部有关"圣莫妮卡"住宅的电影，室内充满了他们自己设计的各种家具以及从旅行中收集的纪念品，过着由他们亲

highlights the mark of national culture. The demand for the design of commodities and dress implying elegant culture comes from the middle class willing to make breakthroughs. They hope to show their elegant taste and culture literacy through consuming behaviors. By adoring "new nationalize design products" these groups of consumers try to establish a knowledge system, aesthetic taste and status symbol distinct from others and highlighting personalities.

A lot of products and furniture brand are named after a group of designers or a certain designer in Italy. And the manufacturers propagandize that the designers are constantly creating the sound designs from traditional style to modern style. Some medium and small Italian furniture companies aim to produce the modern furniture with high quality targeting at traditional culture for the internationalized elite market with the sense of taste. On the one hand, such action ensures the innovation and modernity of furniture design. On the other hand, it makes furniture sold on behalf of "culture" (Figure 2-18-Figure 2-20).

In America, the well-known Herman Miller Research Corporation once released its independently developed and designed "Herman Miller Chair", and yielded a great success. As we look back to this product's access to the market, it can be found that it firstly takes traditional decorative art as the orientation, and then, it adopts the style of elegant culture in design. Specifically speaking, the inventor of this "Herman Miller Chair" is an architect named Charles Ames. He and his wife establish a very glamorous modern life-style. They even make film about "St. Monica" residence, which was filled with various types of furniture designed by themselves and souvenirs collected from different trips. They live a modern pastoral life which is full of connotation of traditional culture that

图 2-19　风格独特的欧洲商业环境设计
（摄影：陈炜）

图 2-18　欧洲民族传统风格的室内装饰物件
（摄影：陈炜）

图 2-20　风格独特的
美国商业环境设计
（摄影：应宜文）

手创造的富有传统文化内涵的现代田园生活，该电影为家具产品的消费者提供了模范角色，并暗示着人们也可以通过购买一把"赫尔曼·弥勒椅子"而拥有相同感觉的田园生活。可见，社会文化以及传统生活方式对人们的影响力，设计师深知，文化意义上的设计远比设计一款新椅子更为重要。

在我国，较多的建筑设计作品体现出传统中国文化的再创新与结合点。对于传统中国文化传承与再创新的实例有：江南水乡乌镇的旧建筑改造项目（图2-21～图2-24）、恩阳古镇风情商业街文化广场设计、佛堂古

they personally created. This film provides the customers of furniture products with a model role, and implies that people can also enjoy the pastoral life that feels the same by purchasing a "Herman Miller Chair". Thus, the influence of social culture and traditional lifestyle on people can be clearly seen. Designers are deeply aware that the design in the cultural sense is much more important than the design of a new chair.

In China, the re-innovation and integration of traditional Chinese culture can be reflected in many architecture designs. The living examples of the inheritance and re-innovation of traditional Chinese culture are: the reconstruction of old buildings in Wuzhen in the south of the lower reaches of the Yangzi River (Figure 2-21-Figure 2-24), the design of featured commercial street and cultural plaza

图2-21　水乡乌镇旧建筑改造景观1

图2-22　水乡乌镇旧建筑改造景观2

图2-23　水乡乌镇旧建筑改造景观3

图2-24　水乡乌镇旧建筑改造景观4

镇改建设计项目等。国际著名华裔建筑师贝律铭设计的苏州博物馆新馆，在材料和装饰手法上进行了大胆的创新，他运用极为巧妙的现代手法充分地展现了中国传统园林建筑的精髓。苏州博物馆新馆不仅仅是建筑设计的奇迹，更是民族文化创新力量的彰显（图 2-25~ 图 2-28）。张艺谋导演的《印象·西湖》《印象·刘三姐》《印象·丽江》原创系列（图 2-29、图 2-30），凭借极强的民族性以及大胆的创新手法，再现了民族文化的艺术生命力。

in Enyang Ancient Town, and the reconstruction of Fotang Ancient Town, etc. The new Suzhou Museum designed by Pei Leoh Ming, an internationally well-known Chinese American architect, adopts innovations very audaciously in materials and decorative methods. He thoroughly presents the essence of Chinese traditional garden architecture through extremely ingenious modern techniques. The new Suzhou Museum is not only a miracle of architecture design, but also a manifestation of innovation power of the national culture (Figure 2-25-Figure 2-28). The original series *Impression—West Lake, Impression—Sanjie Liu*, and *Impression—Lijiang* (Figure 2-29, Figure 2-30) directed by Yimou Zhang re-present the artistic vitality of the national culture with extremely strong national character and audacious innovation.

图 2-25　融合中西文化的苏州博物馆新馆建筑

图 2-26　融合中西文化的苏州博物馆新馆景观 1

图 2-27　融合中西文化的苏州博物馆新馆景观 2

图 2-28　融合中西文化的苏州博物馆新馆正门

图 2-29　张艺谋导演的原创作品《印象·西湖》

图 2-30　张艺谋导演的原创作品《印象·丽江》

20世纪60年代随着流行文化的发展，设计领域对设计师的工作有了新的认识，可以说，设计师是作为具有媒体意识的使者，任务是表现文化代码的变化，促进文化交流，并在这个过程中销售产品与服务。民族的就是世界的，不断涌现的国际设计师们，他们所展示的设计作品，也使得民族文化有了国际发言权。我国民族文化的保护、继承、创新、发展势在必行！希冀我们同行、广大同学们能够通过设计创研的力量把我国丰厚的民族文化转化为国际化创新型的文化设计产品，继而诞生一批新生的国际设计师。

In 1960s, with the development of popular culture, a new cognition has been formed towards designers' work in the field of design. It is tenable to say that as an emissary bearing media awareness, designers undertake the task of expressing the changes of cultural code and facilitating cultural exchange. During this process, designers are also expected to sell their products and services. As the saying goes, national style is the global style. The design works presented by international designers that keep emerging in large numbers also grant national culture the right to speak in the world. The protection, inheritance, innovation and development of Chinese national culture are highly imperative. It is hoped that our colleagues and our students can convert the Chinese affluent national culture into internationalized innovative cultural design products through the force of design, innovation and research, and further cultivate a new round of international designers.

思考题：

1. 请采用双语对照的方式说出物质文化包括哪几方面。

2. 请采用双语对照的方式说出精神文化包括哪几方面。

3. 多元文化的设计差异性表现在哪些方面？

第 3 章 欧美设计经典文献专题

CHAPTER 3 Topic on European and American Design Classic Literature

[本专题导读]

　　本专题精选《建筑十书》西方经典文献以及欧洲、美国设计发展史的重要文献。《建筑十书》的原著者（古罗马）维特鲁威（Marcus Vitruvius Pollio），公元前 1 世纪罗马的一位御用工程师、建筑师，他的这部论著是世界上最早提出建筑设计的三要素"实用、坚固、美观"的著作，对现代设计与艺术风格产生深远的影响；此著最早总结出人体结构的比例规律，可谓现代"人机工程学"的起源。至今，此著已译成多种文字并成为西方名校的教学范本，本教材采用了此著于1914 年哈佛大学出版社的版本文献。通过中英文对照、图文并茂的方法，比较研读，取其精华，使我们掌握各个时期设计发展的突出点和历史脉络，了解欧美设计经典文献及设计发展史更在于开拓未来。

3.1 《建筑十书》第二章节选
Extracts from *Ten Books on Architecture*: Chapter II

原著者：（古罗马）维特鲁威　著
Marcus Vitruvius Pollio

教学范文中英文对照

建筑术语

1. 建筑由以下六个要素构成：秩序、布置、匀称、均衡、得体和配给。

2. 秩序是指建筑物各部分的尺寸要合乎比例，而且部分与总体的比例结构要协调一致。秩序的建立是通过量来实现的，希腊语称量、数。量即是模数的确定，模数则取自于建筑物本身的构件。一座建筑物作为一个整体适当地建造起来，其基础便是这些构件的单个部分。其次，布置是指对构件做出适当的定位，以及根据建筑物性质对构件进行安排所取得的优雅效果。布置的"种类"有三种：平面图法（平面图）、正视图法（立视图）和配景图法。平面图法就是熟练地运用圆规和直尺，按比例在施工现场画出平面图。其次是正视图法，这

The Fundamental Principles of Architecture

1. Architecture depends on Order, Arrangement, Eurythmy, Symmetry, Propriety, and Economy.

2. Order gives due measure to the members of a work considered separately, and symmetrical agreement to the proportions of the whole. It is an adjustment according to quantity. By this I mean the selection of modules from the members of the work itself and, starting from these individual parts of members, constructing the whole work to correspond. Arrangement includes the putting of things in their proper places and the elegance of effect which is due to adjustments appropriate to the character of the work. Its forms of expression are these: ground plan, elevation, and perspective. A ground plan is made by the proper successive use of compasses and rule, through which we get outlines for the plane surfaces of buildings. An elevation is a picture of the front of a building, set upright and properly drawn in the proportions of the contemplated work. Perspective is

是一种正面图形，要根据未来建筑的布局按比例画出。至于配景图法，则是一种带有阴影的图，表现建筑的正面与侧面，侧面向后缩小，线条汇聚于一个焦点。这些设计图的绘制要依靠分析和创意。分析就是要集中注意力，保持敏锐的精神状态画出设计图；创意就是要使含糊不清的问题昭然若揭，积极灵活地建立起一套新的基本原理。这些就是关于布置的术语。

3. 匀称是指建筑构件的构成具有吸引人的外观和统一的面貌。如果建筑构件的长、宽、高是适合比例的，每个构建的尺寸与整座建筑的总尺寸是一致的，这就实现了外形匀称。

4. 均衡是指建筑物各个构件之间的比例合适，相互对应，也就是任何一个局部都要与作为整体的建筑外观呼应。恰如人体，匀称的形体是通过前臂、足、掌、指等小单元表现出来的，完整的建筑作品也是如此。例如，神庙的均衡源于圆柱的直径，或源于三陇板，或源于圆柱下部的半径；石弩机的均衡源于弹索孔；船的均衡源于U形桨架的间距。同样，其他各种器物的比例均是根据其构成部件计算出来的。

5. 接下来是得体，指的是精致的建筑物外观，有那些经得起检验的、

the method of sketching a front with the sides withdrawing into the background, the lines all meeting in the centre of a circle. All three come of reflexion and invention. Reflexion is careful and laborious thought, and watchful attention directed to the agreeable effect of one's plan. Invention, on the other hand, is the solving of intricate problems and the discovery of new principles by means of brilliancy and versatility. These are the departments belonging under Arrangement.

3. Eurythmy is beauty and fitness in the adjustments of the members. This is found when the members of a work are of a height suited to their breadth, of a breadth suited to their length, and, in a word, when they all correspond symmetrically.

4. Symmetry is a proper agreement between the members of the work itself, and relation between the different parts and the whole general scheme, in accordance with a certain part selected as standard. Thus in the human body there is a kind of symmetrical harmony between forearm, foot, palm, finger, and other small parts; and so it is with perfect buildings. In the case of temples, symmetry may be calculated from the thickness of a column, from a triglyph, or even from a module; in the ballista, from the hole or from what the Greeks call the επὶηπηορ; in a ship, from the space between the tholepins; and in other things, from various members.

5. Propriety is that perfection of style which comes when a work is authoritatively constructed on approved

具有权威性的构建所构成。注重了功用、传统或自然，便实现了得体。奉献给雷电与天空之神朱庇特的神庙，或奉献给太阳神与月亮神的神庙，建在露天，处于它们的保护神之下，便在功用上实现了得体，因为我们是在户外目睹这些神祇的征象和伟力的。密涅瓦、马尔斯和海格立斯的神庙应建成多立克型的，因为这些神祇具有战斗的英勇气概，建起的神庙应去除美化的痕迹。祭祀维纳斯、普罗塞尔庇娜或山林水泽女神的神庙，用科林斯风格建造最为合适，因为这些女神形象柔美，若供奉她们的建筑造的纤细柔美，装点着花、叶子和涡卷，就最能体现出得体的品格。如果以爱奥尼亚风格建造朱诺、狄安娜、父神里帕尔以及此类神祇的神庙，就要运用"适中"的原则，因为，他们的特定的气质正好介于线条峻峭的多立克型和柔弱妩媚的科林斯型之间，取得了平衡（图3-1、图3-2）。

principles. It arises from prescription, from usage, or from nature. From prescription, in the case of hypaethral edifices, open to the sky, in honor of Jupiter Lightning, the Heaven, the Sun, or the Moon: for these are gods whose semblances and manifestations we behold before our very eyes in the sky when it is cloudless and bright. The temples of Minerva, Mars, and Hercules, will be Doric, since the virile strength of these gods makes daintiness entirely inappropriate to their houses. In temples to Venus, Flora, Proserpine, Spring-Water, and the Nymphs, the Corinthian order will be found to have peculiar significance, because these are delicate divinities and so its rather slender outlines, its flowers, leaves, and ornamental volutes will lend propriety where it is due. The construction of temples of the Ionic order to Juno, Diana, Father Bacchus, and the other gods of that kind, will be in keeping with the middle position which they hold; for the building of such will be an appropriate combination of the severity of the Doric and the delicacy of the Corinthian (Figure 3-1, Figure 3-2).

图3-1　古希腊雅典建筑的柱式展示
（摄影：陈炜）

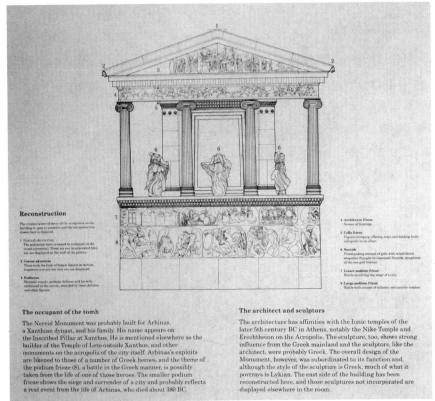

Reconstruction

The original place of many of the sculptures on the building is open to question and the reconstruction shown here is disputed.

1 Raised akroterion
The pediments were crowned by sculptures in the round (akroteria). These are not incorporated here, but are displayed on the wall of the gallery.

2 Corner akroteria
These took the form of female figures in motion. Fragments survive but they are not displayed.

3 Pediment
Dynastic couple, perhaps Arbinas and his wife enthroned at the centre, attended by their children and other figures.

4 Architrave frieze
Scenes of hunting.

5 Cella frieze
Figures bringing offering trays and leading bulls and goats to an altar.

6 Nereids
Freestanding statues of girls with wind-blown draperies thought to represent Nereids, daughters of the sea-god Nereus.

7 Lesser podium frieze
Battle involving the siege of a city.

8 Large podium frieze
Battle with scenes of infantry and cavalry combat.

The occupant of the tomb

The Nereid Monument was probably built for Arbinas, a Xanthian dynast, and his family. His name appears on the Inscribed Pillar at Xanthos. He is mentioned elsewhere as the builder of the Temple of Leto outside Xanthos, and other monuments on the acropolis of the city itself. Arbinas's exploits are likened to those of a number of Greek heroes, and the theme of the podium frieze (8), a battle in the Greek manner, is possibly taken from the life of one of those heroes. The smaller podium frieze shows the siege and surrender of a city and probably reflects a real event from the life of Arbinas, who died about 380 BC.

The architect and sculptors

The architecture has affinities with the Ionic temples of the later 5th century BC in Athens, notably the Nike Temple and Erechtheion on the Acropolis. The sculpture, too, shows strong influence from the Greek mainland and the sculptors, like the architect, were probably Greek. The overall design of the Monument, however, was subordinated to its function and, although the style of the sculpture is Greek, much of what it portrays is Lykian. The east side of the building has been reconstructed here, and those sculptures not incorporated are displayed elsewhere in the room.

图 3-2　古希腊雅典建筑的柱式英文解说
（摄影：陈炜）

6. 若建筑物的室内堂皇壮观，门厅既和谐又雅致，就表现了传统的得体。如果室内装饰的很优雅，但是，入口门厅缺少高贵性和庄重性，就显得不得体了。同样，如果多立克型的上楣雕刻着齿饰，或者三陇板出现于枕式柱头或爱奥尼亚型柱上楣之上，那就是将一种类型的特点搬到另一种类型的建筑上，其外观效果显得很刺眼，因为，这种建筑是根据一套不同的惯例来建造的。

6. Propriety arises from usage when buildings having magnificent interiors are provided with elegant entrance-courts to correspond; for there will be no propriety in the spectacle of an elegant interior approached by a low, mean entrance. Or, if dentils be carved in the cornice of the Doric entablature or triglyphs represented in the Ionic entablature over the cushion-shaped capitals of the columns, the effect will be spoilt by the transfer of the peculiarities of the one order of building to the other, the usage in each class having been fixed long ago.

7. 如果做到以下这点，便可实现自然的得体：神庙地点一开始就要选在最有利于健康的地区，有合适的水源供应，尤其是建造供奉埃斯克勒庇奥斯、健康之神以及掌管医治大众疾病的医药诸神的神庙。病人若从流行病地区迁移到一个卫生的环境中，用上卫生的山泉水，会很快得到康复。如此安排，相应的神祇便会因为地点的特性而获得越来越高的声誉，神的尊严得以彰显。同样，在冬天，卧室和书房的光源应从东面而来，浴室和储藏室的光源应从西面而来，因为，这一区域的天空不会因为太阳的运行而有明暗变化，而是终日稳定不变。

8. 配给是指对材料与工地进行的有效管理，精打细算，严格监管工程开支。如果从一开始建筑师就不想用根本找不到的，或者只有花很大代价才能得到的材料，就要注意这一点，毕竟不是任何一个地方都能提供丰富的坑砂、毛石、冷杉、松木板材或大理石。不同的地方有不同的资源，将其运输到别的地方，既困难又昂贵。在没有坑砂的地方，可以用河沙或海砂代替；若缺乏冷杉或松木板材，可以用柏树、杨树、榆木或油松。其他问题亦可用类似方法解决（图 3-3、图 3-4）。

7. Finally, propriety will be due to natural causes if, for example, in the case of all sacred precincts we select very healthy neighborhoods with suitable springs of water in the places where the fanes are to be built, particularly in the case of those to Aesculapius and to Health, gods by whose healing powers great numbers of the sick are apparently cured. For when their diseased bodies are transferred from an unhealthy to a healthy spot, and treated with waters from health-giving springs, they will the more speedily grow well. The result will be that the divinity will stand in higher esteem and find his dignity increased, all owing to the nature of his site. There will also be natural propriety in using an eastern light for bedrooms and libraries, a western light in winter for baths and winter apartments, and a northern light for picture galleries and other places in which a steady light is needed; for that quarter of the sky grows neither light nor dark with the course of the sun, but remains steady and unshifting all day long.

8. Economy denotes the proper management of materials and of site, as well as a thrifty balancing of cost and common sense in the construction of works. This will be observed if, in the first place, the architect does not demand things which cannot be found or made ready without great expense. For example: it is not everywhere that there is plenty of pit sand, rubble, fir, clear fir, and marble, since they are produced in different places and to assemble them is difficult and costly. Where there is no pit sand, we must use the kinds washed up by rivers or by the sea; the lack of fir and clear fir may be evaded by using cypress, poplar, elm, or pine; and other problems we must solve in similar ways (Figure 3-3, Figure 3-4).

图 3-3 欧洲古建筑赏析 1
（摄影：陈炜）

图 3-4 欧洲古建筑赏析 2
（摄影：陈炜）

9. 若建筑物的设计是根据一家之主的习惯、经济条件或社会声望的不同而有所区别，这便达到另一层面的配给。城市住所要用一种方式来建造，而乡村农舍，因为要收割庄稼，就得用另一种方式来建造；放债人的住宅另当别论，富裕而老于世故的人的住所又有所不同。那些为政府统治出谋划策的位高权重的人物，其住所的设计应适合他们的特殊需求。总之，建筑物的配给应做到适合于不同类型的人。

9. A second stage in Economy is reached when we have to plan the different kinds of dwellings suitable for ordinary householders, for great wealthy, or for the high position of the statesman. A house in town obviously calls for one form of construction; that into which stream the products of country estates requires another; this will not be the same in the case of money-lenders and still different for the opulent and luxurious; for the powers under whose deliberations the commonwealth is guided dwellings are to be provided according to their special needs: and, in a word, the proper form of economy must be observed in building houses for each and every class.

英文所见出处：

Marcus Vitruvius Pollio. Ten Books on Architecture. Cambridge: Harvard University Press, 1914.

（古罗马）维特鲁威著 . 建筑十书 . 剑桥：哈佛大学出版社，1914.

思考题：

1. 请采用双语对照的方式，列出建筑的六个构成要素。

2. 请用英文来解析"Symmetry"的意义。

3. 思考如何将"Propriety"设计理念运用于当代设计之中。

3.2　《建筑十书》第四章节选
Extracts from *Ten Books on Architecture*: Chapter IV

原著者 :（古罗马）维特鲁威　著
Marcus Vitruvius Pollio

教学范文中英文对照

选择健康的营建地点

1. 以下这几点对于城墙的构筑来说是最为重要的 : 首先是选取一处健康的营造地点。地势应较高，无风，不受雾气侵扰，朝向不冷不热，温度适中。此外，应尽量远离湿地，因为当清晨太阳升起时，微风吹向市镇。夜间形成的雾气弥漫着，与湿地动物发出的有害气体混在一起阵阵袭来，侵害居民的身体，使这个地方易于发生传染病。同样，如果城墙筑在海边，朝西或朝南，对健康也不利，因为夏季太阳升起时南面的天空温暖，中午炙热 ;同样的道理，如果朝西的话，太阳升起时天空变暖，中午热起来，晚上变得更酷热难当（图 3–5）。

2. 因此，由于冷暖变化不定，这类地方生长的东西就会被弱化，这种

The Site of a City

1. For fortified towns the following general principles are to be observed. First comes the choice of a very healthy site. Such a site will be high, neither misty nor frosty, and in a climate neither hot nor cold, but temperate; Further, without marshes in the neighborhood. For when the morning breezes blow toward the town at sunrise, if they bring with them mists from marshes and, mingled with the mist, the poisonous breath of the creatures of the marshes to be wafted into the bodies of the inhabitants, they will make the site unhealthy. Again, if the town is on the coast with a southern or western exposure, it will not be healthy, because in summer the southern sky grows hot at sunrise and is fiery at noon, while a western exposure grows warm after sunrise, is hot at noon, and at evening all aglow (Figure 3-5).

2. These variations in heat and the subsequent cooling off are harmful to the people living on such sites. The same

图 3-5　欧洲古建筑赏析 3
（摄影：陈炜）

情形甚至在无生命的物体中也能见到。加盖的酒窖不应朝南或朝西，而应朝北，因为北面不会因季节改变而有冷暖变化，温度是恒定不变的。同样道理，谷仓如果朝阳，储藏的谷物便会很快腐烂；晒干之鱼或水果若不是储藏在背阳的地方，便不可能保存得长久。

3. 当高温使得空气浓度下降，热气吸进并破坏了物质的自然特性，它便溶解和软化了物质，使其疲软到极致，这种现象是亘古不变的。我们可

conclusion may be reached in the case of inanimate things. For instance, nobody draws the light for covered wine rooms from the south or west, but rather from the north, since that quarter is never subject to change but is always constant and unshifting. So it is with granaries: grain exposed to the sun's course soon loses its good quality, and provisions and fruit, unless stored in a place unexposed to the sun's course, do not keep long.

3. For heat is a universal solvent, melting out of things their power of resistance, and sucking away and removing their natural strength with its fiery exhalations so that they grow soft, and hence weak, under its glow. We see this in

以通过铁看到同样的现象。铁无论原本有多坚硬，将它放入炉中以火加热，便会完全软化，易于加工成各种不同的形状。而将这柔软灼热的铁浸入凉水中冷却，它就再次变硬了，恢复了原有的特性。

the case of iron which, however hard it may naturally be, yet when heated thoroughly in a furnace fire can be easily worked into any kind of shape, and stilly if cooled while it is soft and white hot, it hardens again with a mere dip into cold water and takes on its former quality.

4. 我们还能够从以下事实看出情况的确是这样：在夏季，甚至在有益健康的地方而非瘟疫蔓延之地，万物只要生长在炎热的环境中，便会疲软无力；而在冬季，即便是可能发生严重瘟疫的地区，也是健康的，因为寒冷已将这些地区凝结固化了。同样地，当人们从冷的地方移到热的地方时，便因经受不了热而变得衰弱；当他们从热的地方移到寒冷的北方地区时，不仅不会健康状况变差，反而会更加健康，这一点是毫无疑义的。

4. We may also recognize the truth of this from the fact that in summer the heat makes everybody weak, not only in unhealthy but even in healthy places, and that in winter even the most unhealthy districts are much healthier because they are given a solidity by the cooling off. Similarly, persons removed from cold countries to hot cannot endure it but waste away; whereas those who pass from hot places to the cold regions of the north, not only do not suffer in health from the change of residence but even gain by it.

5. 因此在规划城墙时，最好避开会使人体受到热气毒化的地区。根据希腊人所谓元素的基本原理，所有物体都是由四种基本的元素构成的，这些元素便是热、湿、土、气，它们以特定的比例混合，便产生出世界上具有各种特色的生物（图 3-6）。

5. It appears, then, that in founding towns we must beware of districts from which hot winds can spread abroad over the inhabitants. For while all bodies are composed of the four elements, that is, of heat, moisture, the earthy, and air, yet there are mixtures according to natural temperament which make up the natures of all the different animals of the world, each after its kind (Figure 3-6).

6. 因此，当热控制了生物的身体时，便破坏和瓦解了其他所有元素。某些地区，空气本身便造成了这种结果，它更多地驻留于露天水脉之中，

6. Therefore, if one of these elements, heat, becomes predominant in anybody whatsoever, it destroys and dissolves all the others with its violence. This defect may be due to violent heat from certain quarters of the sky, pouring into

图3-6　欧洲古建筑室内环境赏析
（摄影：陈炜）

而人体的自然气质与混合物却不允许这样。同样，如果湿气驻留于人体静脉之中，使其失去了平衡，其他元素就如同液化后变了质，被稀释了，自然的和成效能变消解了。大风和微风中所含的湿气也会使人受凉，造成不利的后果。同理，人体中气与土的自然结合成物若增加或减少，会使其他元素变弱：食物过剩弱化土元素，大气重量过剩则弱化气元素。

the open pores in too great proportion to admit of a mixture suited to the natural temperament of the body in question. Again, if too much moisture enters the channels of a body, and thus introduces disproportion, the other elements, adulterated by the liquid, are impaired, and the virtues of the mixture dissolved. This defect, in turn, may arise from the cooling properties of moist winds and breezes blowing upon the body. In the same way, increase or diminution of the proportion of air or of the earthy which is natural to the body may enfeeble the other elements; the predominance of the earthy being due to overmuch food, that of air to a heavy atmosphere (Figure 3-6).

7. 若有人想更深入地研究这些现象，便可留意于鸟儿、鱼类和陆地上野兽的天性，并以此考察它们组织结构的区别。鸟是一种混合物，鱼是另一种，陆地野兽与前两者又有很大的区别。鸟所含的土元素较少，湿元素适中，但含有大量的气元素。因此，鸟类的构成元素较轻，易于在空气中飞行，流动的空气使它们更易于飘浮于空中。另一方面，鱼具有水生的特性，这是因为它们含有少量的热元素，由大量气和土元素构成，而湿元素几乎没有。它们持续待在水中是那么自如，所以体内缺乏湿元素。若将它们捞出来放在陆地上，它们的生命便因离开水中而不能存活了。同样，陆地上的野兽由于体内只有中等程度的气和热元素，土元素较少，有大量湿元素，湿量很大，故不能长时间在水中生活。

8. 如果这些事物真如我所说的那样，如果我们可以凭感官觉察出动物的身体是由这些元素组成的，进而断定若某个元素或另一元素过了量或出了差错，它们便会生出毛病并分解，那么，我便可以确定无疑地说，如果我们要寻找一个有益健康的环境来筑城，于是，更要尽全力选择气温适中的纬度。

9. 因此我要强调以下这个观点：应该重新找回古老的选址原则并付诸

7. If one wishes a more accurate understanding of all this, he need only consider and observe the natures of birds, fishes, and land animals, and he will thus come to reflect upon distinctions of temperament. One form of mixture is proper to birds, another to fishes, and a far different form to land animals. Winged creatures have less of the earthy, less moisture, heat in moderation, air in large amount. Being made up, therefore, of the lighter elements, they can more readily soar away into the air. Fish, with their aquatic nature, being moderately supplied with heat and made up in great part of air and the earthy, with as little of moisture as possible, can more easily exist in moisture for the very reason that they have less of it than of the other elements in their bodies; and so, when they are drawn to land, they leave life and water at the same moment. Similarly, the land animals, being moderately supplied with the elements of air and heat, and having less of the earthy and a great deal of moisture, cannot long continue alive in the water, because their portion of moisture is already abundant.

8. Therefore, if all this is as we have explained, our reason showing us that the bodies of animals are made up of the elements, and these bodies, as we believe, giving way and breaking up as a result of excess or deficiency in this or that element, we cannot but believe that we must take great care to select a very temperate climate for the site of our city, since healthfulness is, as we have said, the first requisite.

9. I cannot too strongly insist upon the need of a return to the method of old times. Our ancestors, when about to

实施。我们的祖先在想要建设城镇或兵营的地方，就用放养于该地的羊做牺牲，检查他们的肝脏。若肝脏变了色或有毛病，就再杀些羊，看看原先杀的那些羊是否因染上了疾病或是食物中毒而遭到伤害。一旦他们对若干些羊进行彻底检查，认定当地的水与饲料对肝脏有利，便在那里构筑要塞；若发现羊的肝脏有毛病，便认定这种地方出产的食物和水对人体是致命的，就要继续迁移，到其他地方去寻找各方面都有益健康的环境。

10. 以下这个结论是站得住的，即土地可为人们带来健康的种种特性，是可以通过饲料和食物看出来的。也可以注意并记录克里特岛乡村的情况，沿波特里乌斯河两岸分布着两个克里特人的群落，克诺索斯（Cnosus）和戈提纳（Gortyna）。羊群在河的左右两岸吃草，但靠近克诺索斯那一边放养的羊群，由于土地贫瘠而脾脏肿大。相反，戈提纳这边的羊群则很正常。因此，医生们便来研究这一现象，他们在这些地区发现了一种草，羊群吃了之后它们的脾脏会缩小。他们便收集这种草，将其制成药来医治羊群的脾病。克里特人称这种药为asplenon，即"消脾药"。因此从食物或水来看，便可以确定一个地方的自然环境是健康的还是有害的。

build a town or an army post, sacrificed some of the cattle that were wont to feed on the site proposed and examined their livers. If the livers of the first victims were dark-colored or abnormal, they sacrificed others, to see whether the fault was due to disease or their food. They never began to build defensive works in a place until after they had made many such trials and satisfied themselves that good water and food had made the liver sound and firm. If they continued to find it abnormal, they argued from this that the food and water supply found in such a place would be just as unhealthy for man, and so they moved away and changed to another neighborhood, healthfulness being their chief object.

10. That pasturage and food may indicate the healthful qualities of a site is a fact which can be observed and investigated in the case of certain pastures in Crete, on each side of the river Pothereus, which separates the two Cretan states of Gnosus and Gortyna. There are cattle at pasture on the right and left banks of that river, but while the cattle that feed near Gnosus have the usual spleen, those on the other side near Gortyna have no perceptible spleen. On investigating the subject, physicians discovered on this side a kind of herb which the cattle chew and thus make their spleen small. The herb is therefore gathered and used as a medicine for the cure of splenetic people. From food and water, then, we may learn whether sites are naturally unhealthy or healthy.

11. 如果城墙修筑在靠近海边的湿地，朝向北方或西北方，而湿地又高于海岸，那就证明这城墙是根据合理的原理构筑的。挖掘水沟可以形成沿海岸的出水口，当暴风雨降临时，海水高涨，掀起巨浪涌入周围湿地，致使湿地的水翻腾起来，便不能维持正常的湿地生命。于是，所有从深水处游向海边的生物，都会被含盐度极高的海水杀死。位于山南高卢地区的湿地，的确可以作为这一现象的实例，如阿尔蒂诺、拉韦纳、阿奎莱亚周围的湿地，以及处于同类沼泽地区的其他城镇，由于上述种种原因，是十分有益于健康的。

11. If the walled town is built among the marshes themselves, provided they are by the sea, with a northern or north-eastern exposure, and are above the level of the seashore, the site will be reasonable enough. For ditches can be dug to let out the water to the shore, and also in times of storms the sea swells and comes backing up into the marshes, where its bitter blend prevents the reproductions of the usual marsh creatures, while any that swim down from the higher levels to the shore are killed at once by the saltness to which they are unused. An instance of this may be found in the Gallic marshes surrounding Altino, Ravenna, Aquileia, and other towns in places of the kind, close by marshes. They are marvelously healthy, for the reasons which I have given.

12. 但是那些停滞不动的湿地，既无河道也无排水沟，比如旁提那湿地，因滞止而腐烂，向周边地区散发着有害的瘴气。另有一例，在阿普利亚地区有一座城镇叫"老萨尔皮亚"，是狄奥墨得斯从特洛伊返回时兴建的，或者如一些著作家所说的是罗得岛人厄尔皮阿斯所建。该城就位于上文所述的这种地区，城中居民每年饱受疾病之苦，忍无可忍，向执政官马库斯·霍斯蒂留斯去请愿，要求他为老百姓另选一处合适的地点重建他们的城市。他答应了他们的请求，毫不迟疑，迅速作了深入调查，购得了一处十分看好的沿海地产，并请求罗马元老院和平民大会准许他们迁往此

12. But marshes that are stagnant and have no outlets either by rivers or ditches, like the Pomp tine marshes, merely putrefy as they stand, emitting heavy, unhealthy vapours. A case of a town built in such a spot was Old Salpia in Apulia, founded by Diomede on his way back from Troy, or, according to some writers, by Elpias of Rhodes. Year after year there was sickness, until finally the suffering inhabitants came with a public petition to Marcus Hostilius and got him to agree to seek and find them a proper place to which to remove their city. Without delay he made the most skilful investigations, and at once purchased an estate near the sea in a healthy place, and asked the Senate and Roman people for permission to remove the town. He constructed the walls and laid out the house lots, granting one to each citizen for a mere trifle. This done, he cut an opening from a lake into the sea, and thus made.

地。他建起了城墙，以抽签的方式分配土地，让
每个市民依法抽签，并以此抽到的签作为一赛斯
特硬币的代币来购买土地。目前，萨尔皮亚人从
四里之外的老城迁过来，生活在健康的环境之中。

英文所见出处：

Marcus Vitruvius Pollio. Ten Books on Architecture. Cambridge: Harvard University Press, 1914.

（古罗马）维特鲁威著.建筑十书.剑桥：哈佛大学出版社，1914.

思考题：

1. 请结合范文，用英文列出古希腊人认为的四种物体元素。

2. 请结合范文，用英文表述古罗马人如何选择有益健康的居住环境。

3. 请用中英文双语概述选择健康的营建地点的各个要素。

3.3 西方现代设计苗圃——德国包豪斯发展史
Western Modern Design Nursery: History of Bauhaus School

教学范文中英文对照

1919 年，瓦尔特·格罗皮乌斯在魏玛市创建了一所学校——包豪斯，这是一所致力于设计、建筑以及工艺技术教育的学校。1925 年，包豪斯被迁移到了德绍，1932 年，又被转移到了柏林，并在 1933 年被迫关闭于此。包豪斯的设计理论和教育对全世界都产生了深远的影响。

第一次世界大战之前，比利时建筑设计师亨利·凡·德·威尔德曾担任魏玛艺术工商学校以及艺术与工艺学院的院长，此外，他还向萨克森·魏玛大公推荐瓦尔特·格罗皮乌斯作为自己的继任者。于是，魏玛大公于 1915 年召见了瓦尔特·格罗皮乌斯本人，格罗皮乌斯提出了申请并获得授权，重新组织该校；1919 年，格罗皮乌斯接任院长职位时，他将其他两所学校合并起来，命名为"魏玛国立包豪斯学院"。这一举措具有深远的意

The Bauhaus was a school of design, building, and craftsmanship founded by Walter Gropius in Weimar in 1919. It was transferred Dessau in 1925, where it continued until 1932, and then transferred Berlin, ultimately closing in 1933. The ideas and teaching of Bauhaus have exercised a profound influence throughout the world.

Before the First World War the Belgian architect Henry Van de Velde had been director of the Grossherzogliche Sachsische Kunstgewerbeschule and the Grossherzogliche Sachsische Hochschule fur Bildende Kunst at Weimar, and he had recommended to the Grand Duke of Saxe-Weimar that Walter Gropius should be his successor. The Grand Duke summoned Gropius for an interview in 1915, and Gropius asked for and was given full powers to reorganize the schools; when he took up his appointment in 1919 he united the two schools under the name of Das Staatliche Bauhaus Weimar. This was of profound significance because it made clear at the outset that one of the main purposes of the new school was

义，因为这项举措说明新学校建立的目的之一是将艺术与工艺结合起来，然而，之前这两种形式一直是分开的。格罗皮乌斯坚持认为，艺术家或建筑师同时也应该是手工艺者，应该具备运用多种材料的经验，这样，他们才能了解自己的能力，同时应该学习形态样式和设计方面的理论知识。在格罗皮乌斯看来，应该消除艺术家和手工艺者传统上的区别。他还认为，建筑是集体共同努力的成果，每一名艺术家兼手工艺者都要作出贡献，都应对整座建筑完全地投入。因此，格罗皮乌斯是建筑制造领域团队合作的倡导者，其中还包括家具生产、陶艺以及多种建筑艺术领域。

因此，相应的教学应该包含工业制造方面的内容。格罗皮乌斯不反对威廉·莫里斯的主张，甚至与威廉·莫里斯持有同样观点，他们都尝试想要在精美工艺品制造中大量使用机械，但是，格罗皮乌斯认为，制造这种机械应该与设计师的意愿保持一致。格罗皮乌斯的这部分教学对于很多人来说难以理解。很多评论家都问他为何学生必须掌握某种材料和工业生产的工艺技能。格罗皮乌斯认为，机械生产仅仅是手工艺者徒手工具的一种体现，或者说是一种制造阐述方式，认为在高效使用工具或机器前有必要了解材料的属性及性能。

建筑领域的团队合作和工业生产

to unite art and craft which had for too long been divorced from each other. Gropius contended that the artist or architect should also be a craftsman, that he should have experience of working in various materials so that he knew their qualities and that he should at the same time study theories of form and design. The traditional distinction between artist and craftsman should, Gropius thought, be eliminated. He also believed that a building should be the result of collective effort, and that each artist-craftsman should contribute his part with a full awareness of its purpose in relation to the whole building. Gropius was therefore an advocate of teamwork in the creation of a building and in the production of furniture, pottery, and all the various architectural arts.

The teaching thus comprehended industrial production. Gropius was not opposed, as was William Morris, to the increasing use of machinery in the production of well-designed objects, but he believed that the machine should be made absolutely subservient to the will of the creative designer. This part of Gropius's teaching has perhaps been most difficult for many people to understand. Many critics have asked why it is necessary for students to master a craft in material and yet acquiesce in industrial production. But Gropius regarded machinery merely as an elaboration of the hand tool of the craftsman, and thought it was necessary to know the nature of the material and all its potentialities before the tool or machine could be used to the best advantage.

There is obviously a correlation of teamwork in

中的分工有着明显的关联性。但是，想要获得最佳效果，最有可能的办法就是团队成员不仅仅掌握自己所属学科的专业知识，并且能够把握建筑或工业生产时运用与涉及的相关技能。据此，发挥各种机械的作用才能达到最佳性能。包豪斯的训练不是直接针对手工艺水平，而是培养创造性地适用于批量生产的形式与方法。在创造这种形式的过程中，艺术家本人制作出原型，假设设计的是一只茶壶，艺术家用陶土手工制作出来，作为批量生产的模型；艺术家不再是仅仅在画板上作画的设计师，而是兼有设计师与手工艺者的双重身份。

　　培训课程由两套平行的课程培养方案构成，其中一套是材料和工艺方面的学习（实践课程），另一套是造型设计的理论课程（造型课程）。在学校创办的初期，学生们需要由两位老师进行辅导，每位老师负责一套课程，一位是艺术家，另一位是工匠，因为当时如要寻求一位兼有两种能力的老师尚属不易。在教学中，两位老师紧密合作。在学校接受指导的内容为六个月初级的课程，在此期间，学生们接触各类材料，诸如：石头、木料、金属、陶土、玻璃、染料及纺织品等。与此同时，还要接受造型方面的初步指导。材料学习及实验的目的是发掘学生对于某种材料的创造潜力，因为，这是为了激发学生们个人

building and the necessary division of labour in industrial production, but the best results are likely to be obtained in both if members of the team not only master their own particular part but grasp its relation to the complete building or industrial produce. By thus using the machine to the best advantage the training at the Bauhaus was directed not to works of hand craftsmanship but to the creation of type forms which could serve as models for mass production. And in the creation of this type-form the artist himself produces the prototype, that is if it is a teapot he makes this in the clay with his own hands as the model for mass production; he is no longer merely the drawing-board designer, but the designer-craftsman.

The curriculum of training consisted of two parallel courses of instruction, one devoted to the study of materials and craft (Werklehre) and the other to the theories of form and design (Formlehre). In the early years of the school it was necessary for the student to be taught by two masters, one in each section, an artist and a craftsman, because of difficulty at that time of finding teachers who were sufficiently masters of both. These two teachers worked in close collaboration. Instruction at the school began with a preliminary course of six months, during which period the student worked with various materials—stone, wood, metal, clay, glass, pigments, and textile—while he received elementary instruction in the theory of form. The purpose of working and experimenting with materials was to discover with which particular material the student had naturally the most creative aptitude, for it was an essential purpose to bring out the latent creative faculties of the individual. It might be that one student had a strong

的潜在能力。例如：一名学生可能对木料非常有天赋，另一位学生也许对硬质材料、石头、金属有天赋，或者是对纺织品，或者是对染料和色彩有天赋。校内老师首先指导学生如何使用工具，接着，教学生使用机器来替代工具。对于重视造型设计的学校而言，学校为学生会提供各种学习与自然造型表现方面的指导，以及设计集合、几何理论、建筑理论、结构，还有尺寸、色彩、设计方面的理论。

格罗皮乌斯很幸运，能够将一批非常有能力的教师召集起来，其中很多人日后成为各个领域的著名领军人物。第一位是约翰尼斯·伊顿，他在 1919 年入该校任职，早在一年前，格罗皮乌斯就与他接触，当时他在维也纳一家私立学校任教。格罗皮乌斯对伊顿的教学方法印象深刻，并邀请他前往魏玛的包豪斯学校教授初级课程。伊顿的教学法包括了对天然材料的物理属性的理论描述，方法是通过表现和实验，他认为，灵活巧妙地表现一种材料是一种理解其结构的方法之一，并且在运用某种特殊材料时，学生们不能仅仅是培养对材料各方面的一种感觉，必须先鉴赏材料并和其他的材料进行反复比较对照，这样才能认识材料并了解各种材料的属性。在魏玛，包豪斯学校的其他教师有版式设计与平面艺术家列奥宁·费宁格，雕塑家、陶艺家格哈特·马尔克斯，

feeling for wood, another for the harder materials, stone and mental, another for textiles, another for pigments and color. He was instructed in the use of tools and later in the use of machines that in industry have supplanted these tools. In the school devoted to form and design, instruction was given in the study and representation of natural form, in geometry and principles of building construction, in composition and the theories of volume, color, and design.

Gropius was fortunate in gathering together some very able teachers, many of whom afterwards became famous in their various spheres. Among the first was Johannes Itten who joined the school in 1919 and whom Gropius had first met a year earlier teaching in a private school in Vienna. Gropius was impressed with Itten's methods of education and invited him to the Bauhaus to direct the preliminary course. Itten's teaching included the study of the physical character of natural materials by representation and experiment, for it was contended that representing a material intelligently was one way of appreciating its structure. And in working in a particular material the student must not only develop a feeling for it in all its aspects, but he must appreciate its relation to other materials so as to be aware of its qualities by comparison and contrast. Other teachers at the Bauhaus at Weimar were Lyonel Feininger, printer and graphic artist, and Gerhard Marcks, sculptor and potter, both of whom joined in 1919; Georg Muche, painter, weaver, and architect, joined 1920; Paul Klee (painter, graphic artist, writer) and Oskar Schlemmer (painter, stage designer), both joined 1921; Wassily Kandinsky, Painter and graphic artist, who joined in

两人均在 1919 年入该校任职；画家、纺织艺术家、建筑艺术家乔治·摩奇于 1920 年加入该校；画家、平面艺术家、作家保罗·科里以及画家、舞台设计师奥斯卡·史莱默于 1921 年入职；画家及平面设计艺术家瓦西里·康定斯基于 1922 年入该校任职，以及画家、戏剧舞美设计师、摄影师、印刷人斯洛·莫霍里·纳吉于 1923 年入校任职。

1923 年，应图林根立法大会的要求，包豪斯举办了一次作品展，其目的是展示学校创建四年以来的教学成果与发展纪录。格罗皮乌斯认为，如果这是作为一次展览有点为时过早了；他更愿等到更多成熟的作品出现后再举办展览。这次展览的主题是"艺术与工艺的新融合"，其中包括以各种材料制成的设计品，各个车间、各个工作室的产品，理论研究成果等，还有一座独立式住宅设计"号角屋"，由包豪斯工作室设计完成。这座"号角屋"按规划建在一个大型广场上，中间是一个大房间，周围是几个小房间；评论家们对此非常感兴趣并获得赞誉，其中包括教授德斯洛布博士，他是德国国家级艺术总监，对"号角屋"有机统一的设计理念高度赞扬。

尽管包豪斯取得了不小的进步和成功，而且包豪斯创建的时间正好处在一个社会主义统治时期，整个事业本质上在人们看来都是属于社会主义性质，但是，包豪斯学校还是遭遇到

1922; and Laszlo Moholy-Nagy, painter, theatrical designer, photographer, and typographer, who joined in 1923.

In 1923, at the request of the Thuringian Legislative Assembly, the Bauhaus held an exhibition of its work which was to serve as a report on the four years of the life of the Bauhaus. Gropius felt that this was a bit premature; he would have preferred to wait until more mature results could be presented. The theme of the exhibition was 'Art and Techniques, a New Unity', and included in the exhibition were designs in various materials, various products of the different workshops, examples of theoretical studies, and a one-family house called 'Am Horn' which was built and furnished by the Bauhaus workshops. This house was planned as a large square with several small rooms arranged round a central larger one; it was enthusiastically acclaimed by many critics, among them Dr E. Redslob, the National Art Director of Germany, who praised its organic unity.

In spite of the progress and success of the Bauhaus it met with much local opposition from the more conservative members of the community, while the whole enterprises was associated with Socialism in the minds of many because it happened to be established at a time when there was a

当地一些社区的许多保守派的反对，同时，图林根政府对包豪斯也相当有敌意，这些情况或多或少对格罗皮乌斯施加了一些压力，迫使格罗皮乌斯于 1924 年底关闭该学校。教师和学生全心全意地支持罗皮乌斯，12 月 26 日，包豪斯的董事长兼校长通知图林根政府，合同到期日为 1925 年 4 月 1 日，那时他们将关闭包豪斯，这所由他们一起努力建设过的学校。

很多城市都在谈论包豪斯搬迁的可能性，这些城市包括法兰克福、哈根、曼汉、达姆施塔特，还有德绍。最后，德绍市长成功争取到了包豪斯学校搬入德绍市的机会。他为包豪斯学校分配了七处建筑作为校舍，同时，还有一座新的校舍正在建造当中。新校舍根据市议会要求，由格罗皮乌斯设计，1925 年秋季开工，1926 年 12 月竣工。新校舍建筑由三座翼形结构组成，第一部分是设计学院，第二部分是创作工作室，第三部分是学生宿舍。前两部分由一座凌驾于路面上方的天桥连接，这座天桥里设有管理部门的办公室、学生社团的俱乐部和一个格罗皮乌斯教授的私人工作室。学生宿舍是一座拥有 28 套工作室型的六层楼建筑。整个建筑所用的部分建筑材料为钢筋混凝土。在创作工作室的侧翼运用混凝土楼板和用于承重的蘑菇形柱子，承重的蘑菇柱恰当地退后，使建筑的正面可以形成一大片连

Socialist regime. It also met with considerable hostility from the Thuringian Government, which more or less forced Gropius to a decision at the end of 1924 to close the school. Both teachers and students wholeheartedly supported Gropius; the Director and master notified the Government of Thuringia on 26 December of their decision to close the institution, created by them, on the expiration of their contracts on 1 April 1925.

Various cities discussed the possibility of transplanting the Bauhaus, among them Frankfurt, Hagen, Mannheim, Darmstadt and Dessau. The Mayor of Dessau succeeded in securing the transfer of the Bauhaus to his own. He appropriated seven houses for the use of the school while a new building was being erected. This building, designed by Gropuis in response to the request of the city Council, was begun in autumn of 1925 and completed in December 1926. It consisted of three principal wings, a school of design occupying one, workshops another, and a students' hotel a third. The first two were linked by a bridge over a roadway, and in this bridge were administrative rooms, club rooms, and a private atelier for Professor Grropuis. The students' hostel was a six-story building consisting of twenty-eight studio-dormitory rooms. The building was constructed partly of reinforced concrete. In the workshops' wing reinforced concrete floor slabs and supporting mushroom posts were employed with the supports set well back to allow a large uninterrupted glasses screen on the facade extending for three stories. This was probably the first time so ambitious a use of glass screen was employed in an industrial building, and it helped to lead the way to similar

续的玻璃幕墙，延伸了三层楼。这可
能是第一次在工业建筑里如此大规模
地使用玻璃幕墙，这为全欧洲及美国
采用类似建筑结构开辟了道路（图
3-7、图 3-8）。

constructions throughout Europe and America (Figure 3-7, Figure 3-8).

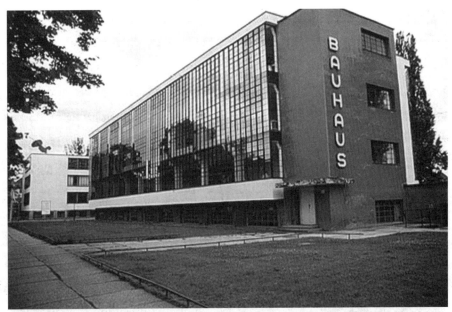

图 3-7　德国包豪斯
设计学校建筑外观

图 3-8　德国包豪斯
设计学校室内环境

包豪斯学校在德绍的重建，也为该校课程调整与修改提供了机会。早期的双导师方法，即一位艺术家和一位工匠联合授课的教学方法不再使用，取而代之的是采用一位受过全面训练的导师独立承担教学任务的办法。这种教学方式日渐可行，因为一些早期毕业于包豪斯学校的学生现在成了该校的导师，他们中包括：约瑟夫·亚伯斯，赫伯特·拜尔，马歇·布劳耶，辛纳克·谢帕，乔斯特·史密特等人都在此时进入该校任职。其中有七位曾经在魏玛时期就任教于包豪斯的教师也来到了德绍新校继续合作。雕塑家、陶艺家格哈特·马尔克斯因为根本没有足够的资金来安置他的陶艺工作室而退出了该校。1923年春，约翰尼斯·伊顿由于在初级课程教学理念上的意见分歧离开了该校，他的教学工作由莫霍伊·纳吉和约瑟夫·艾伯茨承担下来，他们共同扩大了学科的范围。在新校重新制定教学课程的过程中，包豪斯教育体系的原则得到了重新确认：这些原则可以总结为设计、技术、手工艺训练等领域的各种创造性工作的设计，尤其是建筑设计和室内的装饰；模型开发或者是模具在工业生产中的发展和销售。包豪斯创立的设计通用原则是寻求建立一切创意产品之间的依存关系，并保持互相之间的独立性。

包豪斯学校继续在瓦尔特·格罗皮乌斯的指导下发展着，直到1928年；之后，瓦尔特·格罗皮乌斯便辞

With the re-establishment of the Bauhaus au Dessau, the opportunity was taken to revise the curriculum. The earlier method of joint instruction by two masters, an artist and a craftsman, was abandoned and was supplanted by that of one master who was trained as both. This was becoming increasingly possible because several former Bauhaus students were now appointed masters: Josef Albert, Herbert Bayer, Marcel Breuer, Hinnerk Scheper, and Joost Schmidt. Seven of the masters who had been with the Bauhaus at Weimar continued at Dessau. Gerhard Marcks left because there were not sufficient funds to install his pottery workshop at Dessau. Johanned Itten had left in the spring of 1923 owing to differences of opinion on the conduct of the preliminary course, and his work was continued by Moholy-Nagy and Josef Alberts, who jointly broadened its scope. In revising the course at Dessau the opportunity was also taken to reaffirm the principles which guided the Bauhaus system of education: these could be summarized as training in design, technics, and craftsmanship for all kinds of creative work, especially building; the execution of experimental work, especially building and interior decoration; the development of models or type-forms for industrial production and the sale of such models to industry. As a general doctrine the Bauhaus sought to establish the common citizenship of all forms of creative work and their interdependence on each other.

The Bauhaus continued at Dessau under the direction of Walter Gropius until early in 1928, when he resigned because he wishes to devote himself more freely to his creative

职离开，因为他希望能够更加自由地投身个人的作品创意之中，无须受行政职务的束缚；在他的推荐下，瑞士建筑设计师汉斯·迈耶作为继任者，成为包豪斯新一任校长，他曾经担任该校建筑系主任。迈耶于 1930 年 6 月辞去校长一职，市政管理局仍然希望并试图劝说格罗皮乌斯重新回到岗位。但是，格罗皮乌斯却又推荐任命密斯·凡·德·罗继任校长。在 1932 年 10 月，包豪斯学校迁往柏林。

　　虽然，包豪斯学校被迫关闭，但其教学方法并绝没有消亡，而是继续在全世界产生影响。事实上，从包豪斯被关闭之时起，其影响力才变得最为强烈。可能是因为，唯有时间才可以让包豪斯传承的观点与教学理念踵事增华。欧美众多艺术学校已在一定程度上采取了包豪斯的教学方法，特别是许多艺术学校以及研究所的导师和学生所采取的立场都是源于包豪斯。举例来说，纳吉曾经是新包豪斯的主任——现在成了美国芝加哥的一家设计研究所的主管，很好地采用了包豪斯的设计主张。这些教学方式还部分被引进到哈佛大学的建筑系，纽约学校的工业设计实验学校，还有南加州设计学校等。如果说，包豪斯设计理念与教学方法的影响不一定被广泛接受，那么，20 世纪以来又有哪一种艺术教育方法能够与包豪斯有同样大的影响力（图 3-9、图 3-10）。

work without being restricted by official duties; on his recommendation Hannes Meyer, the Swiss architect, who had been head of the department of architecture, became director. Meyer resigned in June 1930 as the result of differences with the municipal authority, who then tried to persuade Gropius to take over again. Instead, Gropius recommended the appointment of Ludwig Mies van der Rohe, who accepted the position. In October 1932, the Bauhaus moved to Berlin.

Although the school was closed, its teaching and methods were by no means dead, and they continued to exercise a wide influence throughout the world. Indeed, it may be said that its influence had been strongest since it ceased to exist, probably because it takes time for such ideas to spread. Many art schools in Europe and America have adopted in part its methods of teaching, especially as many of its masters and students have taken positions in art schools and institutions throughout Europe and America. For example, Moholy-Nagy became director of the New Bauhaus — now the Institute of Design — at Chicago, where Bauhaus methods were employed. They have also been introduced partially at the school of architecture at Harvard University, the Laboratory School of Industrial Design in New York, and in the Southern California School of Design. It would be a mistake to think that the ideas that prompted Bauhaus training are universally accepted, but it is doubtful whether any method of art teaching of the 20th century has had quite the same impact (Figure 3-9, Figure 3-10).

思考题：

1. 格罗皮乌斯的教学模式为何在 20 世纪初期遇到很大的困难，请用英文解说。

2. 在包豪斯学校创建初期，哪两种主要课程交替授课？

3. 请用英文列出 1923 年包豪斯设计展的主题，并简述该校的发展成果。

图 3-9　欧洲现代建筑赏析

（摄影：陈炜）

图 3-10　欧洲现代建筑室内环境赏析

（摄影：陈炜）

第 4 章　艺术设计评论专题

CHAPTER 4　Topic on Art and Design Reviews

[本专题导读]

- - - - - - - - - - - - - - - - - -

　　在艺术设计迈向多元化、跨学科发展的大环境下，艺术设计的评论范围越来越广泛，包括描述设计、评价设计、认识设计、设计批评等，其最终的教学目标旨在提高学生的设计能力与鉴赏水平，提高学生设计说明的写作能力，提高学生的综合人文素质。本专题精选当代产品设计作品、创意设计等的评论文章，同时，列举了较多艺术设计发展瞩目时期的评论书籍、名著、论文作为进一步深化研究的基础，通过中外设计风格比较，图文并茂、观点明晰，使我们了解多元的设计理念以及专业领域的发展现状与新趋向。

4.1 21 世纪的产品设计评析
Analysis of Product Design in the 21st Century

教学范文中英文对照

时下，消费者们对于产品设计的要求越来越高，不仅仅为了便于使用，还要外表美观，这使得产品设计师们遇到了挑战。我们将近几年的产品设计成果，集中专注于电子产品的设计，按照规格分类列出——小型、中型、大型和特大型。为了重点展示产品的设计流程与设计评论，从手绘草图的创意到产品设计中所运用的图标和电脑制作的渲染以及产品到达装配线前的每一个环节都会呈现出来。

特大型（Extra-large）

或许是源于人们对于小型化产品设计的热衷，人们在对未来高科技的想象中，有90%涉及微型的计算机、设备、终端，以及移动电话。与此同时，仍然有相当多的工业设计师把各种前卫技术和潮流的东西融入特大型的设计产品之中。从将早期的触摸屏设计者

Product designers are faced with the challenge of designing merchandise, which is not only functional and easy to use, but attractive and eye-catching to the consumer. We would show the best products designed in recent years with a special focus on electronics, and categorized by size: small, medium, large, and extra-large. Emphasizing the design process and analysis step by step, we show all of the creative work from handmade drawings and sketches to diagrams and computer renderings, which go into the development of a product before it hits the assembly line.

Extra-large

Perhaps the fever for miniaturization has made it so ninty percent of those imagining the future associate high technology with microscope computers, devices, terminals and mobile phones. Meanwhile a considerable number of industrial designers have no qualms about applying the very latest technology and trends toward designing king-size products. From a swing that consigns its primitive playground

变为历史博物馆，X 光机……这样的转向，可以不断地把一些令人不舒服，不美观，有时甚至是受伤（尚未成功）的经历进行改善，如果产品不能完全令使用者满意，至少变得不那么令人厌恶。毕竟，技术革新和工业设计一直力争让产品更加实用，更加人性化。

在对待这种特大型规格的产品时，我们要换个角度处理——这种规格的产品不可能像小小的 MP3 一样卖出成千上万个。因此，这类产品不会有太高的媒体覆盖，也不会在电视上打广告宣传。换句话说，仅仅凭道听途说是无法了解此类产品的。然而，如果凑巧在街上，或者在庆典，在医院，或者在一个操场上看到，我们马上就会感叹道：无论规格大小，工业设计真是无处不在，影响深远。

forefathers to the history museums to X-ray machines that take what can be an uncomfortable, unsightly and sometimes traumatic experience and make it, if not pleasant, than infinitely less hateful. After all, technological innovation and industrial design keep getting more and more practical and user-friendly.

We have to take a totally different perspective when dealing with products of this size: none of the products you're about to see are likely to sell millions of units like an ordinary MP3 player can. Thus it's not like for them to get much coverage in the media or be advertised on TV. In other words, it's unlikely we'll hear of their existence. Nonetheless, if we were to be so lucky as to come across one on the street, at a festival, in a hospital or at a simple playground, we'd be quick to realize that modern industrial design affects everything around us, whatever its size.

大型（Large）

这一规格的产品要比前面小节提到的小了不少，诸如我们周围的各种交通工具、高科技终端产品等，人们更多、更普遍地将这种规格称为"人体尺寸"。此类产品与用户的交互大多是较为直接的接触，这就意味着其设计或应用的技术容不得半点疏漏，因为，哪怕只有很小的错误也将会把本应是十分有用的设计变成败笔。下列产品设计作品的范例，都有一个共同点——对于设计师们几十年来一直深信不疑并坚持贯彻的用户与一系列目标之间关系的质疑。

Large

A few meters below the giants in the previous section we find those products, vehicles and high-technology terminals that move in the ambit better known as "human size". Interaction with the user is in most cases direct, which means that a small mistake in its design or in its applied technology would surely convert what could have been an effective design into a major fiasco. It is the case of the product design examples we are chosen and included in the following illustrations. They all share one thing in common: they fully question the relationship between the user and series of objects whose designs had remained unchanged and pretty much unquestioned for decades. They had seemed so

那些概念都过于传统……甚至有些已过时。下面展出的产品中，有的产品变革或许太过新锐，有些可能触动了以前从没有人触动过的领域（他们说必须有人先迈出这第一步），但是请记住——只有让一件产品动起来，你才能证明运动；而如果没人敢于打碎鸡蛋的话，就没人会做煎鸡蛋。毕竟，如果没有勇于第一个尝试螃蟹的人就没有工业设计的发展。刚刚发明移动电话的时候，也有很多人唱反调，坚决否定第一部移动电话，甚至有人曾武断地说电话做成那么小就必定失败。试问，现在还有谁会记得那些说"不"的人？

eternal…and so old-fashioned. Possibly some of them present too radical a change, perhaps others retouch something that did not need to be retouched (they say there must be a reason that nobody has yet to invent lime soup), but remember: movement is proved only once you set a thing in motion and nobody has ever made an omelet without breaking an egg. After all, where would industrial design be without pioneer? Does anybody still remember those naysayers who, alarmed by the size of the first mobile phones, predicted the failure of the mobile phone?

中型（Medium）

不会占用太多空间的真空机；平板屏幕和可以折叠的键盘；应用各种尖端设计和新技术的现代机器，一台可以在手术甚至术后维持病人体温的设备。在产品设计中，我们收集了各种中型规格的产品，特别是那些比用户手掌要大一些的产品。它们之中，有的代表了技术的创新；有的只是概念作品，距离真正的产品只有一步之遥；有的从审美角度看，则是相当的新奇。大部分展品解决了我们生活中碰到的一些问题：如何用打字员的键盘玩游戏？如何让孩子们的学习更有乐趣？如何才能不用那些不趁手（不可移动）的电脑就可以浏览互联网？如何处理桌面上那些我们不想要的中

Medium

Vacuum machines that hardly take up space; flat screens and foldable keyboards; vanguard designs and new technologies such as that of, a device that regulates a patient's body temperature during and after surgery. Among products design, we've gathered medium-size products, those that do not fit into the user's hand. Some of them represent technological innovations; others are projects that have yet to make the final leap to become a "real" object; others are novelties from an aesthetic perspective. Almost all of them solve problems we've encountered at one time or another: How to play games with keyboards designed for typist? How to make kids have fun while learning? How to connect to the Internet without using an uncomfortable (and immobile) personal computer? How to disguise a medium-size electronic device that we do not want on our tabletop? So, how to solve these design problems, you find yourself

型电子设备？那么，去解决这些问题，就是去努力设想"以前没人想到的创新设计"，这样，产品设计师们的目的就达到了（图 4-1~ 图 4-4）。

wondering "How come nobody thought of this before?" then its creators or product designers have hit the spot (Figure 4-1-Figure 4-4).

图 4-1 蜜语家庭果酱机整体效果图（左）
［设计者：郑昱、林伟伟、汤起，指导教师：徐冰（浙江工业大学）］

图 4-2 蜜语家庭果酱机冷却图（右）
［设计者：郑昱、林伟伟、汤起，指导教师：徐冰（浙江工业大学）］

外观设计图和照片

设计说明：
面包的大众化使得越来越多的人对果酱产生依赖。这款家庭果酱机就很好地解决了市面上果酱过甜和防腐剂的问题。只需按顶部按钮，新鲜果酱自动完成。

all times save to

STEP 1
● 快速转动的刀头将水果搅拌成半果泥

STEP 2
● 果酱机底部加热装置加热，同时刀头缓速旋转进行搅拌

STEP 3
● 冷却15分钟即可享用，果酱机自带计时功能精确计算

图 4-3 蜜语家庭果酱机
［设计者：郑昱、林伟伟、汤起，指导教师：徐冰（浙江工业大学）］

俯视图

左视图　主视图　右视图

仰视图

后视图

图 4-4 蜜语家庭果酱机外观图
［设计者：郑昱、林伟伟、汤起，指导教师：徐冰（浙江工业大学）］

小型（Small）

小型规格的产品设计是多元化的，包含了手机、MP3、PDA 掌上议程、手表、相机、高科技耳机、收音机、精密仪表等。并且当我们留意到它们，我们整日都将它们携带在身上，大量的信息被它们纳于尺寸之间，我们才惊奇地发现，这些产品规格虽小，却奇迹般地压缩尺寸规格，控制着、支配着我们的生活。但是，在您所看到与使用的小型规格的产品中，并不是每一件都让我们的工作更加轻松。其中更多的是把我们的闲暇时间变得更加充实。精密，以及人体工程学是这一规格的产品最为重要的要素。它们的目的是：打破一切束缚，随时连接使用，适应于各种环境，满足用户最细小的需要，提高产品互动性……总而言之，让生活变得更轻松。但是，有一个很重要的方面是我们绝对不能忽略的——产品的设计，正是这些设计打破的束缚，创造了无可替代的功能性，也正是设计让这些产品成为用户关注的焦点。没有人会只看中封面就买下一本书，但是，也没有几个人会怀疑它的成功。美观、小巧，并且实用：这就是完美的产品（图4-5）。

人们都说，工业设计是世界上最令人兴奋的专业之一。尽管 21 世纪的设计师们拥有十分优越的条件，所运用的新技术在五年之前都还只能在科幻小说里见到，然而，现在最好的电脑程序和应用都随手可得，所使用材料的性

Small

Small size products are divertive including small size encompasses mobile phones, MP3 players, PDA handheld agendas, watches, cameras, high-tech earphones, radios, chronometers. When it comes down to it, all those products lots of us carry on us throughout most of the day products that manage to hold an enormous amount of information in a tiny space, that almost miraculously condense, contain and organize our lives. But not all of the products you're about to see and use were designed to make our work easier. Many of them take our leisure and make it more practical. At this size precision and ergonomics are the main objectives. The goal: to break boundaries, to be connect at all times and form all locations, to satisfy the user's most trivial needs, to promote interactivity…in short, to make life easier. But we must not ignore a highly important aspect to the products you'll find that: their design, which breaks boundaries and innovates without overpowering functionality or becoming the center of the user's attention. Nobody will buy these books based solely on their cover, but few will deny its part of their success. Pretty, small and practical: the perfect product (Figure 4-5).

They say industrial design is one of the most exciting professions in the world. After all, 21st century designers have the best computer programs and applications at their fingertips, using new technology that would have been limited to science fiction novels just five years ago, and working with new materials possessing incredible properties,

CONTACT LENS BOTTLE

Our contact lens bottle can not only contain the cleaning liquid at the bottom, but also keep the contact lenses in a clean environment on the top. This design can combine two containers together,and simplify our operation steps.

Besides,the outlet port is higher than the bottom surface of inner box,to avoid the liquid flow back.

Rubble sealing ring

Cleaning liquid container

Inner box
two sections(L&R)

· Operation steps ·

1. Open the CONTACT LENS BOTTLE.

2. Press the transparent inner box down-ward to squeeze out the cleaning liquid.

3.Put the contact lenses into the inner box according to the "L"&"R" instructions.

4.Tilt the bottle to one side to let the liquid flow to one side,then you can pick out the contact lens with as less residue as possible.

5.Pour the cleaning liquid out after cleaning the contact lens.

6.Close the cover,it is convenient for changing the cleaning liquid , and carrying the bottle around.

图 4-5　新型隐形眼镜盒设计
［设计者：郑昱、朱彦、林伟伟、黄文韬，指导教师：朱意灏（浙江工业大学）］

能无比优越，设计的新产品广受大众媒体的关注，设计时的预算也相当充足。但是，产品设计师们精益求精，依然感觉离他们的梦想非常遥远。

　　微型电话、不占用空间的平板屏幕、超轻自行车、存储空间比市面上主流电脑还大的数码相机，以及关注用户健康的便携式终端……这些都已是过去式了。或者更准确地说，是现在的工业设计师们正努力加紧速度创造的，未来的过去式。

　　一台轻量电视机，拥有几乎完美的高评价，能像 PC 一样工作，现在如果人们在讨论它的屏幕能够看见图像、电视转播，或记录，都要归功于它的液晶针管，那又有什么大不了的呢？中国的设计师毛涛设计的嵌成环形的显微镜移动电话获得了索尼爱立信举办的 2004 年设计大赛最高奖，

with the mass media eagerly anticipating new products, and with budgets that are usually extremely generous. Yet product designers keep improving and they still remain far, very far, from realizing their dreams.

Microscopic phones, flat screens that barely take up space, ultra-light bicycles, digital cameras with more memory than the majority of PCs on the market and portable terminals that monitor the user's health to a degree that's difficult to believe…That's all in the past. Or better said, the past in a future that today's industrial designers are striving to arrive at, the sooner the better.

What's the big deal about a lightweight television with almost perfect high definition that performs like a PC if now they're talking about walls where you'll be able to screen any image, retransmission or recording thanks to its luminous pores? What's the point of designing a third generation mobile phone when Chinese designer Tao Mao won Sony Ericsson's 2004 competition top award for ideas with a microscope mobile phone embedded in a ring? Why

在这样的情况下设计第三代移动电话的意义何在呢？有的公司在没有太多现有的计算机知识的帮助下，而是借助一些直观的应用程序，已经有能力创造出各种独一无二款的器械了，在这样的情况下，为什么还要买一辆批量生产的最新款自行车呢？

但是，让我们先缓一缓，对于我们大多数普通人来说，在此将要看到的产品和项目，在当下看来，显然是十分前卫的。在本教材中也标注了创作者与设计师们的名字，无论是青年设计师还是年长一些的设计师，当你看到时，他们肯定已经在为下一个项目作准备了，但是，对于我们大多数人来说，"未来"已经到来了。本教材中的相当一部分产品已经应用到了我们的生活中，而其他还没有走入生活的产品也即将面世。它们有个共同点——都打破了束缚，或者说是跨界的设计。有时候，这些束缚是技术或者工艺上的限制，有些时候则纯粹是审美上的约束。但是最大的跨界设计在于创造一个从没有存在过的产品，一个全然一新的产品时所打破的陈旧模式。有些产品确实是后来者居上。多年以前，人们常常谈论"发明"。这个词现在必须重新用起来了。

产品设计是近年来工业设计革新的产物。这场革新也让设计师们站到了消费者通常所站的位置。有个事例可以说明：在 20 世纪初期，发明家和商人们都尽力满足人们的需求；工业革新和

buy a latest generation mass-produced bicycle when there are already companies capable of creating whatever one-of-a-kind project any enthusiast develops, without so much as the need of previous computer knowledge, thanks to designer programs with intuitive applications?

But let's not get stressed out about it: for most of us mortals, the projects and products that you'll see all of them are still, if not the future, then unmistakably vanguard in the present. Their creators or designers whatever young or old, whose names you'll find here, are surly already planning their next project, but for the majority of us the future is now. A good number of the products you'll find in the following textbook pages are already a part of daily life, and those that would not take long in becoming. They all have something in common: they've broken boundaries. Sometimes that boundary has been a technical or technological limitation, while other times it's been purely aesthetic. But the biggest boundary is the one broken when you create something that hasn't existed before, a totally new product. Some of the products are indeed the latter the better. Years back people used to speak about "inventions". The word will have to be brought back into use.

Product design is the product of revolution in the field of industrial design in recent years, a revolution that has put the designer in the place where the consumer used to stand. It's best to give an example: in the early 20th century, inventors and businessmen made sure they met people's needs;

生产线上大量生产出来的产品让全世界进入新机械的时代，人们的生活也因之便利了许多。相比之下，到了 21 世纪，工业设计师们成了为消费者们创造需求的人，因为现在的消费者既无准备，也没时间，来思考高科技产品为他们的生活带来多大的改变。唯有工业设计师们才会思考这些问题。

新产品和新服务面世的速度越来越快，几乎已经让人无法跟上节奏。当今时代，人人都在猜想，未来的互联网会是什么样的，或者用户们的生活是否都会由电脑、各种移动终端、电视屏幕、手机，或者其他还没有被发明的小玩意儿来引导。实际上，我们本该专门编写一本书来谈谈关于"产品设计革新"的理念以及分享我们已收集的所有设计文献材料。在任何情况下，与各种猜测未来的报告、纪录片和书籍等相比，我们还是着眼于现在。当然，对于设计师以及创作者们来说，都怀有设计领域的梦想，而且勇于去面对终将实现的未来。尽管如此，我们也确实收录了某些只有在科幻片里才会出现的产品——"受损细胞再生器"等诸如此类的新设计。我们也很乐意把这些新兴产品设计出来并成为现实。

the industrial revolution and production-line manufacturing gave way to a world of new mechanical inventions that made people's lives easier. By contrast, in the 21st century, the industrial designers are the ones creating the needs of today's consumer, a consumer who is neither prepared nor has the time to decide or imagine how that high technology product might make his life more comfortable. Industrial designers are the ones who decide that.

The rate at which new products and services jump onto the market has picked up so much that it's almost impossible to keep track of all the novelties out there. Nowadays it's anybody's guess what the Internet will be like in the future or if users will navigate with the help of a PC, portable terminals, TV screens, mobile phones or any other gadget yet to be invented. The truth is we would have published one book on the talk of product innovation design with all the design materials we received for sharing. In any case, and contrary to the flood of reports, documentaries and books speculating on the future, we've opted to stick to the present. Of course, there are design dreams for our product designers or creators at the present and in the future, which is not only possible but also quite probable. Even so, we did take it upon ourselves to include some new products designed and created for science fiction film, such as a "regenerator of damaged cells" and so on. We'll be happy to take these product designs up on it to become a reality.

思考题 :

1. 请用英文专业用语描述 "extra-large" 产品设计的要素。

2. 请用中英文双语的方式解析 "human size" 的设计概念。

3. 请用英文评论 21 世纪 "small size" 产品设计现状与未来发展设想。

4.2 西方设计批评理论与实践：
关于消费文化研究

Theory and Practice of Western Design Criticism:
Research on Consumer Culture

教学范文中英文对照

欧美国家在设计批评方面拥有悠久的学术传统与完善的学科建设。追溯其缘由，凡是现代设计史上的主要设计运动和设计思潮都源于一些西方国家和城市。设计界的批评家自然会亲身经历这些历史时期，并相应地进行学术批评活动和学术研究。因此，相比较其他国家和地区的设计批评还处于零散状况的状态而言，这些设计批评不仅发展成熟，而且对艺术设计的发展起到了重要的推动作用。

就设计批评的现状而言，其特点也与 20 世纪发生了较大的变化。在 20 世纪，设计批评与设计批评研究对建筑理论的依赖性较大。正如我们在设计史中所看到的那样，许多设计风格、设计流派都与建筑风格或建筑流派同源同根；许多建筑师也身兼数职，不仅从事建筑设计，也对平面设计、家具设计甚至艺术创作都有所涉猎。

The Occident has the long academic tradition and perfect discipline construction in design criticism. The reason can be dated back to the fact that the main design activities and thoughts originate from the western countries and cities in the history of the modern design. Naturally, the critics in the design circle have experienced these historical periods personally and conducted the academic criticism activities and academic researches correspondingly. The design criticism of other countries and regions are still in the disordered state, but the western design criticism has not only already matured, but also largely promoted the development of the art design.

From the perspective of the current situation of the design criticism, the characteristics of the design criticism, compared with those of the last century, have changed a lot. During the 20^{th} century, the design criticism and the researches on the design criticism are much more dependent on the architectural theory. As we have seen in the history of art design, many design styles and design schools share a homology with the architectural design and the architectural schools. Many architects play many roles. They not only are

因此，那些从事设计批评的智者也往往是建筑师，真正的设计理论家也往往首先是建筑理论家。但是，随着工业技术的发展，工业设计、服装设计等艺术的研究越来越自成体系；同时，随着文化研究的兴起和当代哲学、艺术对日常生活的关注，设计批评也变得日益多元化，这种多元化包括两个方面。首先是批评者的多元化。批评的主体已经从专业的设计批评家和设计师向其他专业人士扩散。一部分社会学学者和哲学家由于受到 20 世纪哲学、传播学的影响，从文化的层面对各种设计状况作出不同解释。其次是批评指向的多元化。正是由于批评者的广泛介入，在 20 世纪丰富的批评理论的基础上，设计批评的目的也越来越多元化。从传统设计批评对设计功能和形式的关注，转变为对设计与人之间社会关系的研究、对设计所反映的形态的分析、对设计背后伦理价值的反思，从而能够提升社会道德水平等（图 4-6、图 4-7）。

但是，尽管设计批评无处不在，国外设计批评的研究仍然相当薄弱，并且一直在持续发展中，工业设计领域有相当理性的价值评价体系，并通过人体工程学等标准形成了一定的批评准则。

engaged in the architectural design, but also gain a thorough understanding of the graphic design, furniture design and even the art creation. Therefore, many wise men that are occupied in the design criticism are always the architects and the genuine design theorists are the architectural theorists first. With the development of the industrial technologies, the research on art has established its own system, such as the researches on the industrial design, fashion design and costume design. At the same time, the cultural study has emerged and modern philosophy and art have paid great attention to the daily life, so the design criticism has become increasingly diverse. The diversification displays itself in the two aspects. The first is the diversified critics. The criticism subjects have expanded from the professional design critics and designers to other professionals. Influenced by the philosophy and communication of the 20th century, some sociologists and philosophers have given different explanations to the various designs from the point of the culture. The second is the diversification in the criticism direction. Owing to the extensive involvement of the critics, the purpose of the design criticism, on the basis of the rich criticism theories of the 20th century, has become more and more diverse. The traditional design criticism focuses on the function and form of the design, but now it has turned to the researches on the social relation between design and human, the analysis of form reflected by the design, the introspection to the ethic value behind the design so as to enhance the level of social morality (Figure 4-6, Figure 4-7).

However, although the design criticism is pervasive, the researches of the foreign design criticism are still weak; it has been in continuous development. The industrial design circle has rather rational value evaluation system and some criticism criteria have formed under the standards of the ergonomics.

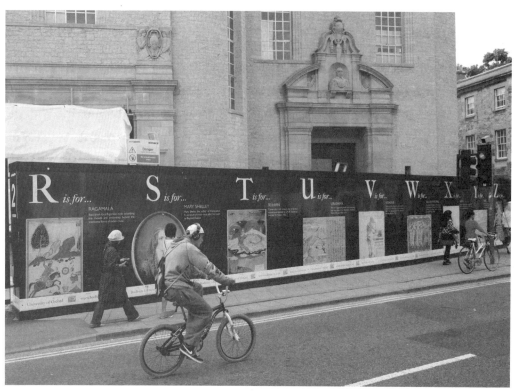

图 4-6 遍布街区的消费文化环境 1

（摄影：陈炜）

图 4-7 遍布街区的消费文化环境 2

（摄影：陈炜）

但这些标准甚至是规范还不能称之为真正的设计批评。服装设计等时尚行业中也有自己的批评家和批评渠道，但这些批评中有相当部分过于感性。相比而言，平面设计领域由于和绘画艺术相距不远，因此设计批评问题容易获得重视。例如 2005 年 9 月，罗德岛设计学院（Rhode Island School of Design）和《ID》杂志在伦敦举办了平面设计批评研讨会。会议主要讨论设计批评、设计史和设计理论之间的关系，以及设计批评在英国的发展情况。早在 1994 年，迈克尔·比尔鲁特（Michael Bierut）等人就曾编辑过一套专门的平面设计批评文集，书名是《近观：关于平面设计的批评文章》（*Looking Closer: Critical Writings on Graphic Design*）。此外，设计批评最活跃的领域当属广告。受传播学理论的影响，广告批评常常能深入浅出地分析出社会生活的方方面面。

However, these standards and even the specifications cannot be called the genuine design criticism. The fashion industry like the costume design also has the critics and criticism channels of its own, but most of the criticisms are excessive perceptual. The graphic design field, compared with the fashion industry, is near to the painting, so its design criticism attracts people's attention easily. For example, the Rhode Island School of Design and the magazine of ID held the seminar on the graphic design criticism in London in the September of 2005. The seminar focused on the relations among the design criticism, the design history, the design theory and the developmental situation of design criticism in Britain. In 1994, Michael Bierut edited a set of specialized collected works on the graphic design criticism. The book's name is *Looking Closer: Critical Writings on Graphic Design*. Besides, the advertising is the most active field in the design criticism. Influenced by the communication theory, the advertising criticism can analyze all the aspects of the social life with profundity and an easy-to-understand approach.

关于消费文化研究

The Research on the Consumer Culture

广告研究不仅涉及设计区域，也和传播学、影视学关系密切。这一特点正反映设计批评的多元化。因此，设计批评并不一定存在于设计学术领域，设计书籍或杂志之外设计批评也无处不在——到处都会有评论员在谈论更为宽泛的社会、文化冲击。大卫·布鲁克斯（David Brooks）写的《在天堂的驱动下：我们现在如何以

The advertising research not only involves design, but also has close relation with the communication and the film studies. This characteristic reflects the diversification of the design criticism. Therefore, the design criticism is not exclusive to the academic field of design and the books and magazines on design. On the contrary, it is pervasive—the critics who talk about the more extensive social and cultural impact are everywhere. David Brooks wrote two books. One of them was published in 2004 titled *On*

将来时态生活》（*On Paradise Drive: How We Live Now (And Always Have) in the Future Tense*，2004）（图4-8）、《天堂中的布波族：一个新的上层阶级以及他们是如何上升的》（*Bobos In Paradise: The New Upper Class and How They Got There*，2001）都是对当代生活方式的分析，这种分析建立在对消费社会中的"物"的解读上。在这方面，美国宾夕法尼亚大学的文学教授保罗·福塞尔（Paul Fussell）是个专家。他关于第二次世界大战时期美国社会文化的专著曾获得1976年美国国家图书奖。他擅长对人的日常生活进行研究观察，视角敏锐，语言犀利。他最著名的著作有《格调》

Paradise Drive: How We Live Now (And Always Have) in the Future Tense (Figure 4-8), and the other one was published in 2001 titled *Bobos In Paradise: The New Upper Class and How They Got There*. All of analysis of the modern life style is based on the interpretation to the objects of the consumer society. Paul Fussell, the literature professor of Pennsylvania University is an expert in this respect. His book on American social culture during the World War II won American National Book Award in 1976. He is good at researching and observing the daily life of people. He is acute in the viewing angles and sharp in language. His two famous books are the *Class: A Guide through the American Status System* (1983) (Figure 4-9) and the *Bad Or, the Dumbing of America* (1992). Although we call him the expert in the field of the British and American literature criticism, his evaluations about

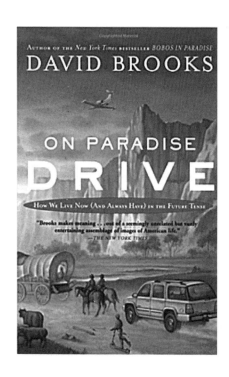

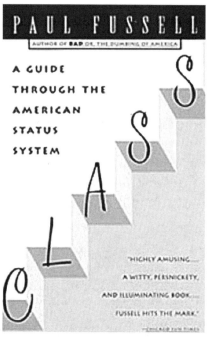

图4-8 大卫·布鲁克斯的著作《在天堂的驱动下：我们现在如何以将来时态生活》（左）

图4-9 保罗·福塞尔的著作《格调》（右）

（*Class: A Guide through the American Status System*, 1983）（图 4-9）与《恶俗》（*Bad Or, the Dumbing of America*, 1992）。虽然我们将他称为英美文化批评领域的专家，但是他在书中大量涉及对产品消费的评价成为我们审视自身消费方式的一针清醒剂。

伯明翰学派的文化研究具有跨学科学术传统，强烈地呈现出伯明翰学派重视不同民族文化的学术意识。伯明翰学派文化研究的对象各不相同，但许多都针对艺术与设计，带有强烈的文学艺术批评的传统。其研究更重视并构建一种健康淳朴、有机整体的工人阶级的传统文化。因此，与法兰克福学派"批判到底"的态度完全不同，他们则重视受众的解码立场的灵活性。为了证明大众文化的意义，伯明翰学派特别重视亚文化研究，研究欧美特别是英国自 20 世纪 50 年代以来几乎所有青少年亚文化现象，并形成了极富影响力的亚文化理论体系。

让·鲍德里亚（Jean Baudrillard, 1929—2007）对包括设计在内的当代文化进行了广泛的研究。他从符号的角度对设计在现代社会中扮演的社会经济角色进行了精确的分析，采取文化研究方法试图解决几个有关功能主

product consumption in his book are a dose of sobriety for reviewing our pattern of consumption.

The cultural research of Birmingham School has the academic tradition of interdisciplinary, which shows that Birmingham School has the academic consciousness and it has paid great attention to different national cultures. Although the cultural research of Birmingham School focuses on the different objects, most of the objects, aiming at the art and design, are marked with the tradition of the literary and art criticism. Its research pays greater attention to and tries to build the traditional culture of the working class. This healthy and plain culture has organic integrality. Therefore, the Birmingham School, which is different from the Frankfurt School which persists in the critical attitude, values the flexibility of the decoding position of the public. In order to prove the significance of the mass culture, Birmingham School pays special attention to the subculture studies and researches almost all the subculture phenomena about the teenagers in the Europe and America since 1950s, especially the Britain. Therefore, Birmingham School has formed the influential subculture theory system.

Jean Baudrillard (1929-2007) has conducted the extensive research on the contemporary culture, including the design. He analyzes the social and economic roles of the design playing in the modern society accurately from the perspective of the sign and symbol design. He adopts cultural research methods to solve several false conceptions about

义的错误观念。这位法国社会学家多年以来一直在研究消费品的设计、生产、流通和使用的种种现象。鲍德里亚的观点是"机械复制消解了设计的唯一性，服务的程度跟商品的价值相关联，这是消费时代的明显证据。"因此，消费过程其实是"意义化和沟通的过程"。它直接意味着一个"阶层分类并具有社会区别的过程"。在鲍德里亚看来，极度泛滥的复制产品实际上已经丧失其身份功能，转化为它们自身的模仿。它们可以被还原为空白形式，失去了原本的意义。实际情况已经到了这样一种程度：在广告的作用下，它不再是被消费的客体影像，而是消费主体的影像。

加拿大记者娜奥米·克莱恩（Naomi Klein）对设计和经济的关系进行研究，她在《不要标志：关注商标霸权》（No Logo: Taking Aim at the Brand Bullies，2000）一书中对知名品牌如何征服世界进行了剖析，并深刻反思这一现象，也分析了反全球化的风潮将如何反扑。哈尔·福斯特（Hal Foster）研究艺术史、当代艺术、建筑和设计，并撰写了设计批评专著《设计和罪恶》（Design and Crime: And Other Diatribes）一书。但是，正如作者所说，这本书的目的和卢斯一样，并不是宣告设计或艺术的"本体"或"自主性"。卢斯的朋友卡尔·克劳斯（Karl Kraus）认供"流动之屋"

functionalism. This French sociologist has been researching various phenomena about the design, producing, circulation and usage of the consumer goods. In his opinion, the mechanical duplication eliminates the uniqueness of design and the service degree has close relation with the commodity value, which are the obvious evidences of the consumption age. Therefore, the consumption process is the process of producing significance and communication. It is equivalent to the process that the class is classified and begins to be marked by the social difference. In Baudrillard's opinion, the excessive duplicated products have lost their identification functions and turned to imitating themselves. They can be returned to the blank form and lost their original meanings. In fact, they have reached to a degree that they, under the influence of the advertising, are the image of the consumption subjects instead of that of the consumption object.

The Canadian reporter Naomi Klein has conducted a research on the relation between design and economy. Her book is titled *No Logo: Taking Aim at the Brand Bullies* (2000). She gives a profound analysis on how the renowned brands can conquer the world and has a deep reflection on this phenomenon in her book. On top of that, she analyzes how the trend of the globalization retrieves its lost ground. Hal Foster researches the art history and the art, architecture and design of the modern time. He wrote a monograph of design criticism titled *Design and Crime: And Other Diatribes*. As the author has said, the purpose of this book is the same as Luce and it is not aimed to declare the "ontology" or "autonomy" of the design or art. Luce's friend Karl Kraus recognizes the concept of Running-room. Similarly, Hal Foster also said: "people should master the location awareness and change of the art autonomy independently. Besides, they

（Running-room）的概念。同样，哈尔·福斯特也认为："人们应该自主把握艺术自主性的位置感知和它的嬗变并重新认识批评学科性的历史辩证感知和它的论证——从而试图为文化提供'流动之屋'。"

should recognize the historical dialectical perception of the critical studies and its argumentation again to provide the 'influx house' for culture."

思考题：

1. 请用英文概述 20 世纪西方设计批评的特点。

2. 根据范文，列举出三部关于消费文化研究的论著。

3. 请采用双语表述的方式，谈谈设计批评对于提升设计功能与形式的重要作用。

4.3 西方设计批评理论：关于文学批评理论与视觉文化研究
Theory of Western Design Criticism: Research on Literary Criticism and Visual Culture

教学范文中英文对照

一、文学批评理论的影响

当代设计批评受到马克思主义、女性主义及符号学的影响非常大。早在 20 世纪 70 年代的意大利，马克思主义设计批评就拥有举足轻重的地位。它们有一个共同的特点，就是试图把握被设计物质与社会文化形态之间的联系。重要的批评文献有：埃米利奥·奥姆巴茨（Emilio Ambasz）为一次展览所撰写的同名文章《意大利：国内新景象，意大利设计的成就与问题》(*Italy: The New Domestic Landscape*) 和皮埃洛·萨特戈（Piecro Sartogo）的《意大利再进化：20 世纪 80 年代意大利社会的设计》(*Italian Re-evolution: Design in Italian Society in the Eighties*，1982) 等。这些文献强调设计的文化意义，并将意大利的设计史研究工作与新的英国设计史联系起来，成立英国伯明翰当

The criticism of contemporary design was greatly influenced by the Marxism, Feminism and Semiotics. In the early 1970s in Italy, the Marxist design criticism had played a significant role. They had a common characteristic which was to try to grasp the relationship between the designed substance and social cultural form. The important critical literatures were as follows: Emilio Ambasz's literature criticism paper titled *Italy: The New Domestic Landscape* and Piecro Sartogo's literature criticism paper titled *Italian Re-evolution: Design in Italian Society in the Eighties* and so on. These critical literature papers emphasized the cultural significance of the design, and connected the studies of the Italy design history with the new British design history. Birmingham Center for Contemporary Cultural Studies was established and the journal of *Block* was continuously founded and so on. The most important content of the study was the technique of expression, it came from the symbol cultural criticism advocated by Roland Barthes (1915-1980).

代文化研究中心（Birmingham Center for Contemporary Cultural Studies），创办了《布洛克》（*Block*）期刊等。这种研究最主要的内容是研究设计的表现手法，它来自罗兰·巴特（Roland Barthes，1915—1980）倡导的符号文化批评。

符号学对当代设计批评的影响也非常广泛。通常在广告、摄影和电影影像等领域，符号学批评的应用显得更加重要。它们将单纯的图示影像分析转为物质文化和通俗文化分析。这种转变将研究者带入设计史领域，诸如西方设计领域曾出现女性主义分析，提出了针对建筑史的批评研究，以及从化妆品包装设计到视觉设计、大众传播媒体的影像分析等都提出富有见解的批评理论；包括对1935~1962年流行品位的批评观点、小型摩托车对"摩登派"风格和生活方式的意义、通俗艺术风格等问题的探索。

Semiotics had a greatly extensive influence on the criticism of contemporary design. As usual, the application of the criticism of semiotics became more important in the fields of advertising, photography, film image and so on. They would transfer the simple analysis of graphic image into the analysis of physical culture and popular culture. This change would bring the researchers into the field of design history, for example, the analysis of Feminism appeared in the field of western design, the study on the criticism of architectural history was put forward, moreover, from the design of packaging of the cosmetics to the visual design and the analysis of the image of mass media, which put forward the insightful criticism theories, including the criticism of the popular taste from 1935 to 1962, and the exploration of the effect of small-scale motorcycles on the "Modern" style, the meaning of lifestyle, the popular art style and so on.

二、视觉文化研究

与文化研究所指向的广义研究对象不同，视觉文化更加直接地将艺术设计当作自己的研究范畴。它把人类生产和消费的二维和三维的可视物品当作文化和社会生活的组成部分。它包括不同类别的美术和不同类别的设计（如平面设计、室内设计、汽车设

Different from the generalized objects in culture research, the visual culture includes art design into its research scope in a more direct manner. Taking human production and 2D and 3D visual consumption items as the components of cultural and social life, it includes different categories of fine arts and design (e.g. graphic design, interior design, automobile design and architectural design), as well as visual

计和建筑设计等），也包括时装等容易引起学者忽视的视觉文化。正因如此，"视觉文化不仅涵盖艺术和设计，而且还包含被艺术史和设计史所忽视或无视的材料。"（图4-10~图4-13）

居伊·德波（Guy Ernest Debord，1931—1994）等人曾通过对日常社会的研究直接影响了"庞克"等设计风潮。20世纪中，在欧洲出现了"情境国际"思潮（Situationist International，1957—1972）。"情境国际"的创立者及主要批评家是撰写《景象社会》(The

culture that is easy to be ignored by scholars such as fashion design. For this reason, "visual culture not only covers art and design, but also includes materials ignored or disregarded by the history of art and design." (Figure 4-10-Figure 4-13)

Guy Ernest Debord (1931-1994) produced direct influences on the design trend such as "punk" by way of research on the everyday life and society. In the 20th century, European appeared the ideological trend of Situationist International (1957-1972). This ideological trend was founded by two critics and scholars, the Guy Debord and Raoul Vaneigem. Guy Debord published his monographs titled *The*

图4-10 视觉文化标识设计1
（摄影：陈炜）

图4-11 视觉文化标识设计2
（摄影：陈炜）

图 4-12　视觉文化标识设计 3

（摄影：陈炜）

图 4-13　视觉文化标识设计 4

（摄影：陈炜）

Society of the Spectacle）的居伊·德波以及曾出版《日常生活的革命》(*The Revolution of Everyday Life*）的哈伍尔·范内哲姆（Raoul Vaneigem，1934—）等。

"情境国际"思潮中主张对当下生活采取的行动和有所作为的观念，成为当时的知识青年主要思想的来源之一。"景象"（或景观，spectacle）一词，是对现代社会的精确描述，排行榜、展览、球赛、电台、电视、杂志、海选、决赛、标语、口号、广告语等成了日常消费品。景象以其特有的形式，诸如信息或宣传资料，广告或直接的娱乐消费，成为主导的社会生活的现存模式，并使商品生产与图像生产变得同步。产品的外观设计、品牌形象设计、广告策划等，甚至商品的市场实现在相当程度上都需要依赖自身品质以外的图像性策划、传播和公众认可度。因此，在"读图时代"，图像已经成为重要的非物质性生产资源，而商业竞争则向图像资源的争夺转变。

"创旧"（detournement）就是运用已存在的方式、概念，加以改造后对原先的意义和作用产生叛逆或者与众不同的视觉效果，并以此传达出不同的，甚至是相反的信息。庞克文化中年轻人运用这样的策略与手法并加以实践，甚至成为他们的艺术形式。例如被称为"庞克"之母的著名服装设计师维维安·韦斯特伍德（Vivienne Westwood）在伦敦共同开设的服饰店

Society of the Spectacle. Raoul Vaneigem (1934-) published his monographs titled *The Revolution of Everyday Life*.

The ideological trend of Situationist International advocates to take actions and do something about the present life, which is a source of thoughts for the educated young at that time. The term of "spectacle" is a precise description of modern society where rank list, exhibition, match, radio, television, magazines, audition, final, sign, slogan and advertisement become daily consumer goods. Spectacle, in its unique form such as information, publicity material, advertisement or direct entertainment consumption, has become the leading mode of social life and synchronized commodity production with image production. Product appearance design, brand image design, advertising planning and even realization in the market, to a considerable extent, rely on image planning, publicity and public recognition besides product quality. In the era of "picture reading", therefore, image has become an important non-material production resource while business competition is giving more focus to the fight for image resource.

The word of detournement means renovating the old. It also means to produce a rebellious or unusual visual effect on the former significance and function by way of reworking on existing methods or concepts so as to convey different and even opposite message. Young people apply and practice this strategy and method in the punk culture, which even becomes their form of art. For example, the famous fashion designer Vivienne Westwood was known as the mother of "punk" attracted the buyers with exaggerating and rebellious design style in the co-run fashion store named "Let it Rock"

"Let it Rock"（1971 年开设，之后数度更名），通过服装夸张反叛的设计风格引起购买者的兴趣。

西方学者对"视觉文化"或"图像时代"的研究却越来越深入。1993 年，马丁·杰（Martin Jay）出版了《低垂的眼睛：20 世纪法国思想中对视觉的诋毁》（*Downcast Eyes: The Denigration of Vision in Twentieth-Century French Thought*）一书，对 20 世纪法国哲学的反视觉性进行了全面的考察。1994 年，美国图像学家米歇尔（W. J. T. Mitchell）提出了"图像转向"（the Pictorial turn or the iconic turn）。米歇尔认为，在"语言学转向"中就已经隐含了某种"图像转向"的思想渊源。随后，他著有《图像理论：语言和视觉表达的评论》（*Picture Theory: Essays on Verbal and Visual Representation*，1995）一书，更为具体地论述了他的批评理论与观点（图 4-14）。

in London. And the co-run fashion store was opened in 1971 and renamed several times thereafter.

Scholars in the west have made more in-depth research on "visual culture" and "image era". In 1993, Martin Jay published his monograph titled *Downcast Eyes: The Denigration of Vision in Twentieth-Century French Thought*. He conducted a comprehensive review on anti-visuality in French philosophical circle in the 20th century. In 1994, American image scientist W. J. T. Mitchell advanced a theory on the Pictorial turn or the iconic turn. According to Michelle, the "linguistic turn" has implied the thought origin of the "image turn". Soon after, Michelle published his monograph titled *Picture Theory: Essays on Verbal and Visual Representation* (1995). It more specifically talks the criticism of his theory and viewpoint (Figure 4-14).

图 4-14 视觉文化海报设计
（摄影：陈炜）

关于西方视觉文化视野中的设计批评理论的名著包括：约翰·沃克（John A. Walker）和萨拉·查普林（Sarah Chaplin）的《视觉文化导言》（*Visual Culture: An Introduction*，1997）（图4-15）、尼可拉斯·米尔佐夫（Nicholas Mirzoeff）的《视觉文化导论》（*An Introduction to Visual Culture*，1999）、马尔科姆·巴纳德（Malcolm Barnard）的《艺术、设计和视觉文化》（*Art, Design and Visual Culture: An Introduction*，1998）（图4-16）、《理解视觉文化的方法》（*Approaches to Understanding Visual Culture*，2001）等。尤其是英国德比大学艺术和设计

Classics on design criticism theory in the viewpoints of western visual culture include the followings such as John A. Walker and Sarah Chaplin's monograph titled *Visual Culture: An Introduction* (1997), Nicholas Mirzoeff's monograph titled An Introduction to Visual Culture (1999) (Figure 4-15), and Malcolm Barnard's monographs titled *Art, Design and Visual Culture: An Introduction* (1998) (Figure 4-16) and *Approaches to Understanding Visual Culture* (2001) and so on. Malcolm Barnard, teacher of art and design history at University of Derby, is especially noticeable. He makes criticism and research in an extensive design scope including film, advertising, architecture, fashion, furniture and automobile based on iconology, semiotics, Marxism and feminism, which provides a new perspective for us to understand design.

图4-15 约翰·沃克和萨拉·查普林的著作《视觉文化导言》（左）

图4-16 马尔科姆·巴纳德的著作《艺术、设计和视觉文化》（右）

史教师马尔科姆·巴纳德（Malcolm Barnard），他根据图像学、符号学、马克思主义和女性主义的方法针对电影、广告、建筑、时装、家具、汽车等广泛的设计领域进行批评和研究，为我们理解设计提供了一个新的视角。

约翰·沃克（John A. Walker）的《视觉文化导言》（*Visual Culture: An Introduction*）一书，对视觉文化进行详细的分类，其中纯艺术包括绘画、雕塑、版画、装置艺术、先锋电影、行为艺术、建筑等；手工艺与设计的分类更为详细，包括：城市设计、店面设计、企业形象设计、标志设计、工业设计、工程设计、插图、平面设计、产品设计、汽车设计、武器设计、交通工具设计、字体设计、木工和家具设计、珠宝、金属工艺、制鞋、陶瓷设计、布景设计、计算机辅助设计、亚文化、服装与时尚、发型、景观与园林设计等。从这个分类中，我们能发现他的分类方法与目前国内设计学的分类差别很大，除了一些分类相互重合、存在矛盾关系之外，也反映了中西"文化研究"视角的差异性。"文化研究"视角的设计批评往往不会从设计的形式与功能入手来研究设计现象，而以哲学理论为基础，成为设计批评的出发点。包豪斯学院恰好将工厂作为设计的统一系统，并最终导致了大量功能主义风格为主体的现代建筑涌现。

John A. Walker wrote his monograph named *Visual Culture: An Introduction*. The Author John A. Walker made detailed classification of the visual culture. The pure art includes painting, sculpture, printmaking, installation art, avant-garde film, performance art, architecture and so on. There is more detailed classification of handicraft and design, which includes urban design, store design, corporate image design, logo design, industrial design, engineering design, illustration, graphic design, product design, automobile design, weapon design, transportation means design, typography design, woodworking, carpentry and furniture design, jewelry, metal craft, shoemaking, ceramic design, set design, computer aided design, subculture, clothing and fashion, hairstyle, landscape and garden design, etc. Great difference can be seen from her classification from domestic design study. Besides some overlapping and contradictory relations, it also reflects the perspective differences between Chinese and western "cultural studies". Design criticism from the perspective of "cultural study" seldom studies design practice in view of form and function but bases itself on philosophical theories as the starting point for design criticism. The Bauhaus, however, sees the plant as a unified system for design and eventually produces the emergence of a great number of functionalism-based modern architectures.

英国电影理论家彼得·沃伦（Peter Wollen）针对电影、时尚和设计文化进行写作。艾伦·韦斯（Allen S. Weiss）在《不自然的地平线：景观设计中的悖论和矛盾》（*Unnatural Horizons: Paradox and Contradiction in Landscape Architecture*）中进行关于美学、声学和景观设计的写作，他认为任何景观设计都出于哲学和神学的目的都是去解决感知和认知之间、现实与理想之间的固有矛盾，然而，似是而非、自相矛盾和冲突在这种永恒的追问中上升，这可找到无数范例，它们构成了艺术与和观念史的基础。这项研究描述了一张蓝图，它暗示着景观设计中的多义性传统。

Peter Wollen, British film theorist, writes about film, fashion and design culture. Allen S. Weiss is engaged in writing of aesthetics, acoustics and landscape design especially in his monograph named *Unnatural Horizons: Paradox and Contradiction in Landscape Architecture*. He believes that all landscape design is for philosophical and theological purpose and solves the inherent contradictions between perception and cognition, between reality and ideal, paradox and contradiction, however, sublimate in such eternal quest, which can be seen in numerous cases. They constitute the foundation of the history of art and idea. This study depicts a blueprint that implies the ambiguity convention and multiple meanings in landscape design.

思考题：

1. 请用英文解析"符号学"对于设计批评的影响。

2. 以范文为基础，请列举三本关于视觉文化研究的论著。

3. 什么是设计批评中的"创旧"概念？请用中英文双语来表述。

第 5 章 创新设计与获奖作品专题

CHAPTER 5　Topic on Design Innovation Awards

[本专题导读]

- -

从古至今，人们通过一系列方式不断地向自然和自身挑战，犹如国际奥林匹克竞赛是在向人类的体能极限挑战一般，诸多的国内、外艺术设计竞赛也是向人类智慧的创造高峰挑战。它的目标是有效地提高艺术设计的学术水准,使其更新、更好和更美。本专题精选 2013 年以来，在动漫设计、环境设计、工业设计领域的获奖作品及其作品解读与设计说明，了解最新设计获奖项目和创新设计作品，掌握前沿的设计信息，有助于我们开阔思路、主动思考、吸取其成功经验，丰富艺术设计的创作源泉。

5.1 动漫设计获奖作品
Animation Design Awards

原创动画设计《梦幻列车》获奖作品解读中英文对照

这部动画电影的故事是以在海外长大的华裔女孩琳琳的中国之行为主要线索，通过她旅行时在一部行驶中的列车车厢内的所见所闻，衍化出一幕幕十分神奇的经历。影片展示出一个个独特的艺术层面，运用动画特有的艺术和技术手段传达了一种中国传统文化与现代生活相结合的人文情怀，同时，影片具有强烈的娱乐性和浓郁的艺术感染力。

这部影片是在一个主题下，由十部动画短片有机串联组成，每部动画短片相互关联，又相互独立。影片的主要特点是借鉴中国经典民族音乐，以现实故事为动画脚本。在新媒体技术的辅助之下，它是集数字技术与各种艺术创作手法于一体的新媒体动漫作品。该作品在把传统的民间造型艺术、经典的民间传统音乐与现代化的高科技动画制作手段相融合的方面作了大量的探索，努

The behaviors of a girl named Linlin growing up overseas were taken as the main line of animated cartoon. With what she has seen and heard in a moving compartment of train during the travel, magical experience was derived one after another. The film shows a very unique artistic level and expresses a kind of humanistic feeling of combining traditional culture of China with modern life by applying unique artistic and technical means of cartoon. Meanwhile, the film is strongly entertained and of thick artistic appeal.

Under one theme, the film is composed of ten animated short films through organic connection and every animated short film is mutually connected and independent. The film is mainly featured by reference to classic folk music of China with practical stories as the scripts. With the aid of new media technology, it is a new media animated work with integration of digital technology and various artistic creation methods. The film has made a lot of explorations in such aspects as traditional folk modeling art, traditional classic folk music and modernized hi-tech cartoon making methods, so as to

力使影片呈现出优美的画面和诗一般的意境（图 5-1~ 图 5-5）。

show beautiful scenes and poetic conception within (Figure 5-1-Figure 5-5).

图 5-1 《梦幻列车》作品赏析 1

（总策划、制片：常虹，编剧、导演：常虹、张振兴、许新国、沈一帆、于瑾、曾青青、郑方晓、钱博弘、方建国、金煜）

图 5-2 《梦幻列车》作品赏析 2

（总策划、制片：常虹，编剧、导演：常虹、张振兴、许新国、沈一帆、于瑾、曾青青、郑方晓、钱博弘、方建国、金煜）

图 5-3 《梦幻列车》作品赏析 3

（总策划、制片：常虹，编剧、导演：常虹、张振兴、许新国、沈一帆、于瑾、曾青青、郑方晓、钱博弘、方建国、金煜）

图 5-4 《梦幻列车》作品赏析 4

（总策划、制片：常虹，编剧、导演：常虹、张振兴、许新国、沈一帆、于瑾、曾青青、郑方晓、钱博弘、方建国、金煜）

图 5-5 《梦幻列车》作品赏析 5

（总策划、制片：常虹，编剧、导演：常虹、张振兴、许新国、沈一帆、于瑾、曾青青、郑方晓、钱博弘、方建国、金煜）

荣获的奖项之一：

2015 年 2 月 26 日，动画电影《梦幻列车》获美国旧金山电影金像奖电影节优秀动画影片大奖（图 5-6）

Award of Merit of Animated film in the San Francisco Film Awards in San Francisco, CA, USA. Feb.26, 2015 (Figure 5-6)

图 5-6 《梦幻列车》获美国旧金山电影金像奖电影节优秀动画影片大奖

（总策划、制片：常虹，编剧、导演：常虹、张振兴、许新国、沈一帆、于瑾、曾青青、郑方晓、钱博弘、方建国、金煜）

荣获的奖项之二：

2015 年 3 月 26 日～4 月 1 日，动画片《梦幻列车》获希腊雅典国际动画电影节动画电影三等奖（图 5-7、图 5-8）

3rd Prize, Feature Animated Movie, 10th Athens AnimFest 2015 in March 26-April 1, 2015 (Figure 5-7, Figure 5-8)

图 5-7 《梦幻列车》获希腊雅典国际动画电影节动画电影三等奖（上）

（总策划、制片：常虹，编剧、导演：常虹、张振兴、许新国、沈一帆、于瑾、曾青青、郑方晓、钱博弘、方建国、金煜）

图 5-8 《梦幻列车》获希腊雅典国际动画电影节动画电影三等奖证书（右）

（总策划、制片：常虹，编剧、导演：常虹、张振兴、许新国、沈一帆、于瑾、曾青青、郑方晓、钱博弘、方建国、金煜）

作品入选：

德国慕尼黑独立电影节

Underground FilmFest in Munich, Germany

伊朗德黑兰第三十三届法加尔国际电影节

33rd Fajr International Film Festival in Tehran, Iran

西班牙马德里国际电影节

Painted Birds Film Festival in Madrid, Spain

印度第一届奥里萨邦国际儿童电影节

1st International Children Film Festival of Balangir at Law College, Balangir Premises, Odisha, India

保加利亚索非亚 Golden Kuker 国际动画电影节

IAFF Golden Kuker 2015 in Sofia, Bulgaria

获奖作者：

总策划、制片：常虹（浙江工业大学）

Planning Directors & Executive Producers: Joe Chang (Zhejiang University of Technology)

编剧、导演：常虹、张振兴、许新国、沈一帆、于瑾、曾青青、郑方晓、钱博弘、方建国、金煜

Original Story & Directed by Joe Chang, Zhang Zhenxing, Xu Xinguo, Shen Yifan, Yu Jin, Zeng Qingqing, Zheng Fangxiao, Qian Bohong, Fang Jianguo, Jin Yu

作曲：孙建国、陈少青

Music Artists: Sun Jianguo, Chen Shaoqing

艺术顾问：何水法、乔治·约翰逊、李嘉慈

Art Consultants: He Shuifa, George Johnson, Karin Lee

作品海报图 5-9~ 图 5-13 所示。

The film posters are shown in Figure 5-9-Figure 5-13.

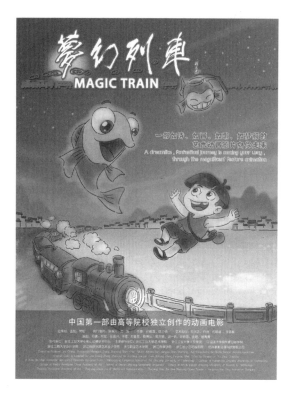

图5-9 《梦幻列车》作品海报1（左）
（总策划、制片：常虹，编剧、导演：常虹、张振兴、许新国、沈一帆、于瑾、曾青青、郑方晓、钱博弘、方建国、金煜）

图5-10 《梦幻列车》作品海报2（左下）
（总策划、制片：常虹，编剧、导演：常虹、张振兴、许新国、沈一帆、于瑾、曾青青、郑方晓、钱博弘、方建国、金煜）

图5-11 《梦幻列车》作品海报3（右下）
（总策划、制片：常虹，编剧、导演：常虹、张振兴、许新国、沈一帆、于瑾、曾青青、郑方晓、钱博弘、方建国、金煜）

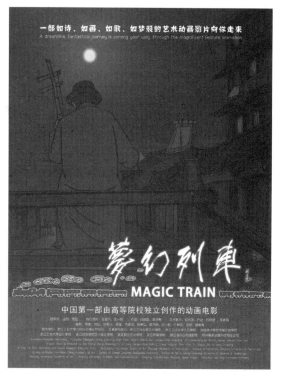

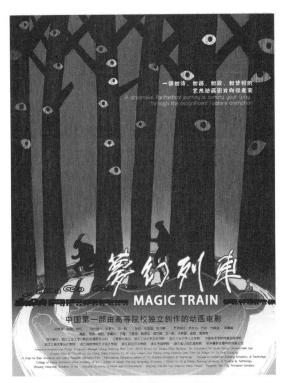

图 5-12　《梦幻列车》作品海报 4

（总策划、制片：常虹，编剧、导演：常虹、张振兴、许新国、沈一帆、于瑾、曾青青、郑方晓、钱博弘、方建国、金煜）

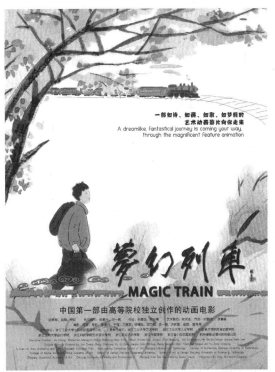

图 5-13　《梦幻列车》作品海报 5

（总策划、制片：常虹，编剧、导演：常虹、张振兴、许新国、沈一帆、于瑾、曾青青、郑方晓、钱博弘、方建国、金煜）

思考题：

　　1. 请用英文谈谈你对这项获奖设计的观后感。

　　2. 请结合自己的设计作品，撰写一篇完善的双语设计说明。

　　3. 请采用双语方式，列举你所知道的优秀中国动画设计作品。

5.2 环境设计获奖作品
Environmental Design Awards

获奖作品解读中英文对照

1. 《诗意佛堂》设计说明

　　义乌佛堂镇江东路整体古建保护状况不佳，大多为 20 世纪 80 年代钢凝结构，空间关系不明确，空间次序混乱，建筑天际线缺少变化。一些老建筑，如四合院、十三头间①掺杂违章建筑，改建之前的总体现状可用"杂、乱、差"三个字来形容。

　　作为我国历史文化保护区，古镇的改造首要考虑的是保留其原始的肌理、空间关系、路网关系，这样能够最大限度地将原生态且最富有古典神韵的千年古镇的"场所感"表达出来。佛堂古镇江东路的建筑改造之后富有诗意，这种诗意不可言喻，就如同诗人语言表达中的暗示（图 5-14、图 5-15）。

1. Design Explanation of *Poetic Fotang*

　　In the city of Yiwu, ancient architecture of Fotang Town at Jiangdong Road is under poor protection in general and most of them are built with reinforced concrete structure in the 1980s, with unclear spatial relations, disorderly spatial order and shortage of changes to skyline of building. Some old buildings like quadrangle dwellings and "thirteen roles" of traditional Chinese drama houses are mixed with illegal ones and they can be described as "disorder, chaos and poor" in general before they are transformed.

　　As the historical and cultural protection zone of China, it is necessary to preserve the original mechanism, spatial relations and road network in priority in transforming ancient town, so as to maximize the original and classic expression of "the sense of place" of 1000-year ancient town. The architecture of ancient town of Fotang at Jiangdong Road becomes poetic after being transformed and such poetic sense is self-evident just like the hint in verbal expressions of poet (Figure 5-14, Figure 5-15).

① 十三头指在中国传统戏剧剧种"秦腔"的角色分为：四生、六旦、二净、一丑，称为"十三头"。十三头间指义乌佛堂镇古建筑的一个室内空间区域，古时用于戏剧表演及存放戏剧道具的建筑空间。

图 5-14 《诗意佛堂》设计意象图

（作者：倪佳欢，指导教师：陈炜、田密蜜）

原始肌理　　　　肌理演变

图 5-15 《诗意佛堂》构思图

（作者：倪佳欢，指导教师：陈炜、田密蜜）

对于古镇的开发或者建筑的保护项目来说，应该是具有一种潜移默化的"体验感"，能使观者与主体发生联系和共鸣，从运动形式上唤醒人们的历史意识，这个过程不需要任何言语，是直击内心、使之震动的。兴许是某种逝去的仪式感，而不只是停留在对传统材料或者符号上的表达。场

For the development of ancient town or protection of architecture, a subtle "sense of experience" will be developed, for connection and resonance between audience and subject, so as to awaken the history awareness of people in movement form. No language is needed in the process, as it directly impacts inner heart of people. Perhaps it is a past sense of ceremony, but not just to stay at the level of the expression of traditional materials or symbols. The sense of place is mutually complemented and

所体验与建筑营造是相辅相成、相互影响的，也是内与外的关系，犹如肉体与灵魂一般紧密相连（图 5-16 ~ 图 5-18）。

influenced with architectural construction and they are also of the relation of inside with outside like the close connection of body with soul (Figure 5-16-Figure 5-18).

图 5-16 《诗意佛堂》设计效果图 1
（作者：倪佳欢，指导教师：陈炜、田密蜜）

图 5-17 《诗意佛堂》设计效果图 2
（作者：倪佳欢，指导教师：陈炜、田密蜜）

图 5-18　《诗意佛堂》设计效果图 3

（作者：倪佳欢，指导教师：陈炜、田密蜜）

作者：倪佳欢

Designer: Ni Jiahuan

指导教师：陈炜、田密蜜（浙江工业大学）

Tutor: Chen Wei Associate Professor, Tian Mimi Associate Professor (Zhejiang University of Technology)

获奖时间及级别：2014 年 11 月 25 日，中国环境设计学年奖最佳建筑设计奖

The Outstanding Award for Architectural Design CHINA ENVIRONMENTAL DESIGN PRIZE on 25th November, 2014

获奖证书如图 5-19 所示。

Award certificate is shown in Figure 5-19.

图 5-19 《诗意佛堂》作品获奖证书

（作者：倪佳欢，指导教师：陈炜、田密蜜）

2.《都是绿洲：深坑酒店设计》设计说明

城市的高速发展不可避免地产生了许多问题。我们此次着眼于激活被废弃的工业用地。本设计方案选址在上海城郊，一个高达 80 余米深的废弃采石深坑。我们从地理与尺度、历史中寻找激活场地的方法。

这块场地位于上海市松江区西北方向，毗邻上海佘山国家森林公园（上海市唯一的以森林资源为主的旅游区），处于城市与乡村交界地块。设计最初利用自然能源的方式是将太阳能转化为生物质能，由此可见，太阳能

2. Design Explanation of *Urban Oasis: A Deep Pit Hotel Design*

With the rapid development of the city, the inevitable result brings a lot of questions. We focus on IP live abandoned industrial use of land. This address of the scheme is chosen the suburbs in Shanghai. It is the as high as 80 meters deep abandoned quarry pit. We do research from the geographical conditions, scale, and historical views in order to find methods for activating sites.

The site locates in the northwest of Songjiang District of Shanghai, which is adjacent to the Shanghai Sheshan State Forest Park (the only main forest resources of tourism area in Shanghai). It is in both rural and urban border land. The initial use of natural energy is to convert solar energy

曾经是激活场地的要素，我们尝试把场地回归到利用太阳能源的生态发展模式，发挥坑洞的地理优势对太阳能进行有选择性的利用。建筑类型定位于酒店，满足城市居民游憩释放压力的需求。我们的建筑需如同火车一般环绕岩石行驶，如此在适当的时候可以接受阳光的照射，在某些时候可以避开过于猛烈的阳光。建筑的能源由太阳能系统提供（图 5-20~ 图 5-22）。

into Biomass energy. So, we try to return the site to the use of solar energy ecological development mode. We not only do use geographical advantage, but also selectively use solar energy. Building type is positioned into the hotel in order to meet pressure releasing demand of urban residents. Our construction should be like a train as the exercise of surrounding rock, so it can accept the illuminate of sunshine at the appropriate time, and it also can avoid too fierce sunshine in some time. The whole building energy is provided by the solar system (Figure 5-20-Figure 5-22).

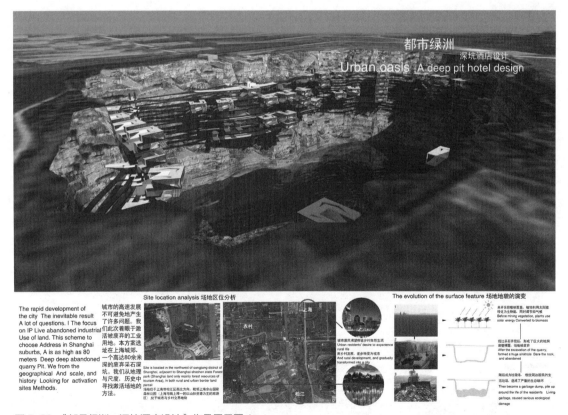

图 5-20 《都是绿洲：深坑酒店设计》作品展示图 1
（作者：钱寒轩、蔡扬，指导教师：陈洁群、万凌）

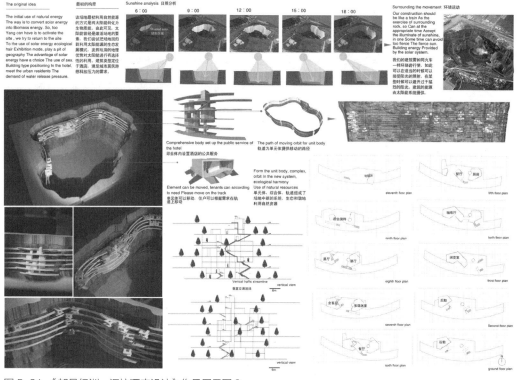

图 5-21 《都是绿洲：深坑酒店设计》作品展示图 2

（作者：钱寒轩、蔡扬，指导教师：陈洁群、万凌）

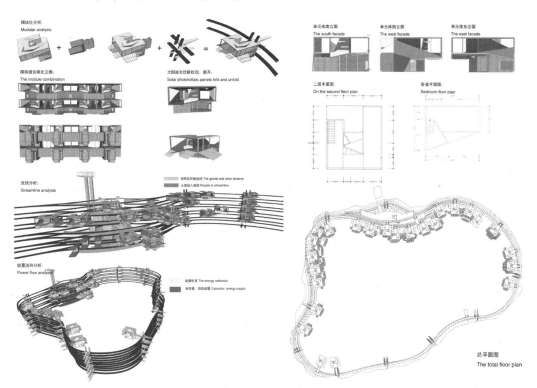

图 5-22 《都是绿洲：深坑酒店设计》作品展示图 3

（作者：钱寒轩、蔡扬，指导教师：陈洁群、万凌）

作者：钱寒轩、蔡扬

Designer: Qian Hanxuan, Cai Yang

指导教师：陈洁群、万凌（浙江工业大学）

Tutor: Chen Jiequn Associate Professor, Wan Ling Designer (Zhejiang University of Technology)

获奖时间及级别：2013 年 3 月，UIA– 霍普杯国际大学生建筑设计大赛优秀奖

The Excellent Award UIA-HYP CUP 2013 INTERNATIONAL STUDENT COMPETITION IN ZRCHITECTURAL DESIGN in March, 2013

思考题：

1. 请用英文谈谈你对获奖设计作品的观后感。

2. 请结合自己的环境设计作品，撰写一篇完善的双语设计说明。

3. 请采用双语方式，列举你所知道的优秀中国环境设计作品。

5.3 工业设计获奖作品
Industrial Design Awards

获奖作品解读中英文对照

1. 新型秸秆粉碎车设计说明

中国北方每年秋收之后，都会在田野中留下无数的秸秆，目前的处理方式比较简单粗暴，一般包括将秸秆倒入河流或者对秸秆进行焚烧，因此现有的处理秸秆的方式不仅没有很好地解决秸秆问题，秸秆的根部仍留在泥土中，影响下次播种，而且过往的处理方式还在一定程度上产生水源污染、毁伤地表、污染环境空气等问题，影响生态环境，也是造成 PM2.5 超标的主要原因。

针对以上这些问题，作者创造性地设计了新型秸秆粉碎车，该装备的设计能够很好地解决秸秆销毁和秸秆根部粉碎的问题。新型秸秆粉碎车设计有五个粉碎组，每个粉碎组由"挖掘爪子"和"粉碎刀片"组成，前置的"挖掘爪子"具有将秸秆切断、挖出秸秆根部的功能，而后置的"粉碎刀片"能够将秸

1. Design Explanation of SPIDER New Type Straw Grinder

Countless straws are left in the fields after the autumn harvest in north China, which are usually disposed by the simple and rude method of pouring into rivers or burning. Besides, the roots are still in the earth to affect following seeding. Therefore the existing straw disposal method is not a complete solution to the straw problem, and can pollute the water resources, damage earth surface and contaminate ambient air, negatively influencing the ecological environment and being a major reason for over-high amount of PM2.5.

In allusion to this problem, The designer creatively designs a new straw grinder that does well in dealing with disposal of straws and grinding of straw roots. The grinder has five grinding groups, each of which consists of "digging claws" and "grinding blades". The front "digging claws" can cut off straws and dig out roots, while the back "grinding blades" will cut the straws and roots into pieces and mix them with soils. As a result, straws residuals are effectively utilized in

秆和秸秆根部进行粉碎，并将粉碎物与泥土混合在一起，将秸秆最终转化为养料，从而实现了秸秆残渣的有效利用，同时，每一粉碎组后面的整平挡板设计为将粉碎后的泥土整平，是一种绿色、环保、低碳、可持续的粉碎方式。

　　新型秸秆粉碎车的动力系统采用了可再生能源、蓄电池、天然气和柴油混合动力，使得机器发动机一直保持在最佳的工作状态，气体排放量很低，是一种经济且环保的工作方式（图5-23、图5-24）。

the form of nutrition. Meanwhile, the leveling boards behind each group smooth the grinded soils. Therefore it is a green, environmental friendly, low carbon and sustainable way of grinding.

The new straw grinder is economic and environment protective in that it is powered by renewable energy sources. The hybrid power of storage battery, natural gas and diesel oil can always keep the engine working at the optimum state with a low gas emission (Figure 5-23, Figure 5-24).

图 5-23 《新型秸秆粉碎车》作品展示图 1

［设计者：张勇、洪海云、阎云逸、赵杨，指导教师：徐冰，获得奖项：第三届中国"太湖奖"设计大赛创意组特等奖（2014 年）］

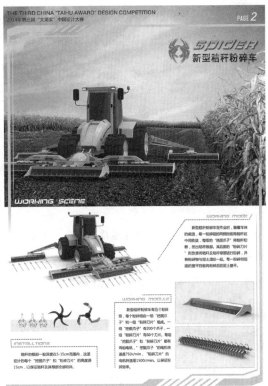

图 5-24 《新型秸秆粉碎车》作品展示图 2

［设计者：张勇、洪海云、阎云逸、赵杨，指导教师：徐冰，获得奖项：第三届中国"太湖奖"设计大赛创意组特等奖（2014 年）］

作者：张勇、洪海云、阎云逸、赵杨

Designer: Zhang Yong, Hong Haiyun, Yan Yunyi, Zhao Yang

指导教师：徐冰（浙江工业大学）

Tutor: Xu Bing Associate Professor (Zhejiang University of Technology)

获奖时间及级别：2014 年 5 月，第三届中国 "太湖奖" 设计大赛创意组特等奖

The Outstanding Award (Top Grade) for Creative Group THE THIRD TAIHU AWARD DESIGN COMPETITION in May, 2014

2. 涵洞先锋设计说明

铁路、公路涵洞地势凹陷，极易积水，在暴雨天气或夜晚由于视线差判断不清涵洞内水况，容易发生车辆被淹事故。

该无线式涵洞水位智能预警系统主要利用激光、LED 警示符号灯以及爆闪光带等三重警示，在暴雨天气能见度较低的情况下提前提醒司机前方涵洞的积水情况，利用红、黄光等既定的警示语言告知司机前方涵洞是否可安全通过，若危险则可尽快改道，避免发生车辆溺水抛锚及乘客溺亡等事故。其改进现有的文字提醒标志，以更丰富的光的形式加强警示功能，增强人身安全及道路安全。

该系统由三个模块组成：水位的监测和传输、LED 和激光灯警示，以及水位的监控和管理。首先，位于涵洞内部的传感器实时监控积水深度，搜集水位信息，通过无线传输至第二

2. Design Explanation of Culvert Pioneer

The low lying culvert of railway and highway are extremely prone to retaining water, where cars can be easily drowned in rainstorm or night due to wrong judgment of the water condition caused by error on line of sight.

This smart wireless pre-warning system against the water stage in the culvert is used for reminding drivers of the forward culvert ponding in rainstorm by a triplex warning, including laser, LED warning code light and flare burst. Established warning language like red and yellow lights will be adopted to tell drivers whether the forward culvert is available. When danger is indicated, drivers may change their routes as early as possible to avoid drowning of cars and passengers and stalling cars. It can enhance personal safety and road safety by its strengthened warning functions with improved word reminding signs and more light forms.

This system is composed of three modules: monitor and transmission of water level, LED and laser lamp warning, and supervision control of water level. First, the sensor in the culver will monitor ponding depth and water level information real-timely, and then transmit such information

模块和第三模块；第二模块根据水位，显示相应的警示信息，提前告知司机前方涵洞此刻能否通过，及时采取相应的措施，或慢行或改道，避免发生车辆溺水抛锚等事故；第三模块接收每个涵洞内部的感应器所搜集的水位数据，形成一个无线网络集成在城市交通控制中心，实时监控各个涵洞的水位情况，及时派遣人员进行排水工作，保证交通安全与畅通（图 5-25）。

to the second and third modules through wireless transmission. The second module will display corresponding warning information according to the water level, indicating whether the forward culvert is passable. Drivers may take measures accordingly, such as lowering the speed or changing the route, in case the car may be drowned and drop anchor. Water level information collected by all the sensors in the culverts will be gathered by the third module to establish wireless network integration in the traffic control center of the city, hence real time monitor water levels of all culverts. Consequently, drainage personnel can be sent to secure a safe and smooth traffic (Figure 5-25).

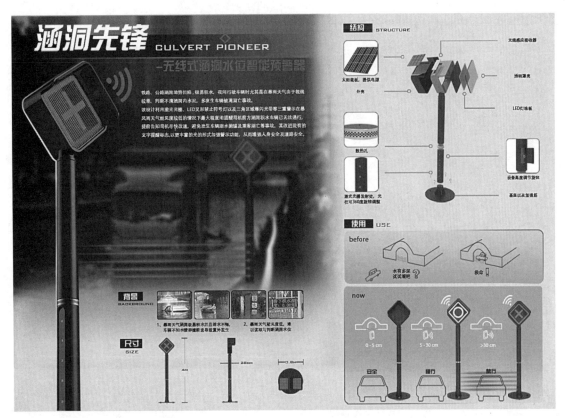

图 5-25 《涵洞先锋》作品展示图

［设计者：齐颖芳、丁雅玲，指导教师：徐冰，获得奖项：浙江省第六届大学生工业设计大赛金奖（2014 年）］

作者：齐颖芳、丁雅玲

Designer: Qi Yingfang, Ding Yaling

指导教师：徐冰（浙江工业大学）

Tutor: Xu Bing Associate Professor (Zhejiang University of Technology)

获奖时间及级别：2014 年 11 月，浙江省第六届大学生工业设计大赛金奖

The Gold Award (First Prize) THE SIXTH SESSION OF UNIVERSITY STUDENTS INDUSTRIAL DESIGN COMPETITION OF ZHEJIANG PROVINCE in November, 2014

思考题：

1. 请结合自己的设计作品，撰写一篇完善的中文设计说明。

2. 试采用英文专业用语，对第 1 题完成的设计说明进行翻译。

3. 请采用双语方式，列举你所知道的优秀中国工业设计作品。

第6章 欧美设计大师专题

CHAPTER 6　Topic on European and American Design Masters

[本专题导读]

　　在艺术设计领域，20世纪初期欧美设计师比较多，21世纪初期以来，中国设计师们不断涌现，他们的原创设计在国际舞台上奏响了新乐章。追溯设计学科两百年以来的发展历程，国际设计大师们在相互学习、相互竞赛中引领了世界发展潮流。这个专题主要引介不同设计领域设计师的成才经历，他们的作品与经历对社会发展、对艺术设计领域产生了重要影响，他们独特的设计审美、原创的设计风格、生平经历与代表性的设计作品很值得我进一步学习与研究。了解前辈设计师们的设计风格形成与设计定位，有利于我们从自身出发，提高专业水平，设立今后发展的目标。

6.1 工业设计大师汉诺·凯霍宁
Hannu Kahonen, Great Master of Industrial Design

教学范文中英文对照

汉诺·凯霍宁（Hannu Kahonen）是北欧当代最著名的工业设计大师之一，他曾被芬兰总统授予"艺术家教授"的称号和"芬兰专业勋章"，被世界文化理事会授予特别嘉奖，被芬兰艺术学会授予终身成就奖，并获得芬兰卡伊·弗兰克设计奖。他创办的 Creadesign 公司在 2009 年被芬兰权威评级机构给予"芬兰创新力最强（SUOMEN VAHVIMMAT）"的评定。他也是一位成功设计企业家、赫尔辛基设计事务所 Greadesign Oy 的创始人（图 6-1）。

凯霍宁是芬兰设计学派人文功能主义传统的继承者。他的设计理念主要体现在三方面：其一，主张"生活与工作一体化"思想；其二，以生态保护为基础，以设计经济为原则，始终恢复理智、归于平和；其三，注重人体工程学，注重材料的知识、产品

Hannu Kahonen is one of the best-known industrial design masters in contemporary Northern Europe. He was awarded with the honor of "Artist Professor" and "Pro Finlandia Medal" by the President of Finland. Also, he received the special award granted by World Cultural Council, the Lifetime Achievement Award from Finland Art Society, as well as the Kaj Franck Design Prize. The Creadesign Company he founded was graded as "SUOMEN VAHVIMMAT" by Soumend Asiakastieto, an authoritative Finland rating agency. Moreover, he is also a successful entrepreneur specialized on design, and the founder of Helsinki Design Office called Greadesign Oy (Figure 6-1).

Kahonen is an inheritor of humanistic functionalism traditions in Finnish design school. His philosophy in design is mainly reflected in three aspects. Firstly, he advocates the idea of "integration between life and work". Secondly, he takes ecological protection as the basis and design economy as the principle, and always pursues restored rationality and peace. Thirdly, he highlights not only ergonomics, but also the

的可用性、辅助功能及可循环性（图 6-2~ 图 6-4）。

knowledge of materials, and the usability, auxiliary function and recyclability of products (Figure 6-2-Figure 6-4).

图 6-1　工业设计大师汉诺·凯霍宁

（图源自：方海，戴梓毅著. 从需求出发：工业设计大师汉诺·凯霍宁. 南京：东南大学出版社，2014：1）

图 6-2　汉诺·凯霍宁创意设计工作室内景

（图源自：方海，戴梓毅著. 从需求出发：工业设计大师汉诺·凯霍宁. 南京：东南大学出版社，2014：57）

图 6-3　汉诺·凯霍宁 2005 年 2F 折叠椅设计

（图源自：方海，戴梓毅著. 从需求出发：工业设计大师汉诺·凯霍宁. 南京：东南大学出版社，2014：146）

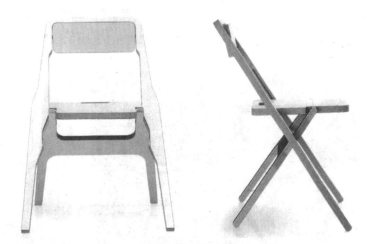

图 6-4　汉诺·凯霍宁 2005 年 2F 折叠椅设计（展开图）

（图源自：方海，戴梓毅著. 从需求出发：工业设计大师汉诺·凯霍宁. 南京：东南大学出版社，2014：147）

走在赫尔辛基中心区的街头，随便往一个方向望去，几乎都可以看到工业设计师汉诺·凯霍宁的作品：大到轻轨、地铁、火车、渡轮，小到路边垃圾桶，甚至是一个门上的锁头。他不愧是欧洲顶级工业设计大师，他在设计上的成就涵盖从交通工具设计到电子通信产品设计、家具设计、公共设施设计、机器装备设计、照明系统与灯具设计及视觉传达设计等领域。除了做大量的实用设计以外，他还致力于教育事业，甚至芬兰的国家设计策略（图6-5、图6-6）。

1971年，凯霍宁毕业于赫尔辛基艺术设计大学（现阿尔托大学），1981年，他成立Creadesign工业设计顾问公司。设计项目超过500项，曾为赫尔辛基城市交通系统（HKL）设计的Vario Tram有轨电车有效改善市

As you are wandering around the streets of downtown Helsinki, you can see the industrial design master Hannu Kahonen's works almost anywhere in any direction: from light rails, metros, trains and ferryboats, to trash cans by the roadside, and even a tapered end on the door. He deserves to be called a top-notch industrial design master in Europe, because his achievements in design include many domains, such as vehicle, telecommunication products, furniture, public utilities, machinery assembly, illuminating system, lamp and visual communication. Apart from a large number of practical designs, he also devotes himself to the education cause, and even the national design policy for Finland (Figure 6-5-Figure 6-6).

In 1971, Kahonen graduated from the University of Art & Design Helsinki (currently Aalto University). In 1981, he established Creadesign, an industrial design consulting company. The company has undertaken over 500 design projects, including Vario Tram, designed for Helsinki HKL to effectively improve citizens' travel mode, the world's first GPS positioning

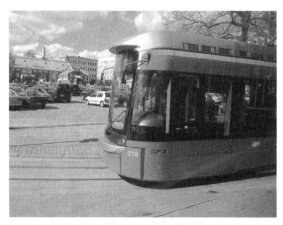

图6-5　汉诺·凯霍宁设计的赫尔辛基轻轨
（图源自：方海，戴梓毅著. 从需求出发：工业设计大师汉诺·凯霍宁. 南京：东南大学出版社，2014：107）

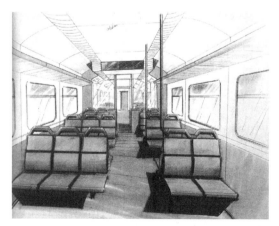

图6-6　汉诺·凯霍宁的赫尔辛基轻轨车厢座椅设计
（图源自：方海，戴梓毅著. 从需求出发：工业设计大师汉诺·凯霍宁. 南京：东南大学出版社，2014：105）

民出行方式；为芬兰 Benefon 公司设计出世界第一款 GPS 定位手机；为 Abloy Oy 设计的系列锁具装配在芬兰的千家万户，成为几十年来一直畅销的经典设计。他于 2000 年被赫尔辛基市长授予"赫尔辛基 450 年奖章"。2001 年和 2006 年分别被芬兰总统授予的"芬兰专业勋章"和"艺术家教授"（芬兰设计领域的最高学术称号）。2003 年被世界文化理事会授予特别嘉奖。2009 年获得芬兰卡伊·弗兰克设计奖（芬兰最高设计荣誉，每年仅评选一人）。2011 年被芬兰艺术学会授予终身成就奖。

同时，他也是芬兰现行设计国策的制订者之一，先后担任芬兰工艺与设计国家委员会主席、芬兰设计博物馆董事会主席等国家设计机构重要职务。

他的作品反映了极佳的工业设计美学，拥有 30 年的工业设计职业生涯，十分了解产品设计对于商业上的应用和需求，一个从整体出发的设计观和用户导向的工作流程是凯霍宁和他 Creadesign 工业设计顾问公司的工作基础。他喜欢通用性及平易近人的设计，从一开始就充分考虑产品设计对于人、科技以及环境之间互动等设计要素与设计目标，用户的利益、客户的需求被转变为制造商经济上的利益便水到渠成了（图 6-7、图 6-8）。

phone designed for Finland Benefon Company, the series of lockset designed for Abloy Oy that's assembled in thousands upon thousands of families in Finland. This series of lockset has also become a classic design that remains as the best-seller over the past decades. In 2000, Kahonen was awarded "The City of Helsinki 450 years-medal" by the mayor of Helsinki. In 2001 and 2006, he was awarded with the honor of "Artist Professor" and "Pro Finlandia Medal" (the highest academic title of design in Finland) by the President of Finland respectively. In 2003, he received the special award granted by World Cultural Council. He was awarded Kaj Franck Design Prize (the highest honor of design in Finland, only one winner every year) in 2009. In 2011, he received the Lifetime Achievement Award from Finland Art Society.

In the meanwhile, he is also one of the formulators of the existing national design policy in Finland. Kahonen has also served in important positions in national design institutions successively, such as the Chairman of The National Council for Crafts and Design of Finnish, and the Design Museum Finland.

Kahonen's works are a reflection of the magnificent industrial design aesthetics. With thirty years of experience in professional industrial design, he thoroughly understands the application and demands of product design in commerce. The philosophy of design which takes entirety as the entry point, and the users-oriented work procedure are the foundation of Kahonen and his industrial design consulting company Creadesign. He likes universal and approachable design. From the very beginning, he thoroughly considers the elements and objectives of design, such as the interaction between product design and human beings, science and environment. Thus, customers' demands can be converted into manufacturers' economic benefit without too much extra endeavors (Figure 6-7, Figure 6-8).

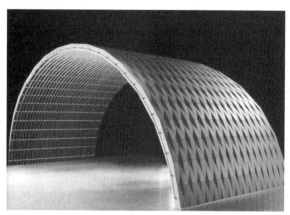

图 6-7　汉诺·凯霍宁运用 Kalpi 结构的展位顶棚设计
（图源自：方海，戴梓毅著. 从需求出发：工业设计大师汉诺·凯霍宁. 南京：东南大学出版社，2014：145）

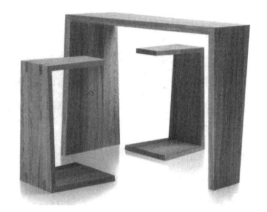

图 6-8　汉诺·凯霍宁的卡朋尼瓦（Kapeneva）长凳设计
（图源自：方海，戴梓毅著. 从需求出发：工业设计大师汉诺·凯霍宁. 南京：东南大学出版社，2014：150）

思考题：

　　1. 请用英文概述汉诺·凯霍宁的设计经历。

　　2. 汉诺·凯霍宁的设计理念主要有哪三方面？请用英文表述。

　　3. 请思考工业设计大师汉诺·凯霍宁的作品对你有哪些启发。

6.2　时装设计大师缪齐雅·普拉达
Miuccia Prada, Great Fashion Designer

教学范文中英文对照

　　PRADA 品牌创始人是马里奥·普拉达（Mario Prada），至今全世界超过 120 家门店，每年营业额在百亿法郎……老品牌经历百年而不衰的原因之一在于品牌与企业发展在不断创新、与时俱进与追求完美；更重要的原因在于 PRADA 品牌的继承人马里奥·普拉达的孙女——缪齐雅·普拉达（Miuccia Prada）（图 6-9）。

　　The brand founder of PRADA was Mario Prada. Up to now, it has over 120 shops across the world with tens of billions of francs of annual turnover. One of the reasons of no decline of old brand after hundred years of development is continuous innovation, keeping up with the times and pursuing perfection between brand and enterprise development. More important reason lies in brand inheritor Miuccia Prada, the granddaughter of Mario Prada (Figure 6-9).

图 6-9　缪齐雅·普拉达时装设计大师

（图源自：吉安·鲁吉·帕拉齐尼著. 普拉达传奇. 郭国玺，陈植译. 北京：中国经济出版社，2013：1）

缪齐雅·普拉达 1949 年 5 月 10 日出生于著名的世界时装之都米兰，1969 年她获得政治学博士学位。她致力于左翼运动，是一名意大利共产党员；那么，这究竟是怎么回事呢？ 20 世纪 70 年代，她在政治学院（Sciences Po）学习，随后为了谋生，在她祖父的皮制品加工厂工作。缪齐雅对这份事业并没有什么信仰："我觉得这个工作太阶级化，太女性化，不够知性。"她是这么说的。

在缪齐雅·普拉达于 1978 年成为"箱包女王"之前，"酷"是对她最恰当的评语，尤其她还是共产党员呢！如今我们已经很难想象了，可这位米兰人当年的确长久奋斗在共产前沿！

1978 年她成为 PRADA 公司的掌门人，在她接管公司之前，PRADA 品牌其实已显露出陈旧的姿态，然而，她意识到要让品牌持久，必须寻找一条"传统与现代融合"的新路。在这个理念的推动下，PRADA 品牌保留了以往设计完美、制作精致的传统，进而打造一个精品王国，其每一件产品都充满着庄重、成熟、典雅的风韵。老品牌非但不因年老而落伍，反而充满了生命力，像一朵奇葩盛开在世界时装大舞台上（图 6-10 ~ 图 6-12）。

缪齐雅·普拉达是世界首屈一指的时装与时尚设计大师。1979 年，发布了她的第一款背包及包件，赢得赞誉。1985 年她设计推出全新的黑色、耐用、

Miuccia Prada was born in famous world fashion capital Millan on May 10th, 1949, and she acquired PhD degree in politics in 1969. She was one Italian communist dedicated to left-wing movement: then exactly how it happened? She learned at Sciences Po in 1970s, and worked at her grandfather's leather processing plant later on for making a living. She had no much belief on this cause: "I think this work is too class characters, too feminized, and not too intellectual", she said so.

"Cool" was most appropriate comment on Miuccia Prada before she became "bag queen" in 1978, especially she was one communist! Now it is very difficult for us to imagine, but such Milanese indeed strived for communist frontier then.

She became the person in charge of PRADA in 1978. In fact, PRADA had revealed outmoded posture before she took over the company. However, she realized that to achieve enduringness, the brand must find one new path "integrating tradition and modernity". Driven by this concept, PRADA maintained the past perfect design and exquisite making traditions, and then created this boutique kingdom. Its products are full of solemnity, maturity and elegant charm. The old brand had not dropped behind due to old age; it is full of vitality like a flower blossoming in world fashion stage (Figure 6-10-Figure 6-12).

Miuccia Prada is a second to none fashion and fashion design master in the world. In 1979, she released her first style shoulder bag and bag accessories, and won praise. In 1985, she designed and launched brand new black, durable and

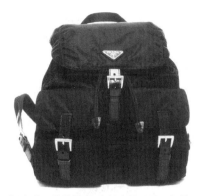

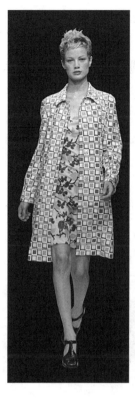

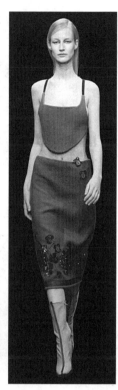

图 6-10 缪齐雅·普拉达的成名之作 1984 年第一款普拉达双肩包（左）
（图源自：吉安·鲁吉·帕拉齐尼著. 普拉达传奇. 郭国玺，陈植译. 北京：中国经济出版社，2013：插图第 9 页）

图 6-11 缪齐雅·普拉达的 1996 年秋冬女装系列设计（中）
（图源自：吉安·鲁吉·帕拉齐尼著. 普拉达传奇. 郭国玺，陈植译. 北京：中国经济出版社，2013：插图第 3 页）

图 6-12 缪齐雅·普拉达的 2000 年春夏女装系列设计（右）
（图源自：吉安·鲁吉·帕拉齐尼著. 普拉达传奇. 郭国玺，陈植译. 北京：中国经济出版社，2013：插图第 4 页）

细致的尼龙手袋系列，在质地材料上的创新和跨界艺术上的追求成为品牌的独特风格，她获得极大成功。1992 年她推出价位较低的二线品牌 MiuMiu，并把大女人梦想变回小女孩的设计理念植入品牌之中。1993 年她获得美国时尚设计理事会的国际奖，这是时尚界颁给设计师的最高荣誉。1995 年她荣获"最佳时装设计师"称号。1996 年，PRADA 集团创立 PRADA Holding Bv，并将国际声誉极高的 FENDI 等国际品牌纳入该集团。2000 年，她设计了春夏保龄球袋和鳄鱼皮医生袋，之后又新出作品 Gazar，即曾用于 20 世纪 50 年

exquisite nylon handbag series. The innovation on texture materials and pursuit on crossover art had become the unique style of brand, thus she acquired enormous success. In 1992, she launched lower price second-line brand named MiuMiu, and implanted the design concept "turning big woman to little girl" into the brand. In 1993, she won international award conferred by Council of Fashion Designers of America (CFDA), the highest honor awarded by fashion circles to designers. She won the title of "best fashion designer" in 1995. In 1996, PRADA Group established PRADA Holding Bv and incorporated international brands with great reputation such as FENDI into such group. In 2000, she designed spring and summer bowling bag and crocodile doctors bag, and launched new work Gazar later on, i.e.

代的奢华成装设计的棉质薄纱配合朋客式样的童话绘画设计的虚化设计，达到"技惊四座"的效果。2003年《华尔街日报》评选她为全欧洲最具影响力的30位女性之一……这就是普拉达2015年的设计实力，足够让人瞠目结舌……（图6-13、图6-14）

忘了说，除了是可可（Coco）以外，缪齐雅·普拉达还是女权主义者……这种情况一直持续到1978年她与帕特里佐·贝尔泰利（Patrizio Bertelli）相识。两人一起动手大干起来，共同开创事业。她负责设计包，他负责制造和销售。他们的事业日渐繁荣，但离日后普拉达的规模还很远……然后有那么一天，这对夫妇参观了一个军需品工厂，买下了一种名叫"poccone"的防水布料。他们用这种料子做成包，结果风靡一时，直到今天仍然广受欢迎。普拉达品牌就此有了新亮点。

凭借这一成功获得财富后，夫妻俩又通过其他产品进一步稳固这一品牌：1988年推出了第一套鞋和成衣系列，5年以后男装系列问世。品牌在全世界范围内获得了更大的成功……1994年美国时尚大奖——这相当于美国时尚界的奥斯卡——授予给了缪齐雅·普拉达，无疑是对她的成就的肯定。在她之前，只有一位女性曾获此殊荣，她名叫可可·夏奈尔（Coco Chanel）。我们期待将来这个大奖会颁给中国的某一位著名设计师（图6-15、图6-16）。

blurring design combining cotton chiffon (once used for clothing design in 1950s) with peer style fairytale drawing design, reaching astonishing effect. In 2003, she was appraised as one of 30 most influential women across Europe. ... This is the design strength of PRADA in 2015, which is enough to raise people's eyebrows... (Figure 6-13, Figure 6-14)

Except Coco, Miuccia Prada is also one feminist...Such situation lasted until her acquaintance with Patrizio Bertelli in 1978. They joined in hands to start business. She took charge of designing bags, while he was responsible for manufacturing and sales. Their cause gradually flourished, but was still far away from the scale of PRADA later on...However, one day, the couple visited one military supplies plant and bought waterproof cloth called "poccone". They used such cloth to make bag, which became fashionable and still popular at present. The brand PRADA had new bright point since then.

After acquiring wealth via such success, they further stabilized the created brand via other products. They launched the first shoe and garment series, and men's series came out five years later. PRADA acquired greater success all over the world...The 1994 American fashion award-equivalent to Oscar in American fashion circles, was awarded to Miuccia Prada. Indubitably it was the identification on her achievements. Only one woman Coco Chanel won such honor before her. Looking forward to that such award can be awarded to one famous Chinese designer in the future (Figure 6-15, Figure 6-16).

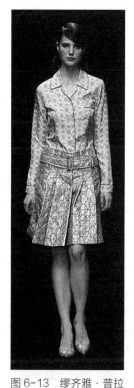 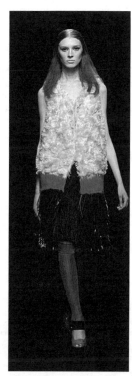 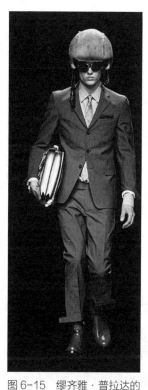

图6-13　缪齐雅·普拉
达的2002年春夏女装系
列设计

（图源自：吉安·鲁吉·帕
拉齐尼著. 普拉达传奇.
郭国玺，陈植译. 北京：
中国经济出版社，2013：
插图第5页）

图6-14　缪齐雅·普拉
达的2008年秋冬女装系
列设计

（图源自：吉安·鲁吉·帕
拉齐尼著. 普拉达传奇.
郭国玺，陈植译. 北京：
中国经济出版社，2013：
插图第6页）

图6-15　缪齐雅·普拉达的
2005年春夏男装系列设计

（图源自：吉安·鲁吉·帕拉
齐尼著. 普拉达传奇. 郭国玺，
陈植译. 北京：中国经济出
版社，2013：插图第7页）

图6-16　缪齐雅·普拉达
的2010年秋冬男装系列
设计

（图源自：吉安·鲁吉·帕
拉齐尼著. 普拉达传奇.
郭国玺，陈植译. 北京：
中国经济出版社，2013：
插图第8页）

普拉达英文官方网站：www.prada.com

思考题：

1. 请用英文概述缪齐雅·普拉达的时装设计经历。

2. 缪齐雅·普拉达对品牌设计作了哪些革新？请用英文表述。

3. 请思考时装设计大师缪齐雅·普拉达的作品对你有哪些启发。

6.3 信心与毅力：设计大师詹姆斯·利安那特
Confidence and Tenacity: Designer James Lienhart

教学范文中英文对照

詹姆斯·利安那特记得 30 年前曾被问过这样一个问题："如果你能做任何事，你想做什么？"

"我说我想住在芝加哥市中心，一个四周全是玻璃的房子，可以看到开阔的湖。我想要一个极简主义抽象派艺术的环境，让自己身临其境在真正设计得很好的东西之中，做出激动人心的原创设计。"他说："从某种角度上看，能够那样大声地说出来，就使我能够做到。"（图 6-17、图 6-18）

James Lienhart remembers being asked this question thirty years ago: "What would you do if you could do anything?"

"I said I wanted to live in downtown Chicago in an all-glass building with a great view of the lake. I wanted a minimalist environment and to surround myself with things that are really well designed, and produce exciting original design, " he says. "And somehow just being able to say it out loud like that made me able to do it." (Figure 6-17, Figure 6-18)

图 6-17　詹姆斯·利安那特设计 1
（图源自：Lienhart Design Company 公司网页）

图 6-18　詹姆斯·利安那特设计 2
（图源自：Lienhart Design Company 公司网页）

事情并不是一直就是这个样子的。利安那特从事设计这一行将近 50 年了。他有过机会在这些大公司工作，包括 Unimark，RVI 和 Murrie Lienhart Rysner；做过《美好家园·装饰》杂志的艺术指导；为一家新杂志《星球》策划标志；创立了一家贺卡公司，经历所有这些努力，他从中找到满足。但今天，在他自己五个人的办公室里，他干得可能比他以往任何时候都更努力。他寻找到真正的快乐。

他说："我一直都很快乐。虽然，在我的一生中有几次我觉得就要迷失自己了，有时候过了一阵子我才意识到。但我始终得重新找回自己的价值，不再试着总是取悦别人。"

能够改变方向，有时候转向完全不同的方向，当然是完全未知的事业，但却需要极大的信心。利安那特已经发现给了他最大信心的是征服了一件事情，这件事情曾难住了大多数人：就是害怕失败，或甚至是害怕犯错误。

"每个人都有这种害怕失败的恐惧。你不想被人拒绝，或看上去像一个愚蠢的人，比方说，如果你开了一家公司，然后又不得不卑躬屈膝地回来找你原来的工作。"利安那特说。像他自己一样，许多人都是在寻觅走一条安全之路的教育中长大的：找一份好工作，牢牢抓住它，攒钱，从中找到某些信心和快乐。

他说，然而这不是最明智的建议，

It wasn't always so. Lienhart has worked in design for nearly five decades. He has had the opportunity to work at major design offices, including Unimark, RVI, and Murrie Lienhart Rysner; to be the art director at Better Homes & Gardensand Lookmagazine; to develop the visual identity for a new magazine (*Sphere*); and to start a greeting-card company. In all of these endeavors, he has found satisfaction. But today, in his own five-person office, working harder than he possibly ever has before, he has found real happiness.

"I go by my happiness quotient. There have been times in my life, though, that I have felt like I was losing myself—sometimes it took a while before I realized it. But I always had to get back to my own values, and stop trying to please other people all of the time," he says.

Being able to shift direction, sometimes into radically different and certainly unknown courses, takes a great deal of confidence. Lienhart has found that what has given him the most confidence is overcoming the one thing that holds most people back: fear of failure or even of making a mistake.

"Everyone has this fear of failure. You don't want rejection or to look like a jerk, say, if you start a business and then have to come crawling back looking for your old job," Lienhart says. Like himself, many people were brought up to take the safe course: Get a good job, hold on to it, save your money, and somehow find confidence and happiness in that.

While this is not unwise advice, he says, it does not work

并不是对每个人都行得通。安全之路常常是迂回、曲折的。对这条路越熟悉，旅行者就会越害怕离开它，不管他或她喜不喜欢这趟旅行。

那就是为什么要把不知道变成知道，而且要尽可能做到恰到好处是如此重要的原因。"你可能会一切都以安全为前提，一直在寻找那条安全的小路。但要做任何真正值得去做的事情，在设计领域你就得冒些险，"利安那特说，又加了一句，"只有当你认识到你的生活价值是什么的时候，你才能开始冒险。"

人们怎样才能发现那点呢？做一点理疗是很好的，减少一点工作的时间，他说。远离了工作的负荷，你非常想做的事情就会浮现出来。这些事情的确就在每个人的内心深处，利安那特说，那些才是你生命中真正热爱的东西（图6-19、图6-20）。

通过各种各样的工作经历，利安那特发现他酷爱的事情是设计创造商

for everyone. The safe path is often a circuitous one. And the more familiar that path becomes, the more fearful the traveler is to leave it, whether he or she is enjoying the journey or not.

That's why it is so important to turn the unknown into the known, and to do this as expediently as possible. "You can get so damn security-based that you are always looking for the safe path. To do anything worthwhile, you have to take a few risks in design, " Lienhart says, adding, "You can only start to take risks when you realize what your life is worth."

How does one discover that? A little therapy is a good thing, as is taking time away from work, he says. Away from the demands of work, the things that you desperately want to do will emerge. Those things are really inside everyone, Lienhart says; those are your true passions in life (Figure 6-19, Figure 6-20).

Lienhart discovered, through his varied career experiences, that his passion was in creating brand identities

图6-19　利安那特设计公司作品1
（图源自：Lienhart Design Company 公司网页）

图6-20　利安那特设计公司作品2
（图源自：Lienhart Design Company 公司网页）

标和标志，解决所有真正具有挑战性的交流问题。但是，对他本人而言，更为重要的是与顾客之间的直接接触与沟通，最好是与公司的 CEO 或者总裁。多年以来，设计师们都是在做方案、做项目，在做方案期间，他一直都在努力取悦许多不同的经销人员、厂商经理以及委托代理人。

他解释说："这的确毫不客气地摧毁了我的信心，但是，我感到我现在已经克服这一切了。我想和有眼光的人合作。这是一种我想要的个人关系。他们尊重你，你也尊重他们。最后我们创作出大家都引以为豪的设计作品。"正如米尔顿·格拉舍说的："非凡的设计作品为优秀的顾客而做。"

但是，你怎样才能摆脱这种有损你快乐的情形呢？利安那特做了三件非常重要的事情来保护他自己。

敞开胸怀

首先，他意识到是他自己的价值观让他成为一名有创意、有价值的设计师，他必须坚持这些价值观。他以两次和顾客打交道的经历为例，来说明他为什么如此警觉。

第一次经历中，当时他在为一个大客户做商标方案。利安那特进行了许多研究、访问、信息收集，并且严格遵守客户要求的设计解决方案。但是，当他上交方案时，感到违背了他

and solving any really challenging communications problems. But even more important for him is to have direct contact with the client, ideally the company's CEO or president. For many years, the designer was working on projects in which he was trying to please many different marketing people, brand managers, and account representatives.

"It really destroyed my confidence briefly, but I feel I have it back now. I want to work with people who have vision. It is a personal relationship that I want. They respect you, and you respect them. We end up producing work that we can all be proud of," he explains. As Milton Glaser says, "Extraordinary design work is done for extraordinary clients."

But how do you get out of a situation that is detrimental to your happiness? Lienhart has done three very important things to protect himself.

Keep the Door Open

First, he realized that his own values are what make him original and valuable as a designer and he sticks to these values. He cites a pair of experiences with clients that illustrate why he is so vigilant.

In the first experience, he was creating a trademark program for a large client. Lienhart conducted plenty of research, interviews, and information collection, and adhered very strictly to what the client requested for the design solution. But when he presented the project, after contorting

自己的设计意愿，扭曲了他的作品，虽然做到与客户明确要求的规定一模一样，然而，他并没有得到赞扬。

"他们（客户们）说这是他们所看到的最差劲的作品，"设计师回忆道。"那是我说'不值一提吧'的时候。从现在开始，我要做我认为对客户最好的东西，如果他们无法理解为什么对他们合适，那么好吧……至少，我知道我给了他们我所能做到的最好的设计。"

利安那特以一种完全不同的方式及态度处理了另一次设计工作经历。很明显你不能总是那样做。现在，我要真正地花时间去了解我的顾客，理解他们的想法，然后再决定我是否适合这项任务。

当他20世纪90年代晚期离开莫里·利安那特·里斯尼的时候，他有过一次类似的经历，虽然不那么激烈。该公司有一个令人羡慕的包装客户，就像是奥斯卡·梅尔、克拉夫特、可口可乐那样的大人物。事实是某个品牌的消费品包装设计令人失望……的确是这样的。

"首先，你得意识到产品包装犹如'冰山一角'，它是一种表面的、能够看见的建议，整个公司都有赖于它的成功。因此，许多人热衷于包装设计就不足为奇。不用说，许多设计师、厂商经理、经销人员和CEO都会有某一点点他们的意图想要在最后设

himself and his work to exactly what the client specified, he was not met with applause.

"They said it was the worst work they had ever seen," the designer recalls. "That's when I said, 'Screw this.' From now on, I'm going to do what I think is best for the client, and if they don't understand why it's right for them, then fine... at least I know I gave them the best I could do."

Lienhart went into another experience with a completely different attitude. Obviously, you can't do that all the time. I now really take time to get to know my clients, understand their vision, and then decide if I'm right for the assignment."

He had a similar although less Draconian experience when he left Murrie Lienhart Rysner in the late 1990s. The firm had an admirable bouquet of packaging clients—heavy-hitters like Oscar Mayer, Kraft, and Coca-Cola. The truth is some brand consumer-packaging design sucks... it really does.

"First, you have to realize the package is the visible tip of the iceberg. The whole company depends on its success. So, is it any wonder so many people are interested in the package design? Needless to say, many designers, brand managers, marketing people, and CEOs all have a little something they want included in the final design. There have been a few—very few—package design assignments where you have a

计作品中体现的东西。在包装设计领域里,很少有,几乎没有可能,让你(设计师)有机会与关键的人一起合作完成设计。因此,离开莫里·利安那特·里斯尼设计公司的理由是很简单的。但我喜欢那里的人们。"

chance to work with the key person of vision. So, it was very easy to leave Murrie Lienhart Rysner. I really love the people there."

保留自己的空间

Keep Your Own Space

另一个多次挽救了利安那特思维的计划,最终让他自己独自经商、维持自己的设计公司、使他置身于当时他可能会产生许多关联的公司之外。在这儿,他做着自己的事(设计工作),为一群有选择性的客户完成方案,客户都与他有着长期的关系。结果表明这对他的新公司的发展极为有利。

Another plan that has many times saved Lienhart's sanity, and ultimately allowed him to go into business for himself, was maintaining his own office, outside of any organization he might have been involved with at the time. Here, he has done personal work and completed projects for a select group of clients with whom he has built long-lasting relationships. These have turned out to be very beneficial to his new office.

没有什么是合适的,或是最佳的时间来开个人的设计公司,利安那特说。重要的是要去行动。他建议道:"单干你也许会非常紧张,你也许没有任何推销能力,或者甚至刚开始没有生意可做。但最终你会找到解决方法的。"

There is no right or best time to get a personal design office started, Lienhart says. The important thing is to do it. "You might screw up on your own. You might not have any marketing ability or even any business to start with. But you will find a way to do it," he advises.

写下目标

Get It in Ink

最后,切实地写下你的目标,是让它们成为现实的第一步。当利安那特回想起他以前的日子,当他仅仅想象自己在城市里过着一种他想过的生活的时候,这样的梦想似乎不切实际,也不太可能。

Finally, actually writing down your goals is the first step in making them real. When Lienhart thinks back to his earlier days, when he imagined himself living the kind of life he wanted in the city, such dreams seemed neither practical nor possible.

"这样的创业目标，对你而言，必须是激动人心的，不仅仅是你应该或不应该做的事情。如果必要的话，休息几周之后，想明白到底什么是你真正想要的。认真想想什么才能真正使你快乐，把它写下来，然后就去做。回到家，继续做……"设计师詹姆斯·利安那特说："开始的唯一方法就是开始行动。"

"Such pioneer goals must be things that are exciting to you, not just what you should or should not do. Take a few weeks off, if necessary, to figure out exactly what it is you want. Think about what really makes you happy, write it down, and then do it. Come back home and move on it, " the designer James Lienhart says. "The only way to start is just to start."

思考题：

 1.请用英文简述詹姆斯·利安那特的设计创业经历。

 2.詹姆斯·利安那特做了哪三件事帮助自己创业成功？请用英文表述。

 3.请思考设计大师詹姆斯·利安那特的创业之路对你有哪些启发。

第 7 章　艺术设计与环保材料专题

CHAPTER 7　Topic on Art and Design and ECO Materials

[本专题导读]

近年来，生态环境（ECO）这个词已经成为一个流行语。显然，我们十分关注环境保护的问题，环保设计也已成为我们生活密不可分的一部分。作为设计师，应该将先进技术与传统技艺相结合，提高设计材料的利用率，采用清洁能源生产以及使用可持续的生产流程，使我们设计的新产品凸显出现代化高效、环保、新颖和智能的特点。本专题以图文并茂的方式解析环保设计材料的运用，结合中外实践型绿色环保设计的实例，突出环保设计对于我国当代以及未来艺术设计师的重要性，将环保设计理念融入我们今后具体的设计之中。

7.1 环保设计材料运用
Make good use of ECO Design Materials

教学范文中英文对照

人类进行艺术设计的历史，从某种角度讲也是一部不断发现材料、利用材料、创造材料的历史。随着近现代科学的发展，材料的生产和研究逐渐走上科学化轨道，以至形成了一个材料科学与工程新学科。每项设计工作中、设计师或工艺家都应当在使用材料时尽量考虑到材料科学，注重材料的科学知识，注重使用材料的科学性，这正是我们需要不断提升的。在相当长的历史时期内，对材料的认识和加工往往是经验性的，没有准确的定性、定量的科学界定，对材料多是一般性外在的描述和经验感受，而缺少科学的分析和把握。在现代工艺及生产中，特别是在艺术设计中仅仅靠一般经验已不能适应。如现代陶艺，虽然是手工制作，但陶艺设计师们对各种釉料的研究、陶土的研究配制已上升到化学科学的层次，不仅提高了

The history of art design of human being, to some extent, is also a history of material discovery, utilization and creation. With the development of modern science, the production and research of materials are becoming more and more scientific to the extent that a new subject of material science and engineering is formed. In every design, designers or artists shall take material science into consideration, pay attention to scientific knowledge of materials and scientific nature of material use as far as possible in the utilization of materials. We must improve such awareness. In a long historic period, the understanding and processing of materials are always experimental without accurate qualitative and quantitative scientific definition. Materials are mostly described externally and felt in experience, which lacks scientific analysis and grasp. Ordinary experience can no longer adapt modern technology and production, especially art design. For example, although modern ceramic art is hand-made, ceramic artists have reached a chemical science level in the research of different glazes and preparation of argil, which can not only improve the success rate, save raw

成功率和节省了原材料，而且能把握风格的变化和表现，从而能够创造出前所未有的作品。

materials but also grasp style change and expression to create unprecedented work.

材料的分类

设计师们进行分类和组织材料的方式，都将渗透到他们所做的设计实践和创造的作品中。设计师们对材料的识别、理解、命名与分组方式等进行考察、筛选并探索材料的潜能，考虑"全面"了解材料的可行方法，是非常好的一件事。

材料可以根据其机械性能进行分类和归档，设计师在考虑材料的预期功能时将对材料的机械性能进行评估。例如：

Ways of material classification and organization of designers will all penetrate into their design practice and created works. It is a good thing for designers to investigate the ways of material identification, understanding, naming and grouping, to screen and explore the potential of materials and to "comprehensively" understand feasible methods of materials.

Materials can be classified and filed according to their mechanical performance. Designers will also evaluate the mechanical performance of materials when they are considering expected functions of materials. For example:

图 7-1 金属环保材料 1

图 7-2 金属环保材料 2

强度： 材料可根据其抗压能力分为高强度材料和低强度材料。

Strength: Materials can be classified into high strength materials and low strength materials according to their compressive property.

刚度： 材料可根据其外加应力与弹性应变的比例分为硬度材料和弹性材料（图 7-1、图 7-2）。

Rigidity: Materials can be classified into hard materials and elastic materials according to their proportion between applied stress and elastic strain (Figure 7-1, Figure 7-2).

图 7-3　纺织环保材料 1

图 7-4　纺织环保材料 2

塑性：如果一种材料在受拉时具有塑性，就可以被称为具有"延展性"；如果在受压时具有塑性，那么则可以被称为具有"可锻性"。

Plasticity: If a type of material has plasticity when it is pulled, it has "ductility"; if a type of material has plasticity when it is pressed, it has "forgeability".

韧性：材料可以是坚韧或易碎的，这与材料在断裂前吸收多少能量有关。

Toughness: Materials can be tough or fragile, which is related to energy absorbed by materials before their breakage.

硬度：材料可以根据其表面抗凹陷能力的大小分为硬材和软材（图 7-3、图 7-4）。

Hardness: Materials can be classified into hard materials and soft materials (Figure 7-3, Figure 7-4) according to their surface anti-depression ability.

　　材料也可以根据其可能的功能或预期的应用进行分类，例如用于顶棚的材料可与用于地板表面、隔断等的材料分在一组。尽管这是用于实践的逻辑归档系统，但也能很好地发挥作用并促进具有创造性和更精彩的设计产生。

Materials can also be classified according to their possible functions or expected applications. For example, materials used in ceiling can be grouped together with materials used in floor surface and partition. Although it is a logic filing system used in practice, it can also play a good role and promote the creation of more creative and excellent design.

设计师也可能采用与材料科学定义相符合的分类和组织方法。使用这种方法来发现，单一材料可实现多种功能：木材可用作地板表面材料，但它也可能用作墙体或顶棚的饰面材料，它也许会因为其结构的完整性而作为一个装饰面，它可以被认为是温暖、持久耐磨的地板材料或需要精心打理的表面。但是，这种分类方法仍然属于预料之中，也有不符合这些定义的一些当代材料，例如由两种或两种以上材料制成的复合材料，或形状记忆合金，或压电陶瓷等为了应对环境保护而设计的"智能"材料等。

人们对数目庞大的材料进行分类，有的按材料的作用分为结构材料与功能材料两大类；有的按照材料在各行业中的不同用途分为建筑材料、电工材料、耐火材料、光学材料、感光材料、航天材料等；根据材料的不同物理性质又可分为高强度材料、导电材料、半导体材料、磁性材料、绝缘材料等；最通行的分类是按材料的化学属性分为金属材料、无机非金属材料和有机高分子三大类，有机高分子材料称为聚合物或塑料。

在艺术设计领域通常把材料分为两种类别。一是天然材料，指自然界中存在的原始材料。天然材料可以分为未经加工和已加工材料。未经加工材料如：木材（图7-5、图7-6）、石材、

Designers can also adopt classification and organization methods which meet the definition of material science. Use of such methods finds out that a single material can realize multiple functions. Wood materials can be used in floor surface or as a facing material of wall and ceiling. It may be used as a decorative surface for its structural completeness. It can be regarded as a warm, durable and wearable floor material or a surface which needs careful maintenance. However, such classification methods are still within expectation. There are also some contemporary materials which do not meet such definitions such as composite materials made from two or more kinds of materials, shape memory alloys, piezoelectric ceramics or other "intelligent" materials which are designed to response to the environment protection.

People classify huge quantity of materials. Some are classified into structural materials and functional materials according to their functions; others are classified into building materials, electric materials, fire-proof materials, optical materials, photosensitive materials and aerospace materials according to their usage in different industries; they can also be classified into high strength materials, conductive materials, semiconductor materials, magnetic materials and insulating materials according to their different physical properties; the most common classifications are metal materials, inorganic nonmetallic materials and organic polymer materials according to their chemical properties. Organic polymer material is also called polymer or plastics.

Materials are generally classified into two types in art and design. The first type is natural materials, which refer to original materials existing in the nature. Natural materials can be classified into unprocessed materials and processed materials. Unprocessed materials include wood (Figure 7-5, Figure 7-6),

图 7-5 木质环保材料 1

图 7-6 木质环保材料 2

图 7-7 纸质环保材料 1

图 7-8 纸质环保材料 2

图 7-9 高分子人工材料 1

图 7-10 高分子人工材料 2

天然漆等。加工材料如：纸（图 7-7、图 7-8）、橡胶、金属等。二是人造材料，指的是经过对自然材料化学性能、物理性能重新组合后的再造材料，如塑料、有机玻璃、化学纤维等（图 7-9、图 7-10）。

stone and natural lacquer, etc. Processed materials include paper (Figure 7-7, Figure 7-8), rubber and metal, etc. The other type is man-made materials, which refer to reconstituted materials after combing the chemical properties and physical properties of natural materials, such as plastics, organic glass and chemical fiber, etc (Figure 7-9, Figure 7-10).

材料设计与表现

材料设计的表现方法丰富多彩。设计的选材有一定的法则，更注重随机性和偶发性。在取材方面，设计者要根据需要去选择环保材料，

Expression techniques of material design are rich and diversified. Material selection of design has certain rules, which are more random and accidental. In material selection, designers shall select materials according to environmental

被选用的各种材料彼此有联系，应能够准确表达设计者的意图。诸如环境设计选材，一定要冲出思维定式，求新求异，超越常规。在室外，不同的自然光使物体产生不同的色彩效果和光影效果，晴天物体的颜色较鲜艳、明暗反差较大；阴天物体的颜色较灰暗，明暗对比较弱。我们一般根据设计创作的意境与情调来因时因地选景选材。

为了把设计思想明确而完美地表达出来，设计者要把握构图的要素。构图是材料设计创作的关键，它是对画面形象及结构的全面经营和探索。在构图时，始终要注意画面的均衡，并且要恰如其分地确定画面范围，以此来辅助作品的完美体现。构图形式上没有任何条条框框的局限，设计者应该充分发挥个人才智，抓住瞬间的灵感随机产生，在艺术设计领域里不断创新。

protection requirements. Different materials which are selected are related to each other and are able to express the intention of designer. For example, material selection of environmental design must get rid of mindset to innovate and go beyond the convention. Different natural lights outdoors will make things produce different color and shadow effects. Things are brighter with distinct contrast in light and shade in sunny days and they are darker with weak contrast in light and shade in cloudy days. We often select scene and materials according to specific artistic conception and sentiment of design creation.

Designers shall grasp elements of picture composition to express the design idea clearly and perfectly. Picture composition is the key of material design and creation. It is a comprehensive management and exploration of picture image and structure. Designers shall always pay attention to the balance of picture and confirm the range of picture accurately in picture composition to support the perfect reflection of work. There is no restriction in rules and regulations in the form of picture composition. Designers shall give full play to their own intelligence, grasp momentary inspiration and create continuously in art and design.

思考题：

1. 请用英文解析环保材料"强度"与"刚度"的差异。

2. 请采用双语表述方式，列举六种环保设计材料。

3. 建议进行一次设计材料考察，将收集到的材料名称分别用中英文双语标注，自制一张实用的设计师材料对照表。

7.2 环保设计作品展示
Exhibition of ECO Design Works

环保性质与标识（中英文对照）（表 7–1）

环保性质与标识（中英文对照） 表 7–1

环保性质（中文）	环保性质（英文）	标识符号
可生物降解	Biodegradability	
节能	Energy Saving / Low Waste	
低损耗	Low Loss	
可回收再生	Recyclable Regeneration	
回收利用	Recycling	
无毒	Non–toxity	
公平贸易	Fair Trade	
可持续性	Sustainability	

环保设计实例之一

环保设计点评：Surfin 系列的产品都是使用经 FSC 认证、100% 不含甲醛的白桦胶合板制成的，并以环保无毒的水基燃料和防紫外线的抛光漆进行染色，将温室气体的排放量降到最低。这款 Ecotots Surfin 儿童桌设计旨在提高儿童独立学习的能力（图 7–11、图 7–12）。

ECO Design Review: Certified by the FSC, the Surfin series of products is made of formaldehyde-free birch plywood and dyed with environmentally friendly non-toxic water-based fuel and UV-proof polishing varnish, keeping greenhouse gas emissions at the minimum level. This Ecotots Surfin Children's Table is designed to develop children's ability of independent learning (Figure 7-11, Figure 7-12).

图 7-11 Ecotots Surfin 儿童桌设计（火焰色）　　　图 7-12 Ecotots Surfin 儿童桌设计（苹果绿）

（Inmodern 公司专利产品，图片来源：www.baidu.com 网站）　（Inmodern 公司专利产品，图片来源：www.baidu.com 网站）

环保设计实例之二

环保设计点评：Paperpod 的硬纸板家具的美丽之处在于它的朴实无华，这款座椅看似外表很普通，其最大的优势在于可以让孩子自行绘画及装饰，由此激发孩子的想象力，采用节能、低损耗、无毒、可回收利用的环保材料（图 7-13）。

ECO Design Review: Paperpod's cardboard furniture distinguishes itself with simplicity and unadornment. The chair looks very ordinary, but its biggest advantage is that it enables children to paint and decorate freely so as to arouse their imagination. It is made of energy-saving, low-loss, non-toxic, recyclable and environmentally-friendly materials (Figure 7-13).

图 7-13 Paperpod 学步椅

（Paperpod Carboard Creations 公司专利产品，图片来源：www.baidu.com 网站）

环保设计实例之三

环保设计点评：这款花卉灯饰为 David Trubridge 公司的专利产品，体现了一种优雅而朴素的审美观。灯罩是采用可持续利用的胶合板数控切割而成的，极大地减少了材料浪费，并采用天然、无毒的环保油料，可谓是用最少的材料达到最佳的效果（图7-14、图 7-15）。

ECO Design Review: This flower lamp is a patent product of David Trubridge. It highlights an elegant and simple aesthetic perception. The lampshade is made of sustainable plywood by way of numerical control cutting, which greatly reduces the waste of material. The use of natural non-toxic environmentally-friendly oil achieves the best effect with the least amount of materials (Figure 7-14, Figure 7-15).

图 7-14　平板包装绘画灯饰设计
（David Trubridge 公司专利产品，图片来源：www.baidu.com 网站）

图 7-15　平板包装绘画灯饰设计（使用效果）
（David Trubridge 公司专利产品，图片来源：www.baidu.com 网站）

环保设计实例之四

环保设计点评：江西服装学院主办的"环保创意服装设计展"，所有参展作品均从美化环境为出发点，有的作品采用"可生物降解"的材料设计，在使用后可回归土壤并被其他生物降解；有的作品采用"可回收再生"的材料设计，在使用后可作为一种未经

ECO Design Review: On the "Environmental Creative Clothing Design Exhibition" organized by Jiangxi Institute of Fashion Technology, all the works give the top priority to environmental beautification. Some are designed by biodegradable materials which return to the earth after use and are degraded by other creatures. Some are designed by "recyclable regeneration" materials which can be used as

图 7-16　江西服装学院主办的"环保创意服装设计展"作品 1（将废物再加工以创生再利用价值与锻炼设计审美能力）

图 7-17　江西服装学院主办的"环保创意服装设计展"作品 2（将废物再加工以创生再利用价值与锻炼设计审美能力）

加工过的原材料使用，有助于进一步降低对环境的影响；有的作品采用竹子等可再生资源的原材料设计等。这些设计再加工"变废为宝"，创生了材料的再利用价值，同时，提高了设计水平与审美能力（图 7-16、图 7-17）。

unprocessed raw materials after use to help further reduce the impact on the environment. Some are made by renewable resources such as bamboo. These designs and reprocessing turn the waste into wealth, thus, these make the materials recyclable and improve the design level and aesthetic perception in the meantime (Figure 7-16, Figure 7-17).

环保设计实例之五

环保设计点评：茶文化是中国传统文化中的一颗明珠，源于神农，闻于周鲁公，兴于唐朝，盛于宋代。早在我国汉代的文献中已有"茶具"记载，在唐诗中更是举目可见。茶具有助于提高茶的色、香、味，一件高雅精致的茶具，不仅具有实用性，更是

ECO Design Review: Tea culture, as a bright pearl in traditional Chinese culture, was sourced from Shennong (a supreme tribal leader in ancient China), emergent during the reign of the Duke Lu of Zhou Dynasty, and flourishing in Tang and Song Dynasties. "Tea sets" were first recorded in the literature of Han Dynasty and widely mentioned in the poems of Tang Dynasty. Tea sets help improve the color, aroma and

图 7-18　中国原创的环保茶壶设计（采用低损耗的设计材料）

一件艺术欣赏品。制造茶具的材料多种多样，唐代曾有金属材质、玻璃材质的茶具，到明清时期盛行紫砂材质、竹木材质的茶具等。这款现代研发的中国原创茶壶正是凝聚了我国以往制造茶具的经验，采用"低损耗"的设计材料，将最佳的现代技术与传统手工技艺相结合，通过材料的巧妙运用来减少产品生产过程中产生的废料，外观设计上保留了传统茶具的质朴大方之美（图 7-18）。

taste of tea. In particular, an elegant and exquisite tea set serves as both a practical item and an artwork. Tea sets can be made from a variety of materials, ranging from metal and glass in Tang Dynasty to the popular dark-red clay and bamboo in Ming and Qing Dynasties. The modern research and development of this original Chinese teapot has integrated the experience of tea-ware making in China. The teapot, with its "low-cost" design materials, is a perfect combination of modern technology with traditional craftsmanship. Such a combination reduces waste generation in the production process by ingenious application of materials, while retaining the simple and elegant beauty of traditional tea ware for appearance design (Figure 7-18).

思考题：

1. 请用英文解析"ECO Design"的特点与理念。

2. 请用中英文双语表述环保创新设计的八种性质与标识符号。

3. 请用英文谈谈如何以关爱环境的态度来设计创新环保作品。

第 8 章　艺术设计流程与管理专题

CHAPTER 8　Topic on Process and Management of Art and Design

[本专题导读]

8.1 关于工业设计流程
Work Process of Industrial Design

教学范文中英文对照

现代设计的应用越来越广泛了，这是很值得高兴的事，但与此同时有些地方设计似乎正在退步。

起初，设计任务对于很多公司来说还是比较特殊的任务。诸如：很多产品的问题都是和工厂经理或 CEO 一起处理和解决，客户会将公司策略和目标清晰地表述出来。

设计的应用现在已扩展，但同时也变得平凡。有些公司购买设计服务的部门，甚至和为公司购买小零件的部门竟然是同一个部门，他们完全不需要了解设计是什么。价格本身开始指导决定，当竞争包含价格，这也同时影响了用在工作上的时间。结果是，调研及背景工作，特别是最终产品的质量会被牺牲掉。某些公司的设计活动被安排得像体育竞赛一样，这显示出一种价值上的转变。24 小时马拉松无论如何不可能提供对于生产要求或

The application of modern design is becoming more and more widely, it is a thing which is worth of happiness. However, at the same time, the designs appear to fall behind in some places.

At first, the task of design is a special task for many companies. For example, the problems of many products are solved by the plant manager or the CEO of the company, and the client will state the strategies of the company clearly.

Design application has been extended nowadays, but it also became a thing of commonplace. In some companies, the department which is charge for buying the design services is even the same department with the department which is responsible for buy the small parts, and they don't know what the design is completely. When the price begins to guide the decisions, when the competition concludes the price, it will affect the time spent on working. As a result, the research and the background, especially the quality of the final product will be sacrificed. The design activities of some companies are arranged like a sports contest, and that shows a kind of value transformation. 24 hour of marathon could not provide the

者产品耐用度方面的评估，而这些对于工业设计师来说，都是他们工作里的核心部分。

　　早期关于工业设计的书中会把工业设计流程归纳为以下几步：市场调研、草图创意、方案深入、讨论定案、2D 效果图表现、3D 效果图表现、结构分析、手板样件、量产。这样的结构是非常不符合逻辑的，它把思考的过程简化成了直线，现实中的问题不可能没有反复就都能得到解决。而那些通过极快速度设计出来的产品所运行的恰恰是这样的流程，他们完全不给思考的过程留出时间和机会，不排除会出现一两次灵感澎湃而产出好设计的情况，但不可能每次都做到。

　　在此，介绍比较贴近现实而有效的工业设计流程。当接到设计工作的时候，我们首先考虑用户的需求，然后是针对制造者、经营者作大量的背景调查与前期调研工作，搞清楚各个相关方面所关心的问题，也为接单找到理由。比如说，用户关心的是产品是否舒适、安全、能不能用、有什么功能；制造商关心的是生产成本、产品质量、服务、技术、环境成本等；经营者关心如何维护、生命周期有多长、经营成本、是否可持续、经营质量及可靠性、竞争力、效率、品牌、用户跟踪等；而社会则关心公共服务、法律法规、市容市貌等。把这些不同角度的问题都放在一起，归纳出大致

requirements of productions or product durability assessment. However, for an industrial designer, all of these things are the core parts of their work.

Early books on industrial design will summed up the industrial design process as the following steps: market research, sketch creativity, further plan, discuss the finalized, 2D rendering performance, 3D rendering performance, structural analysis, hand samples and mass production. This structure is very illogical, and it reduces the process of thinking to a straight line. However, the real problem can't be resolved without working over and over again. While those products designed of extremely fast speed are running by such process, they do not leave any time and opportunity for thinking, there might be one or two good inspiration surging and output design, but it can't work every time.

Here, this paper introduces the effective industrial design process which is more close to the real world. When receiving the design work, we should consider the needs of users firstly, and then we should do a lot of background investigation and research work for the needs of manufacturers and operators, too. It is to clear up the related problems, and it is also a reason for the order. For example, the users are always concerned about if the product is comfortable or not, safety, if the product can work or not, what is the function. The manufacturers are always concerned about the cost of production, product quality, service, technology and environmental cost, etc. The operators are concerned about how to maintain it, the life cycle, the operation costs, if it is sustainable, operation quality and reliability, competitiveness, efficiency, brand, user tracking, etc. However, the society is caring for the public service, the laws and regulations, the city's appearance. Put these things together, summing up the

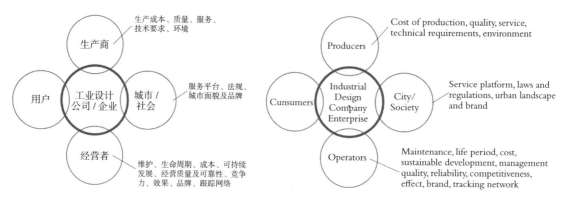

图 8-1　工业产品设计互联图（中文）　　　　图 8-2　工业产品设计互联图（英文）

的轮廓和所有要满足的条件，然后才开始进行设计（图 8-1、图 8-2）。

同时，设计的过程是反复地尝试新想法、实验、模型，不断地和客户沟通，与所涉及的各方面沟通，直至找到一个满足各方要求的解决方案。简而言之，就是进行大量的前期调查分析，甚至采用"笨鸟先飞"的方法，不断地寻找最佳解决方案直至问题解决。没有捷径，唯有务实，有时最直接的方法是最有效的。

outline roughly to meet the conditions, and then the design can be started (Figure 8-1, Figure 8-2).

At the same time, the process of design is a process which is full of trying new ideas, experiments, models, and constantly communicating with the customers, and the communications with all aspects, until you find a proper solution to meet all of the requirements. In short, it needs a large number of prophase investigation and analysis, and even the using the method of "A slow sparrow should make an early start". That is to make a constantly looking for the best solution for the problems. There is no shortcut, only being pragmatic, is the most direct and most effective method sometimes.

思考题：

1. 请用英文专业用语表述出早期工业设计流程的主要环节。

2. 请用中英文双语解析生产商 Operator 的五个基本工作步骤。

3. 结合相关设计经历，谈谈如何通过沟通达到各方满意的设计过程。

8.2 品牌管理与视觉信息设计
Branding Management and Visual Information Design

教学范文中英文对照

在 21 世纪，我们的世界观比以前更依赖于视觉冲动。与此同时，我们需要面对电子媒体带来的越来越多的过剩信息。因此，我们有必要建立一种心智过滤系统，或者是感知思维系统，以帮助我们在面对信息和感官刺激的时候依然能够作出明智的决定。对于市场上的任何产品，如果没有图形设计元素几乎是不可能的。诸如用户界面设计、图形、包装、各种宣传手册都与图形设计息息相关。如果希望获得成功，所有的产品及物件都必须在图形方面精心设计，因为它们会影响到信息结构的承载与传播。

图形设计师的首要任务就是要运用个人的心智模式，或者，至少影响个人积极地从过去的经验中提取能够触类旁通的信息。然后，掌握品牌管理与视觉信息设计是非常重要的（图 8-3、图 8-4）。

In 21th Century, our perception of the world is much more dependent on visual impulses than ever before. At the same time, we have to deal with a plethora of sources of information, increasingly distributed by digital media. Therefore, it is necessary to develop mental filter systems, or mechanisms of perception through which individuals can continue to make sound decisions about the information and perceptual stimuli presented to them. It is nearly impossible for any product or service to be available on the market without a graphically designed element. User interfaces, pictograms, packaging, all kinds of manuals are all graphically designed. To be successful, these offerings have to be well designed and thought through in terms of their graphical impact and how the information they contain is structured.

It is the graphic designer's first task to use an individual's mental models, or at least to positively influence the accrual of such cognitive representations of meaning. Then, it is important to master the Branding Management and Visual Information Design (Figure 8-3, Figure 8-4).

图 8-3　视觉品牌信息与建筑环境整体化效果

图 8-4　视觉品牌与建筑立面结合的传播方式

从历史上来看，图形设计起源于应用艺术。它扎根于海报艺术家以及标志设计师们。然而，当今的图形设计师有两大活跃的领域，这两个领域的边界是模糊而机动的。一方面，品牌管理是在客户们心目中建立一种视觉识别和形象熟知度。因此，图形设计师从客户已有的心智模式入手，比如，在包装罐上使用绿色，给客户营造出一种新鲜、有机、环保的感觉。另一方面，视觉信息设计将复杂和抽象的内容简约化，通过逻辑构成、视觉层次结构以及使用视觉隐喻手法，使消费者能够更好地吸收和理解商品信息（图 8-5~ 图 8-8）。

Historically speaking, graphic design has its origins in the applied arts. It has its roots in the professions of poster artists and sign designers. However, today there are two big fields of activity for a graphic designer, while boundaries of these two fields are fluid. One the one hand, branding management refers to helping an offering establish a visual identity and familiarity in the eyes of customers. Thus graphic design taps into and adopts a number of patterns of which the customer already has a mental model: use of the color green in packaging can, for example, suggest an association with the user's ideas of freshness, organic products or, more recently, environmental friendliness. Visual information design, on the other hand, pertains to the task of making complex and abstract content accessible in a simpler way. Through logical composition, visual hierarchy and the use of visual metaphors, customers are supported in their absorption and comprehension of commodity information (Figure 8-5-Figure 8-8).

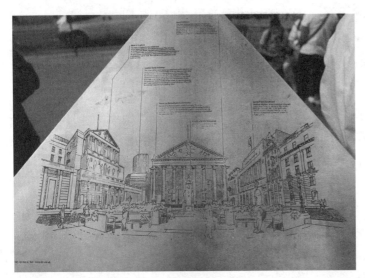

图 8-5 信息导视 1

图 8-6 信息导视 2

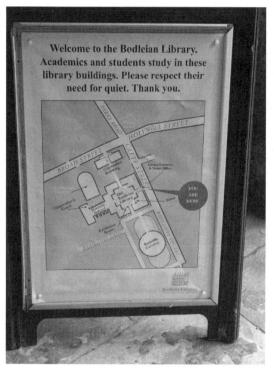

图 8-7　信息导视 3

图 8-8　信息导视 4

　　品牌管理能够从情感上拉近客户与设计主题，或者相似情感经历之间的距离。在此基础上，视觉信息设计引导一种令人满意的、契合客户的经验。品牌管理和视觉信息设计并不对立，其实它们高度地彼此依赖。尽管如此，品牌管理和视觉信息设计有不同的侧重点。毫无疑问，品牌管理是市场定位的重要组成部分，它能够营造氛围，促使客户认知并考虑接受。视觉信息设计则在设计服务过程中具有更大的潜在显性影响力。它改变社会处理信息的方式，并能够影响客户感知服务的价值，或者说，它在服务提供者和服务接受者之间的"传递信

Branding management supports the customer to emotionally approximate himself with the design theme or similar emotional experience. Within this setting, visual information design leads to a satisfactory and positively associated user experience. Branding management and visual information design are not opposed to each other. Nevertheless, these two fields have different focuses. There is no disputing that branding management is an essential part of market positioning, as it creates the atmosphere that motivates the user to become aware of and consider the offering in the first place. Visual information design has far greater underlying and explicit influence in the service design process, since it changes how society handles information, and moreover has the power to affect users' perceptions of the value of a service proposition or indeed of any of the information transfers

图 8-9　信息导视 5

图 8-10　信息导视 6

息"环节的体验中有着举足轻重的作
用（图 8-9、图 8-10）。

　　我们需要考虑取向性和可靠性的
需求。适应这种思维定势是必要的。
如果视觉设计呈现出凌乱状态，那么，
何以令人们相信清洁服务是真实的
呢？在线工具如果不能和网络视觉语
言接轨，或者使用了十年前的网络美
学与视觉设计语言，那么它的可信度
又能有多少？至少，在潜意识上，视
觉交流时遇到不好的或者不一致的图
形设计时，一种负面的情绪会由此产
生。现今社会，客户有着一种强烈的
感觉，希望将产品和服务渗透进日常
生活中去（图 8-11、图 8-12）。

　　视觉信息起着重要的作用。它
先于实际的服务流程，控制着客户的
期望值，并且，能够在交互过程中促
进信任。所谓外观和感觉，可以唤起
一种积极的情绪，甚至通过视觉信息
设计的帮助使服务可行。最后，视觉

between service provider and the service recipient that is
integral to the service experience (Figure 8-9, Figure 8-10).

　　We need to think of orientation and reliability. It is
necessary to accommodate this mind set. How authentic is a
cleaning service whose visual design presentation is it messy?
How much trust is warranted for an online tool that appears
inconsistent with the Internet's visual design language, or
uses web aesthetics that are ten years old? A negative feeling
occurs, at least unconsciously, if one encounters bad graphic
design or disparities in visual communication such as those
mentioned above. Customers today have a strong sense of
how a product with service components can be integrated
into their everyday life (Figure 8-11, Figure 8-12).

　　Visual information plays an important role. It preempts
the actual service process, it controls customer expectation,
and it can promote trust during interaction. The so-called look
and feel can evoke a positive prevailing mood, or even makes
the service usable in the first place through visual information
design assistance. Lastly, the visual appearance acts as an

图 8-11　信息导视 7

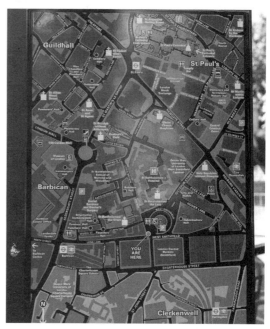

图 8-12　信息导视 8

图 8-13　KACHIKACHI 旅游特产软件
界面信息导视 1
（设计者：郑昱、林伟伟）

外观充当着连接客户与积极体验的桥梁。因此，视觉信息设计是设计构想的关键组成部分（图 8-13~ 图 8-15）。

anchor that links the user to the positive experience. Visual information design is henceforth a key competence in the conception of design propositions (Figure 8-13-Figure 8-15).

图 8-14　KACHIKACHI 旅游特产软件界面信息导视 2
（设计者：郑昱、林伟伟）

图 8-15　KACHIKACHI 旅游特产软件界面信息导视 3
（设计者：郑昱、林伟伟）

现在，信息是设计的关键。设计师，包括新定义的信息设计师和信息架构师，扮演着一个重要的角色。我们作为阐述者，不仅仅是发送者和接收者之间的直译。我们所说的，和我们怎么说，会对艺术设计作品产生不同的影响。如果我们要和客户交谈，我们需要知道他们的语言与需求。为理解而做设计，我们必须懂得设计。对于图形设计师来说，无论对象是产品还是服务，为了充分地表达设计的构想与理念，都需要是严谨的、经过深思熟虑的设计过程。

These days, information is the key of design. And designers including the newly defined subset of information designers and information architects have a responsible role to play. We are interpreters, not merely translators, between sender and receiver. What we say and how we say it makes a difference for art design works. If we want to speak to customers, we need to know their language and needs. In order to design for understanding, we need to understand design. For graphic designers, it does not matter if they are working on a product or a service offering in order to adequately convey the thoughts and concepts of design proposition.

思考题：

　　1. 请用双语方式表述"品牌管理"对于设计的重要性。

　　2. 请用英语解析"视觉信息设计"的作用与意义。

　　3. 请用英文撰写一篇关于 21 世纪设计师责任的感想短文。

8.3 设计管理与品牌创新实例之一
Living Examples of Design Management and Brand Innovation I

教学范文中英文对照

实例之一：如何创造速溶咖啡的新观念

当今，让新产品开发厂商最为担心的问题之一：新产品开发出来推向市场时，消费者却不了解，也不认同。每一年，全世界的生产厂家大约开发数十万种新概念产品或者新设计产品，其中有 80%~90% 都未能被消费者接受，最终惨遭淘汰。我们分析其中原因当然很多，但是，开发厂商的推销思路与消费者的接受度不同步可能是最普遍的原因了。

可以说，每种产品都会投射出某种形象，开发及生产厂商也可以通过品牌策划让它投射出某种形象。通常对于消费者不喜欢的形象，产品研发者总想方设法地予以克服、掩盖，而对于消费者喜欢的形象，则加以强化、展示，使之利于产品销售，这种做法，

Example One: How to Create a New Concept of Instant Coffee

Today, one of the most worried problems of new product developers is that when the new product comes out to the market, consumers do not know and accept it. Each year, almost hundreds of thousands of new concept products or new design products are developed all over the world, but eighty to ninety percent of which are not accepted by the consumers and were washed out finally. Of course, there are many reasons, but the most common reason is that developers' marketing ideas is not synchronized with the consumers.

It can be said, each product has its own image and developers and manufacturers can endow it special brand image through brand planning. In general, developers should try to overcome and cover the image that consumers do not like, while strengthen and show the image that consumers like, which benefits selling, this called project positioning.

就称之为投射定位。

　　我们在进行投射定位时，判断消费者是否喜欢某一形象，还比较容易。主要困难在于有时候即使知道消费者不喜欢某一形象，却难以究其原因，甚至连当事人也不清楚。

　　在此，我们希望讲述关于消费新观念的典型实例——传统咖啡与速溶咖啡（图 8-16）。

　　一直以来，西方人对于咖啡的制作极为讲究。传统咖啡的冲泡方法主要有：虹吸式冲泡法、滤纸式冲泡法、滤布式冲泡法、水滴式冲泡法等。采用这些方法冲泡咖啡不仅费时、费力，而且对咖啡等原材料浪费较多，经济成本也相当高，其中滤纸式冲泡法是由家庭主妇为了省时省力而发明的实用方法（图 8-17）。

　　为此，生产厂商研发出"速溶咖啡"，预想这种新产品投入市场以后必

When positioning, it is easy to estimate whether consumers like some certain image or not. The main problem is that though we know consumers do not like some image, but it is very hard to find the reasons, even the consumers themselves do not know clearly.

In this book, we hope tell typical examples on the new concept of consumption—traditional coffee and instant coffee (Figure 8-16).

The westerners are very particular about making coffee all the time. The traditional coffee brewing methods are: syphon type, filter type, filter cloth type, drop-style brewing method. Using these methods not only time-consuming, laborious, but also waste material and cost highly. The filter type brewing method is a practical method that was invented by housewives to save time and effort (Figure 8-17).

For this reason, manufacturers developed the "instant coffee", and expected that it will be popular and benefit

图 8-16　传统咖啡制作（耗时耗力）

图 8-17　传统咖啡制作——滤纸式冲泡法

定大受欢迎,会带来丰厚的盈利。因为,速溶咖啡很适合现代人的快节奏生活之需,提供便捷、省时、高效的冲泡方法,而且在价格上也远远低于传统咖啡。于是,生产厂商在这个新产品上花费巨资,以各种媒体的形式宣传该产品。

然而,出乎意料的是速溶咖啡的市场销量竟然寥寥无几。尽管传统咖啡的广告比率远远少于速溶咖啡,但是,占据整个市场销量之冠的是传统咖啡。显然,对速溶咖啡的广告宣传在某方面出现了问题。生产厂商立刻请来了消费心理学家对此现象进行研究。消费心理学家采用了问卷调查法,对消费大众进行调查。问卷首先询问消费者是否使用速溶咖啡,然后再问那些回答说“不”的人为什么不喜欢。结果,大部分人都回答说:“我们不喜欢这种咖啡的味道。”

这一结果让厂家深感奇怪,因为经过科学方法的测试,这一速溶咖啡与传统咖啡在味道上并无区别。毫无疑问,被调查者讲的并不是真正的理由。看来,一定有某种连当事人也不十分清楚的原因,影响了速溶咖啡的形象。

于是,消费心理学家又采取了心理学调查的“投射”技术,为家庭主妇们设计了两张购物表,并把它们拿给不同的女士看,让她们按自己的想象描述两位“家庭主妇”的个性特征。

心理学家所设计的两张购物表区别不大,在表中绝大部分项目都相同,

a lot when the new product put on the market. Because instant coffee meets the need of modern people's rapid pace of life, which provides convenient, time-saving and efficient brewing method and its price is lower than traditional coffee. Thus, manufacturers spend and advertise a lot in this new product.

However, unexpectedly, the market sale of instant coffee is low. Though the traditional advertise rate is far less than instant coffee, but traditional coffee dominate the market. Obviously, the advertisement of instant coffee has some problems. The manufacturers immediately invited psychologist to study the phenomenon. The psychologist uses questionnaires to survey the consumers. Firstly, questionnaires ask whether the consumers use instant coffee, then ask the people who replied "no" why they do not like instant coffee. As a result, most of them replied that "We do not like the taste of instant coffee".

The manufacturers feel strange about the result, because instant coffee and traditional coffee is no difference in the taste according to the scientific tests. There is no doubt that the respondents are not replied the real reason. It seems that there must be some kind of reasons that consumers are not clear, which influence the image of instant coffee.

Thus, psychologists use project technique of psychology investigation to design two shopping lists for housewives, show them to different ladies and let them describe the characteristics of two housewives according to their imagination.

There is a little difference between the two shopping lists, most of the items are same, but only one item is

另有一项极为不同，那就是：表一中主妇购买的是速溶咖啡，而表二中是新鲜咖啡。然而，就这一项差别，使接受测试的女士们对这两位假想中的家庭主妇的个性特征，描述上也就有了很大的差异。她们把那个买速溶咖啡的主妇描述成一个懒惰、喜欢凑合、不怎么考虑家庭的妻子，而把那位买新鲜咖啡的主妇描述成勤快能干、喜欢料理家务、热爱家庭的妻子。

这恰恰找到了连当事人都无法察觉的不喜欢速溶咖啡的真正理由。

这项调查结果使厂家非常吃惊。原来，他们在广告中宣传的速溶咖啡"便利、省时"的优点，却被消费者看成是缺点了，因此，新产品速溶咖啡给人们留下的印象是消极的，而非积极的。由此，生产厂商真正意识到，当务之急是创建产品消费的新观念，速溶咖啡需要一个受人们欢迎的新形象了。在接下来的广告宣传中，完全避开了原来在消费者心目中形成的便利、省时的"消极形象"，转而，着重强调速溶咖啡所具有鲜咖啡的味道和芳香，与传统咖啡的味道一样。

随后，在杂志的整页广告中，可见一杯咖啡后面放上一大堆棕色的咖啡豆。我们也在速溶咖啡的包装上见到这样的广告语："百分之百的纯咖啡。"不久，速溶咖啡的消极形象逐渐被淡化了，人们在不知不觉中开始接受了速溶咖啡真正创新的特点：高

different: table 1 is instant coffee while table 2 is fresh coffee. However, this point makes a difference when respondents describe the characteristics of two housewives. They describe the housewife who buy instant coffee as a lazy, improvised and care less about family, while describe that who buy fresh coffee as a diligent, capable and love her family.

That finds the real reason that even the consumers do not know why they do not like instant coffee.

The finding surprises manufacturers. It turns out that the advantage of instant coffee that convenient and time-saving in the advertisement was seen as a disadvantage from the consumers' point of view, so the new instant coffee give people a negative impression rather than positive. Thus, manufacturers realize that they need to create a new concept of the product and the instant coffee needs a new image that people welcome. The following advertisement should completely avoid the originally negative image that convenient and time-saving in consumers' mind, instead, emphasis the taste and aroma of the instant coffee, which is as same as the traditional coffee.

Then, we could see whole pages advertisements which would show a cup of coffee in front of a pile of brown coffee beans from all kinds of magazines. On the instant coffee packaging, we also could see advertising language like "one hundred percent of pure coffee." Soon, instant coffee's negative impression is gradually weakened. People unconsciously begin to accept the truly innovative features

图 8-18　以纯咖啡豆为背景的速溶咖啡推广 1

图 8-19　以纯咖啡豆为背景的速溶咖啡推广 2

效及时、省时省力等。新产品速溶咖啡也成为世界各国销量最大的咖啡之一了（图 8-18、图 8-19）。

of instant coffee such as a saving of time and labor. Instant coffee, the new product also becomes one of the largest coffee sales around the world (Figure 8-18, Figure 8-19).

思考题：

1. 什么是"投射定位"？请用英文加以说明。

2. 请用英语解析一开始"速溶咖啡"不能被人们认可的原因。

3. 开发商采用了怎样的品牌管理措施来解决难题，请采用双语方式表述。

8.4　设计管理与品牌创新实例之二

Living Examples of Design Management and Brand Innovation Ⅱ

教学范文中英文对照

实例之二：市场调研是新产品开发的安全带

Example Two: Market Research in the Life Belt of New Product Development

20 世纪 80 年代后期，在市场调研的帮助之下，菲利浦照明公司成功开发了"温和色彩"的新系列灯具。这款新产品设计是通过开发一种能用静电涂在灯泡内侧的颜料来实现的，这种灯具被称为"温和色调"。

首先，新产品投放之前，菲利浦公司安排了周全的市场调研，用以确定这种新灯具是否因为其灯形状新颖、光影淡青、色光柔和而对顾客有巨大吸引力。这项调查包括确认顾客是否会对这种新型灯具设计有多付费的意愿。

在新产品投放前阶段，必须考虑以最佳方式向顾客展示该产品，还要有足够的被访者做一系列问卷答复。这对定价问题是特别重要的，仅仅从

In the later phase of 1960s, with the help of the market investigation, Philip Lighting Company successfully developed new series of the lights with "warm color". Such new product design was realized through developing the pigment that could be applied inside the bulb with the static electricity. Such light was named as "mild hue".

First of all, before the introduction of the new product, Philip Company arranged comprehensive market investigation to confirm whether this new light could attract many customers due to the novel appearance of the light, shadow light greenish blue, and mild colored light. Such investigation includes confirming whether the customers are willing to pay more cost for such new light.

In the early phase of the new product launching, it is necessary to consider displaying the products to the customers with the best method. Besides, it requires efficient respondents to do a series of questionnaire. It is quite

一个小组讨论或少量深度访问所得的指导意见是不够坚定可靠的。菲利浦照明公司曾对户主做了二百次以上面对面的访谈，要求他们在逼真的展示环境中检验这种新产品。随机抽取的200名购灯者组成的一个样本，可以期望产生70%的精准度，这对生产厂商今后的决策是很有帮助的。

通过早期的调研结果表明，新设计的方形灯颇受大众欢迎，因为它的色彩设计多种多样，与众不同并且超凡脱俗。调研样本中有接近80%的受访者说：尽管传统有色灯具的销量相当低，但是，对于这款"温和色调"系列灯具他们会相当喜欢，并且非常乐意购买这种有色灯。让新产品开发商和调查员都意想不到，真正将这款新产品投放市场时会达到这么令人满意的效果。正是这一淡青色想法令人们兴奋，而略微超出的价格也让多数人接受了。

接下来，就是为新产品设计一种适用的包装。为此，菲利浦照明公司专为女士进行了集中调研，因为她们是购买灯具等家庭装饰的主要群体。公司先派了四个小组去评判，按实物大小制作包装的可接受性。每个组都带回了同样的报告书：要求包装能显示这款灯具的独特形状，外包装上写有清楚的照明瓦数，用恰当的描述表明在家中颜色协调的可能性。由此，使新产品的促销、定价和包装等环节都完成得相当成功。

important to the pricing problem. The guidance opinion from the group discussion or a little in-depth discussion is not firm and reliable. Philip Lighting Company has conducted face-to-face interview towards the households for over 200 times, and required them to check this new product under the vivid exhibition environment. A sample composed of 200 light purchasers randomly selected can be expected to generate 70% accuracy, which is quite helpful for the manufacturers to make decision in the future.

The early-phase investigation result indicates that, the square front lamp with the new design is quite popular with the public, as its color design is so diversified, different from others and extraordinary refined. In the investigation samples, about 80% respondents said that, although the sales of the traditional colored lights was relatively low, this series of lights with "mild hue" greatly attracted them, and they were quite willing to buy them. To the new product developers and investigators' surprise, inputting this product into the market achieved satisfying effect. The idea about the nattierblue made people so excited, while the slightly higher price was accepted by most people.

Next, design a proper package of the new product. For this purpose, Philip Lighting Company specially carried out investigation towards the female, as they were the main group for purchasing the home decoration, such as lights, etc. The company firstly dispatched four groups for judging the acceptance of package made according to the size of the entity. Each group brought back the same reports: require the package to show the unique shape of this light, clearly state the wattage on the outer package, and properly present the possibility of the color harmony in the house.

关于这款灯具的广告宣传活动也是调研人员的检验范围和研究重点。看过该产品的宣传广告，大批被调查者对"温和色调"的灯具据有很高的热情，受其革新性的吸引急于买这种灯具。可是，无一类广告有特别强的影响，革新性产品需要考虑用更实在的方法。于是，公司又安排在每个大厅里，邀请 40 位目标被访者来评价商业电视的有效性，并且对广告促销活动做了适当的修改。在之后的三年中，公司持续性地检验广告宣传活动的效果，定期地追踪购买者的感受与新产品使用情况，这样的调研样本由每一组 2400 位购买灯具者组成，可见规模与数量之庞大。

值得一提的是，菲利浦公司还雇用了 MAS 公交车进行问卷调研与广告宣传活动，周期性地调整广告的视觉接受度，以此检验"温和色调"品牌的知名度，取得了第一手的产品调研信息。步骤清晰、注重细节、准确到位的市场调研，确保了新产品在市场上的良好口碑与稳定销售量。

The advertising activity about this light is the test range and research emphasis of the investigators. After seeing the advertising of this product, most respondents showed great enthusiasm for the light with "mild hue", and were quite willing to purchase this light due to its innovation. However, no advertisement had strong influence. With regard to the innovated product, it is necessary to consider more practical methods. Therefore, the company invited 40 targeted respondents to evaluate the efficiency of the commercial television in each hall, and made proper modification on the advertising promotion activities. In the later three years, the company continuously checked the effect of the advertising activities, and regularly traced the consumers' feeling and new product usage status. Such investigation sample was composed of 2400 light purchasers. Thus, it can be seen that the scale and quality are so great.

It is worth mentioning that Philip Lighting Company also rented MAS for the questionnaire and advertising activities. Periodically adjust the vision reception of the advertising, check the popularity of the "mild hue" brand, and obtain the first-hand product investigation information. The clear steps, attention on details, and accurate market investigation ensure the good reputation and stable sales volume of the new product in the market.

思考题：

1. "温和色调"灯具在设计上有哪些新颖之处？请用英文表述出来。

2. 根据范文内容，请用英文概述品牌管理与市场调研的基本步骤。

3. 请用中英文双语设计制作一份详细的产品市场调研信息表。

8.5　设计管理与品牌创新实例之三
Living Examples of Design Management and Brand Innovation Ⅲ

教学范文中英文对照

实例之三：创立新品牌的求索之路

这是一个百年前的老故事，但是，我们现在仍饶有兴趣地提起它，因为它是商界用新设计和新品牌创业成功的一大经典案例。

这段故事源自美国俄亥俄州一家小店的售货员普洛斯特，和杂货店老板盖姆是好友，他们俩志趣相投，两人经常互相串门，在一起喝咖啡、聊天。

盛夏的一天，普洛斯特到老朋友盖姆家作客，他们一起在楼房前喝咖啡闲聊，盖姆夫人正在一旁洗衣服。普洛斯特突然发现，盖姆夫人手中用的是一块颜色黑黝黝的粗糙肥皂，与她洁白细嫩的手恰恰形成鲜明的反差。他不禁叫道："这肥皂真令人厌恶！"

为此，普洛斯特和盖姆开始议论起如何做出一种又白又香的肥皂来。

Example Three: The Exploration Road of Creating a New Brand

This is an old story of a hundred years ago. However, we are still interesting to mention it because it is a classic case of successful business with new design and brand venture.

This story derives from Procter, a salesclerk of a small store in Ohio of America. He was congenial to Gamble, the boss of the grocery store. Procter and Gamble were friends of similar purposes and interests. They often dropped around mutually, and drank coffee and chatted with each other.

In a day of summer, Procter visited his old friend Gamble. They drank coffee and chatted in front of Gamble's house. When Mrs. Gamble was washing the clothes at side, Procter suddenly discovered that the black and rough soap in Mrs. Gamble's hand completely contrasted to her white and tender hands. He could not help shouting, "This soap is so disgusting."

Therefore, Procter and Gamble started to discuss how to make a white and fragrant soap. In that era, every family

在那个年代，家家户户使用看上去黑黢黢的肥皂，这是一件平常的事，但是，普洛斯特是一位有心人，他萌发出创业的念头。

普洛斯特和盖姆商量后，决定开办一家专门制造肥皂的小公司，名称就用他俩名字的头一个字母 P 和 G，叫 P&G 公司。普洛斯特请自己的哥哥威廉姆当技师，研制洁白美观的新型肥皂。经过一年的精心研制，一种洁白的椭圆形肥皂出现在他们的面前。

普洛斯特和盖姆欣喜若狂。犹如面对刚刚诞生的婴儿一样，该给它起一个什么动听的名字呢？普洛斯特煞费苦心，日夜琢磨。

星期天，普洛斯特和往常一样来到教堂做礼拜，可是，心里总想着为新肥皂命名的事儿，当他聆听神甫朗读圣诗："你来自象牙似的宫殿，你所有的衣物沾满了沁人心脾的芳香……"普洛斯特心头一热："对！就叫'象牙肥皂'。象牙一般的肥皂，洁白如玉，此名称又语出圣诗，能洗净心灵的污秽，更不用说外在的尘埃了。"美好的产品，圣洁的名字，谁能不爱呢？P&G 公司为此申请了专利。

为了把这种新产品推向市场，普洛斯特和盖姆求助于广告宣传。他们聘请名牌大学的著名化学家，分析"象牙肥皂"所含的化学成分，从中选出最有说服力和诱惑力的数据，巧妙地穿插在广告中传达给消费者，让消费

used black soaps, which was so common. But, Procter was an observant and conscientious person. He germinated entrepreneurial ideas.

After Procter and Gamble discussed this issue, they decided to establish a small company specialized in producing soaps, and use the first character "P" and "G" of their names titled the P&G Company. Procter invited his brother William as the technician to develop white and nice soaps. After one year of elaborate research, a clean and while oval soaps were appeared in front of them.

Procter and Gamble were mad with joy, like newly born infants. What should they name it? Procter took great pains and thought about it deeply day by day.

On Sunday, Procter came went to church as usual. However, he kept the name for the new soap all along. When he listened to the priest to read the psalm, "You come from the ivory palace, and all your clothes are with refreshing fragrance…" Suddenly, something popped into his mind, "Right! We can call it 'ivory soap'. Such soap is as white as polished jade. This name is also from the psalm. It can wash away the filthy of the spirit, not to mention the dust outside." As for such good product and such holy name, who did not like it? For this reason, the P&G Company had applied for a patent.

To introduce this new product to the market, Procter and Gamble focused on the advertising. They invited a famous chemist from a famous university to analyze the chemical components contained in "ivory soap", and selected the most persuasive and incentive data, skillfully inserted it into the advertising and conveyed it to the consumers, so as to make the consumers to firmly believe the superior quality of "ivory soap". Certainly, the P&G brand became so popular.

者对"象牙肥皂"的优良品质深信不疑。P&G 果然一炮打响。

一百多年来，P&G 凭借创新设计与品牌管理，加上有效的广告宣传，发展成为饮誉全球的洗涤用品跨国公司，P&G 的商标也走进亿万家庭。

For over one hundred years, the P&G company has been developed into a famous transnational enterprise specialized in washing product over the world by virtue of the innovation design and brand management, as well as the effective advertising. Besides, the trademark of P&G also has walked into billions of households.

思考题：

1. 这个实例带给你什么启发？请用英文概述你的感想。

2. 请用英语表述对身边常见生活用品的不足与改进提升的想法。

3. 请用双语表达方式，列举 1~2 个关于我国品牌创新的实例。

参考文献
References

（一）古籍文献

[1] （东晋）顾恺之.《魏晋胜流画赞》.见《津逮秘书》、《四库全书》本.

[2] （南朝·宋).宗炳《画山水序》.见《津逮秘书》、《四库全书》本.

[3] （南朝·齐).谢赫《古画品录》.《美术丛书》1936年上海神州国光社铅印本.

[4] （唐）朱景玄《唐朝名画录》.《美术丛书》（第二集）1936年上海神州国光社铅印本.

[5] （北宋）郭若虚《图画见闻志》.《津逮秘书》（第七集）1621年虞山毛氏汲古阁刻本.

[6] （北宋）刘道醇《宋朝名画评》.《景印文渊阁四库全书·子部·艺术类·书画之属》1984年台湾商务印书馆影印本。

[7] （宋）陈思《书苑菁华》第十六卷.清光绪十三年（1887年）大同局石印本.

[8] （宋）邓椿《画继》第二卷.《津逮秘书》（第七集）1621年虞山毛氏汲古阁刻本.

[9] （元）赵友钦《革象新书》第一卷.1935年上海商务印书馆影印本.

[10] （清）徐沁《明画录》第五卷.《读画斋丛书·乙集》1799年桐川顾氏刻本.

（二）中文文献

[1] 蔡元培.大学的意义：蔡元培卷.济南：山东文艺出版社，2006.

[2] 蔡元培.文明的呼唤：蔡元培文选.天津：百花文艺出版社，2002.

[3] 曹意强.二十世纪的中国绘画.杭州：浙江人民美术出版社，1997.

[4] 陈瑞林.20世纪中国美术教育历史研究.北京：清华大学出版社，2006.

[5] 方海，戴梓毅.从需求出发：工业设计大师汉诺·凯霍宁.南京：东南大学出版社，2014.

[6] （英）贡布里希.艺术发展史.天津：天津人民美术出版社，1991.

[7] 杭间.设计的善意.桂林：广西师范大学出版社，2011.

[8] （美）海勒，（美）魏纳著.跟着设计大师的逻辑走.郑孟迁译.北京：电子工业出版社，2013.

[9]（意）吉安·鲁吉·帕拉齐尼著.普拉达传奇.郭国玺，陈植译.北京：中国经济出版社，2013.

[10] 李妍姝.产品创新.北京：中国纺织出版社，2004.

[11] 卢少夫，林曦.立体构成.杭州：浙江人民美术出版社，2005.

[12] 墨柔塔（法）著.设计管理：运用设计建立品牌价值与企业创新.范乐明等译.北京：北京理工大学出版社，2011.

[13] 倪镇.智设计·活文化.北京：清华大学出版社，2015.

[14] 潘耀昌.20世纪中国美术教育.上海：上海书画出版社，1999.

[15]（德）佩夫斯纳·N.美术学院的历史.长沙：湖南科学技术出版社，2003.

[16]（美）沙里宁·伊利尔.形式的探索：一条处理艺术问题的基本途径.北京：中国建筑工业出版社，1989.

[17] 熊贤君.近现代中国科教兴国启思录.北京：社会科学文献出版社，2005.

[18] 邱春林.设计与文化.重庆：重庆大学出版社，2009.

[19] 应宜文.美国《学校艺术教育设备的设计标准》.装饰，北京：清华大学美术学院承办中国装饰杂志社，2014（1）（总第260期）：139.

[20] 张旅平.多元文化模式与文化张力.北京：社会科学文献出版社，2014.

[21] 曾繁仁.现代中西高校公共艺术教育比较研究.北京：经济科学出版社，2009.

[22] 中华人民共和国文化部教育科技司编.中国高等艺术院校简史集.杭州：浙江美术学院出版社，1991.

（三）外文图书

[1] Anfam, David. Abstract Expressionism. London: Thames and Hudson, 1999.

[2] Biggs, John. Teaching for Quality Learning at University. Philadelphia: SRHE & Open University Press, 1999.

[3] Bruner, Jerome. The Process of Education. U.S.A. Cambridge: Harvard University Press, 1960.

[4] Clapp, Edward P. (Ed). 20 UNDER 40: Re-Inventing the Arts and Arts Education for the 21st Century. Bloomington: Author House, 2011.

[5] D' Amico, Victor. Creative Teaching In Art International Textbooks in Art Education. Scranton: International Textbook Company, 1942.

[6] Davidson, Susan, (Ed). Art in America Three Hundred Years of Innovation. London: Merrell Publishers Limited, 2007.

[7] Donald, James. Sentimental Education: Schooling, Popular Culture and the Regulation of Liberty.

London:VERSO, 1992.

[8] Dow, Arthur Weslay. Composition (9th ed). New York: Doubleday, Page and Company, 1920.

[9] Efland, Arthur D. A History of Art Education: Intellectual and Social Currents in Teaching the Visual Arts. New York: Teachers College Press, 1990.

[10] Fishel, Catharine. How to Grow as a Graphic Designer. New York: Allworth Press, 2005.

[11] Freeman, Kerry. Teaching Visual Culture Curriculum, Aesthetics, and the Social Life of Art. New York: Teachers College Press, 2003.

[12] Gardner, Howard. Art Education and Human Development. Los Angeles: Getty Publications, 1990.

[13] Halsey, A. H, (Ed). EDUCATION: Culture, Economy, and Society. Oxford: Oxford University Press, 1997.

[14] Hetland, Lois. Studio Thinking: the Real Benefits of Visual Arts Education. New York: Teachers College Press, 2007.

[15] Lee, Alison & Danby, Susan (Ed). Reshaping Doctoral Education International Approaches and Pedagogies. London: Routledge, 2012.

[16] LUCIE-SMITH, Edward. Lives of the Great Modern Artists. London: Thames & Hudson, 1999.

[17] Marcus Vitruvius Pollio. Ten Books on Architecture. Harvard University Press, 1914.

[18] McLanathan, Richard. Art in America: A Brief History. New York: Harcourt Brace Jovanovich Publishers, 1973.

[19] Moore, Alex. Teaching and Learning: Pedagogy, Curriculum and Culture. London: Routledge, 2001.

[20] National Art Education Association. Design Standards for School Art Facilities. Publisher: National Art Education Association, 1993.

[21] Noblit, George W. & Corbett, H. Dickson. Creating and Sustaining Arts-Based School Reform. New York: Routledge, Taylor & Francis Group, 2009.

[22] Prather, Marla F. & Arnason, H. H. History of Modern Art. New York: Harry N. Abrams, Inc., Publishers, 1998.

[23] Proefriedt, William A. High Expectations: The Cultural Roots of Standards Reform in American Education. New York: Teachers College Press, 2008.

后 记
Postscript

现代设计已经成为社会生活不可缺少的部分，目前，我国各大重点高校、专业艺术大学（学院）、艺术职业教育学院等都有不同特长的艺术设计专业，很多师生作品近年来在国际设计竞赛上屡屡获奖。但是，与世界先进的现代设计教育相比，我们的国际化视野有待进一步开阔。目前，重要的是设计学专业英语的水平亟需提高，特别是解读国外设计作品的能力、运用设计学国际通用专业术语的能力等方面的训练。不从语言入手，不能解决关键问题，从而影响我们的设计构思乃至设计作品的国际竞争力。

作者经过两年多的努力编写本教材，以期推动设计学双语教学的进程，从本专业基础入手、引介西方设计经典文献、设计大师及其作品、艺术设计评论、设计流程与管理实例等，精选并翻译了我国古典文献中蕴含的先进设计理念，从我国优秀的传统文化中汲取设计灵感，增强对母语及母语文化的自豪感。

记得曾有一位设计学资深教授对本人说："双语教学就是'双倍'工作量的设计教学。"虽然，这是一句宽慰的话，但却说出了双语授课教师们的心声，因为，对于双语任课教师来说，既要完善中文的教学内容，又要准备已有教学内容的英文翻译，工作量之大难以想象，也是学生们难以体会到的。然而，这本教材是旨在为设计学领域正从事双语教学或者预备开设双语课程的教师省时省力而编写的一本参考书。对于我们高校学生来说，本教材所有精选的范文均以中英对照的方式呈现，图文并茂，可以对照查阅。这是一部加强对双语理解与思考的"工具书式"的专业教材。

书中选编了国内、外设计师的作品，为本教材所用图例提供作品的设计者还有：常虹、Peggy Qian、卢少夫、林曦、陈洁群、徐冰、朱意灏、田密蜜、张振兴、许新国、万凌、郑昱、林伟伟、汤起、朱彦、黄文韬、沈一凡、于瑾、曾青青、郑晓芳、钱博弘、方建国、金煜、倪佳欢、钱寒轩、蔡扬、齐颖芳、丁雅玲、张勇、洪海云、阎云逸、赵杨等人。在此致以诚挚的感谢！

应宜文
2015 年 5 月